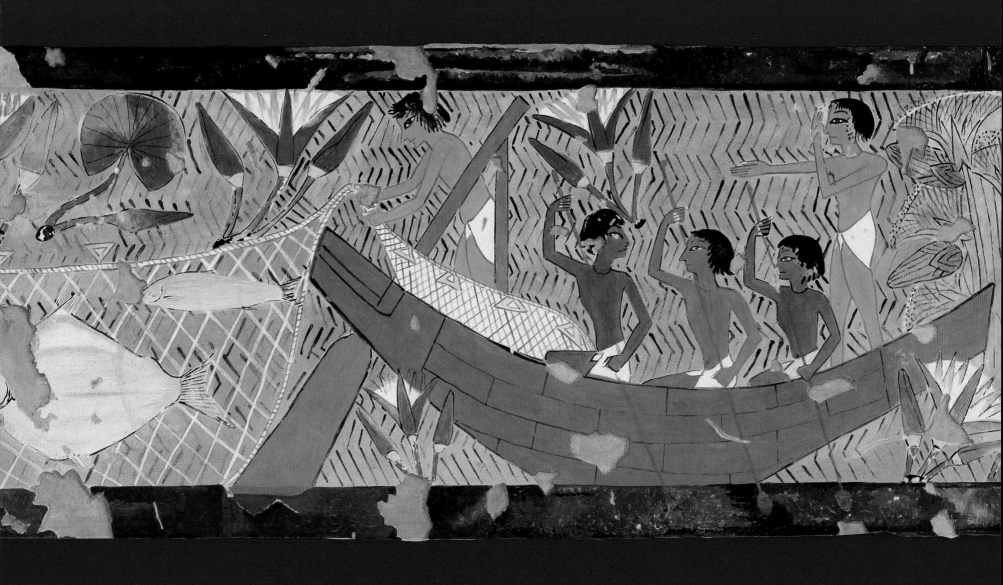

On a Painted Ocean

Art of the Seven Seas

A rocky cliff and beach
are transformed by
Claude Monet into an
impressionistic study that
captures the transient
beauty of the sea at its
margin with the land.

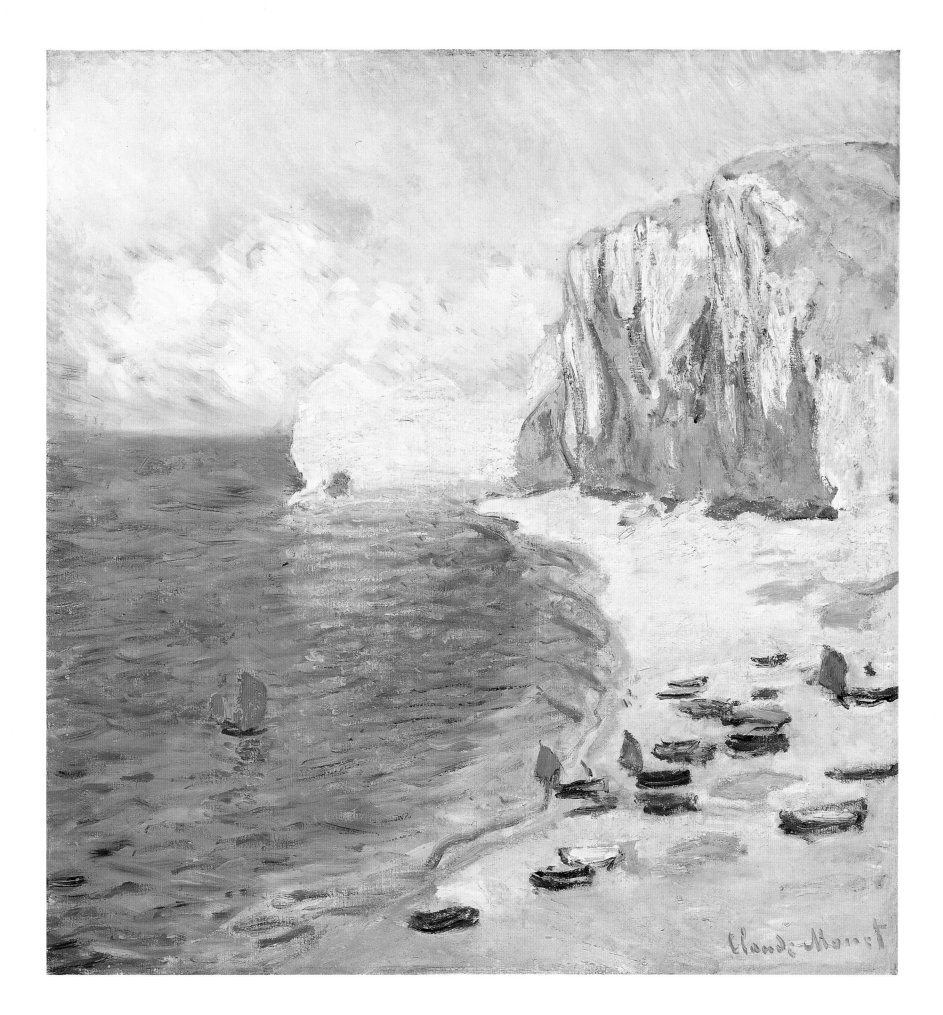

Claude Monet

The Clipper Ship Ocean Telegraph, ca. 1858
James Edward Buttersworth
Oil on canvas
69 x 86.5 cm. (27.12 x 34.25 in.)
South Street Seaport Museum, New York

Waves lash the swift clipper ship *Ocean Telegraph*, which is painted with the realism characteristic of works by American marine master James Buttersworth.

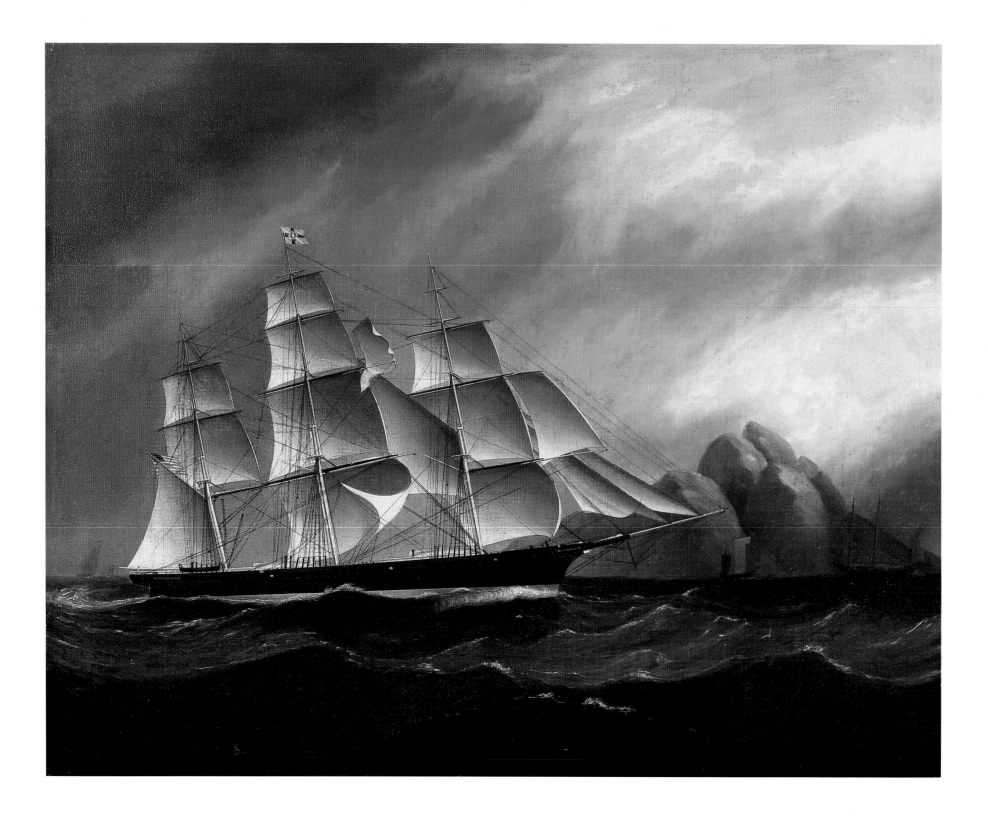

On a Painted Ocean

Art of the Seven Seas

By Peter Neill

in collaboration with
James A. Randall
and Suzanne Demisch

Edited by Gareth L. Steen

 New York University Press
New York and London

Published by New York University Press
New York and London

c 10 9 8 7 6 5 4 3 2 1

Introduction and essays: Peter Neill
Editor: Gareth L. Steen
Consulting editor: James A. Randall
Design: Beveridge Seay
Designer: Jack Beveridge
Printed in Hong Kong by Everbest Printing Co., Ltd.

Library of Congress Cataloging-in-Publication Data

Neill, Peter, 1941-
On a painted ocean : art of the seven seas / Peter Neill ;
with James A. Randall and Suzanne Demisch ;
edited by Gareth L. Steen.
p. cm.
Includes index.
ISBN 0-8147-5787-1
1. Marine art. I. Randall, James, 1938- . II. Demisch, Suzanne.
III. Steen, Gareth L. IV. Title.
N8230.N45 1995
758'.2 – dc20 95-32496
 CIP

Table of Contents

This decorative compass rose features H.M.S. *Pembroke*, the ship the artist served on, surrounded by sketches of the same ship with sails trimmed for each compass point with a westerly wind blowing.

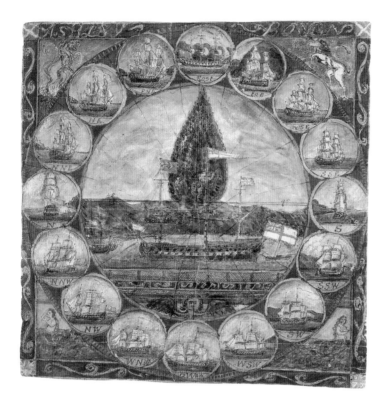

Compass Rose With Shipping Sketches, 1784-1789
Ashley Bowen
Watercolor and ink on paper
24.8 x 24.8 cm. (9.75 x 9.75 in.)
Peabody Essex Museum, Salem, Massachusetts
Gift of Alexander O. Victor, 1981
Photo: Mark Sexton

Foreword

FROM ANTIQUITY TO THE PRESENT DAY, the fascination with the sea has been expressed through art. In paintings and vases from the Mediterranean basin, ancient scrolls from the Far East, in classical renditions and folk art, even in posters and ship calling cards, artists have sought to portray the romance, the mystery, the power and the majesty of the sea.

The history of Mobil is indelibly linked with the sea. Less than a decade after Colonel E. L. Drake's 1859 oil discovery in Titusville, Pennsylvania, shipments of kerosene, tanning oil and other products of the fledgling industry were being delivered throughout the world aboard beautiful square-rigged ships.

"Kerosene clippers," as they came to be known, carried case-oil from New York and Philadelphia to Europe and to far-away ports in China, Japan, India, Australia and New Zealand. They returned with tea, sugar, camphor, rattan and matting. In all, 23 of these beautiful vessels plied the sea lanes for Mobil's predecessor companies, establishing a tradition of safe, efficient and economic transport of crude oil and high-quality petroleum products to world-wide markets.

The first ship anywhere expressly designed to carry oil in bulk was the *Glückauf* with a cargo capacity of 7,100 barrels, owned by the German affiliate of a Mobil predecessor company. Launched in 1886, the steel-hulled ship was propelled by sails and powered by a coal-fired steam engine. Two years after the *Glückauf* opened the tanker era, the first true ancestor of Mobil's modern-day fleet, the 7,100-barrel *Standard*, was launched in Chester, Pennsylvania.

Since the days of romantic sailing ships, Mobil's fleet has evolved through steam-powered oceangoing tows and tankers to the double-hulled, diesel-powered leviathans–very large crude carriers, or VLCCs–that today can carry over two million barrels of crude oil each. While the beauty and romance of clipper ships have passed, the tradition of quality shipping lives on as Mobil tankers continue to ply the sea lanes, meeting the global requirements for petroleum transport.

Mobil Shipping and Transportation Company is proud to present this volume, *On a Painted Ocean– Art of the Seven Seas,* to honor those whose lives have been inextricably twined with the sea.

Gerhard Kurz
President
Mobil Shipping and Transportation Company

Preface

LET ME WELCOME YOU with great enthusiasm to this beautiful meditation on the image of the sea in art. Selected by Peter Neill, president of New York's South Street Seaport Museum, the pictures contained herein survey the full horizon of the ocean as an element in world culture. Each page is a delight – frequently a surprise in that Peter has chosen unusual paintings by the best-known artists or the best work of artists who have not otherwise been reputed as "marine."

Here by the waters of Vineyard Sound and the Atlantic, I have always found my personal solace – as a coastal dweller, a walker of the beaches, a sailor. These images recall many feelings associated with that experience, and suggest as well the extraordinary breadth of human involvement contained in the various maritime themes of world discovery, sustenance, warfare and technology. Peter's introduction to these sections evoke an interesting dual interpretation – the external, historical content of each picture as well as its internal, cultural meaning. If these essays sometimes resort to poetry, it is because the quality of the image as both document and metaphor demands such language.

Nothing can substitute for the sea. Nothing can replace being by it, or in it, or on it. Nothing ultimately can recreate its ever-changing dynamic of motion and light. But to capture such an impossibility is a goal of art and a paradoxical motivation for all artists. You can see here a full measure of the attempt, just as you can see how close the best have come. I wish you fair winds on this painted ocean.

– Walter Cronkite

Introduction

by Peter Neill

IMAGES OF THE SEA are as universal as the sea itself. What is clear from our experience is that for all time the oceans have exerted their powerful pull upon human consciousness in profound ways as reflected in our attempts – however primitive, however refined – to express our history and our being.

To compile, then, a volume inclusive of such broad evocation is visionary, if not impossible; and this book is predicated on that understanding. What I have attempted is to make a purely subjective choice of images from world culture that simply suggest themes that over time have emerged – driven by, shaped by, the sea. It has been a wonderful opportunity to revel in the visual language of the ocean, to wonder at its many subjects and styles, and to offer humbly an individual selection, hopefully provocative, that expands both the narrow geographical focus and the more traditional definition of "marine art."

You will find here some of the predictable masterpieces – the work of the great 17th and 18th century Dutch and English masters. You will find the expected portraits of captains and of ships in extremis off recognizable points of land; and you will find memorialized events, heroic encounters of ships of the line or the engagements of fleets, the outcome of which changed the geopolitical balance of power of an era.

But in an effort to broaden our notion of the genre, you will find that forms that exploit maritime subjects in unusual ways – the decoration of an ancient Greek bowl, for example, or an illustration from a classic sea novel – have also been included. I have selected, among other media, woodcuts and tapestries, maps and illuminated manuscripts, and posters and advertising ephemera. Of the well-known artists, I have frequently chosen less familiar works, and I have included artists that have heretofore been outside the established marine tradition or are relatively unknown beyond their national boundaries. I have also been subjective about time, beginning with tomb paintings from an early Egyptian dynasty and ending with a work by a 20th century Abstract Expressionist.

Understanding these assumptions is important to the enjoyment of this book, and I invite you to extend them to your personal knowledge and to compile a volume of your own images, no doubt different, but an exercise nonetheless as gratifying as this one. Close this book, and dream of your own painted ocean.

✿

If our environment is divided into three parts – sea, land, and sky – then, of the three, the sea is the most alien and dynamic. The sky, although reflective of weather, is two-dimensional and apart. The land is static, seemingly immutable in the face of our most inspired engineers and their earthmoving tools. The interruptions of quake and avalanche, upheaval and

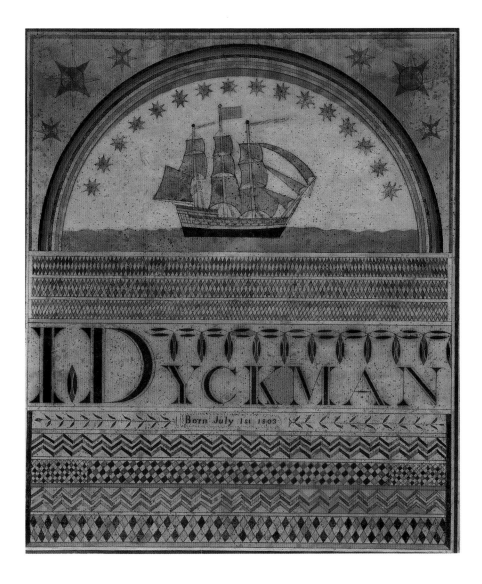

Birth and Baptism Certificate of I. Dyckman, 1803
Anonymous
Pen and watercolor on paper
35.2 x 30 cm. (13.87 x 11.80 in.)
Museum of Fine Arts, Boston, Massachusetts
Gift of Maxim Karolik

So pervasive has the lure of the sea been down through the ages that its presence is often found in unusual places – such as on this birth certificate hand-drawn for I. Dyckman in 1803. It depicts a ship sailing beneath a canopy of stars.

subsidence, are still terrifying anomalies within the stability of a land settled, cultivated, even abused. The land is our natural home.

But the sea is characterized by movement and change, by random patterns of light and dark, turbulence and placidity, by transcendental calm and tempestuous anger, indeed by a multidimensional assault upon all our senses. The sea is indifferent to our futile acts on land of war and peace, hate and love, the ever-contradictory vector of social behavior that we presume to call progress. Until recently at least, this waterworld had remained unaffected by our puny existence. We have propagated our species and polluted the land and air to a degree that our detritus and emissions have severely corrupted these elements. Now, the sea is threatened – fish populations have been diminished, water tainted, and the food chain disrupted by temperature change and social waste. Humankind must forge a new environmental covenant with land, air and sea.

The ocean covers most of the planet's surface. Water exchanges from sea to sky, irrigates and runs off the land to gather in the ocean once again. It is like a suspension in which we float, the amniotic fluid that unites us all. When I stand at the shore – or travel on the water – I invariably know its power. I am struck by my weakness and humility before something that is totally beyond my control. I am certain that feeling is universally shared, that certainty affirmed by the commonality of expression found in images drawn over time by artists from all lands responding, like me, to this stimulus. The relationship is physically obvious and psychologically mysterious; it is surely the realm of the divine.

Joseph Conrad described the sea as a "primor-

dial, undifferentiated flux." The poet W.H. Auden called it the "barbaric vagueness and disorder out of which civilization emerged." Jonathan Raban, a contemporary novelist and editor of an excellent anthology of writing about the sea, names it "primal theater," a place of "incandescent quality." These descriptions, with their reliance upon metaphor, use poetry to encompass the infinite dimension, the richness, the chaos, the force of the sea. The challenge is no different for the visual poet; the critic John Ruskin wrote: "To paint water in all its perfection is as impossible as to paint the soul."

Those of us who are not artists, but whose role it is to interpret culture, must also rely upon metaphor – well-charted waters where the dangers are cliches. Nonetheless, for purposes of this Introduction, I have chosen two images that measure the idea of "passage," the transit from birth to death – from the simple birth and baptismal certificate of I. Dyckman, born 1803, to the spectacular painting by John Singleton Copley of *Watson and the Shark* (1778) with all its dramatic intimation of death.

To live is to be launched upon the waters, ill-prepared and lacking in the skills to guarantee survival. Along the way, fraught with peril, we pass the navigational points of name-giving, initiation, apprenticeship, relationship, maturity, understanding. We disappear, frequently without a trace. Who was Dyckman? Who was Watson? Who is to know when the tranquil journey, its innocent outset marked in simple notice, will be transformed into nightmare? Anyone who looks into Watson's face cannot avoid a shudder of identification. There go I, naked and pure. There go we in our frailty, overboard, reliant on our crewmates of necessity to pull us free, victims subject to the vicious, random, unrelenting attack of the shark.

This sense of passage exists from the earliest times. It pervades our mythological explanations of origin. We pass from timelessness into time and back again, a wave-like rhythm of generations and repeated folly. We find it carved into rocks and painted on the walls of ancient tombs. We find it drawn in the crude scientific marks of the day on charts that claim to delineate what is absolutely known. We find it in the atom and at the limits of the universe, in space and cyberspace alike. Like Watson's shark, there are monsters in the margins, and they are familiar to each of us.

Following this brief Introduction, the book is arranged by subjects. Each of these loosely structured chapters is accompanied by a brief essay evocative of the theme. The selection will take you from icons of early mariners to exploration, from conflict to commerce, from sustenance to trade, from wreck to technological revolution. We will explore historical depictions and folk tales, heroic acts, chronicles of endurance, some celebrations, many tragedies. We will make a contemplative passage through art, a passage that will take us in a circumnavigation of discovery and change to a final image, a single creative emanation that I propose can stand inclusive for it all.

In the end, the sea is a mirror of the self; it reflects just as it absorbs. In it, we can see anything and everything, from the foundation of facts to the inspirations for fictions. It is paradox. Charles Tomlinson, in his poem "On Water," concludes:

> *and yet it confers*
> *as much as it denies:*
> *we are orphaned and fathered*
> *by such solid vacancies:*

This powerful scene is based on the real-life trauma of Brook Watson, a 14-year-old English boy who lost a leg to a shark while swimming in Havana Harbor in 1749. The artist, John Copley, did not witness the attack, yet managed to charge the scene with a grisly realism unusual in his day.

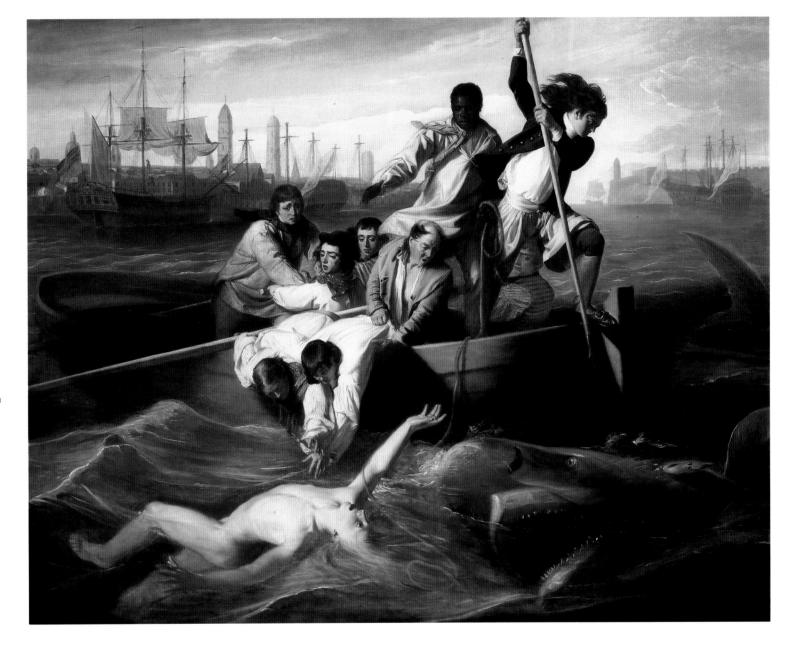

Watson and the Shark, 1778
John Singleton Copley
Oil on canvas
182.2 x 229.8 cm. (71.75 x 90.5 in.)
National Gallery of Art, Washington, D.C.
Ferdinand Lammot Belin Fund

The Eternal Sea

For tho' from our our bournes of Time and Place
The flood may bear me far,
I hope to see my Pilot face to face
When I have crost the bar.

Alfred Lord Tennyson
From "Crossing the Bar"

SOLID VACANCIES: the stuff of myth. Out of the sea have emerged images of origin and meaning – primitive figures from Africa, painted bowls from ancient Greece, wall murals from pre-Columbian Mexico, tomb decorations from Egypt, manuscripts from Arabia illuminated with scenes of early seamen. Every culture and every continent has its primal views, each a response to the mystery that was unknown and undefinable beyond the horizon.

The themes are established from the beginning: the solitary sailor, the pursuit of sustenance, the place of conflict and surprising encounter. Jonah is swallowed by the whale. The flood rises from the inconceivable storm; the ark runs hard aground on Ararat; and the animals, two by two, are saved to repopulate the world. Ships float in an ocean of glass through a transparent circumference

This Zairian painting depicts a bizarre creature, the Mami Wata – part mermaid, part siren – who blows a horn to lure unsuspecting mariners. According to an African legend, the Mami Wata is friendly to those who keep her secrets, but "eats the souls of those who do not."

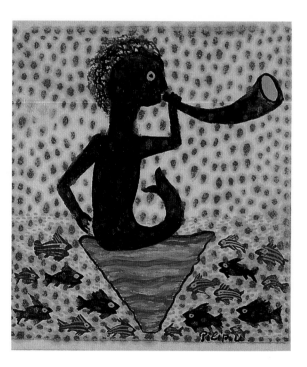

(above) *Mami Wata,* 1948
Pili Pili
Oil on paper
Collection of Eric Kawan
Brussels, Belgium

(right) *The Meeting of the Boats,* ca. 1567-1582
Mogul miniature, Akbar Period
Illustration from *The Romance of Amir Hamza*
Manuscript page: color on parchment
Museum of Applied Arts, Vienna

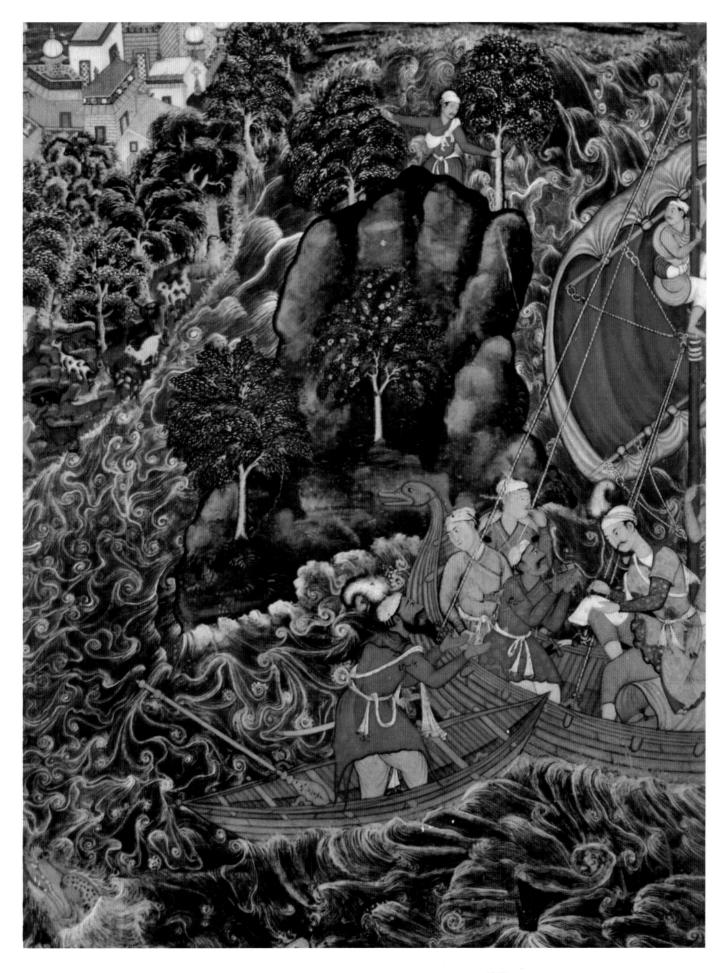

Two ancient seafaring cultures literally collide when the boats of Arabic and Indian mariners meet off a rocky promontory in this scene from a 16th century Mogul-era manuscript from India.

The Eternal Sea

of marsh, birds, and distant civilization. Proud vessels carry saints on pertinent missions, and the fleet serves as backdrop for a visitation of angels or a call to God. Barbarians invade, Pharaoh's army drowns in parted waters, and men like gods sail the wine-dark sea.

These images are the essence of culture, passed as visual continuities through the generations. Artist after artist takes them as inspiration, refines them in an ensuing present, and abandons them, sometimes for centuries, as cultural patrimony to be discovered, preserved, studied and admired anew. These images are universal and eternal.

As such they unite us. They bring us together in recognition of common experience. We are far from home, lost in the empty galleries of a foreign museum or led by the hand into some forgotten cave when there upon the wall the guide points out a crude ship, a human figure, a netted fish — symbols of a distant human enterprise, the activity itself *and* its artistic depiction. We are caught by surprise.

Mayan Seacoast Village, ca. A.D. 800–1000
Watercolor by Ann Axtell Morris of a wall mural in the
Temple of the Warriors at Chichén Itzá, Yucatán (1931)
Peabody Museum,
Harvard University, Cambridge, Massachusetts
Photo: Hillel Burger, 1981

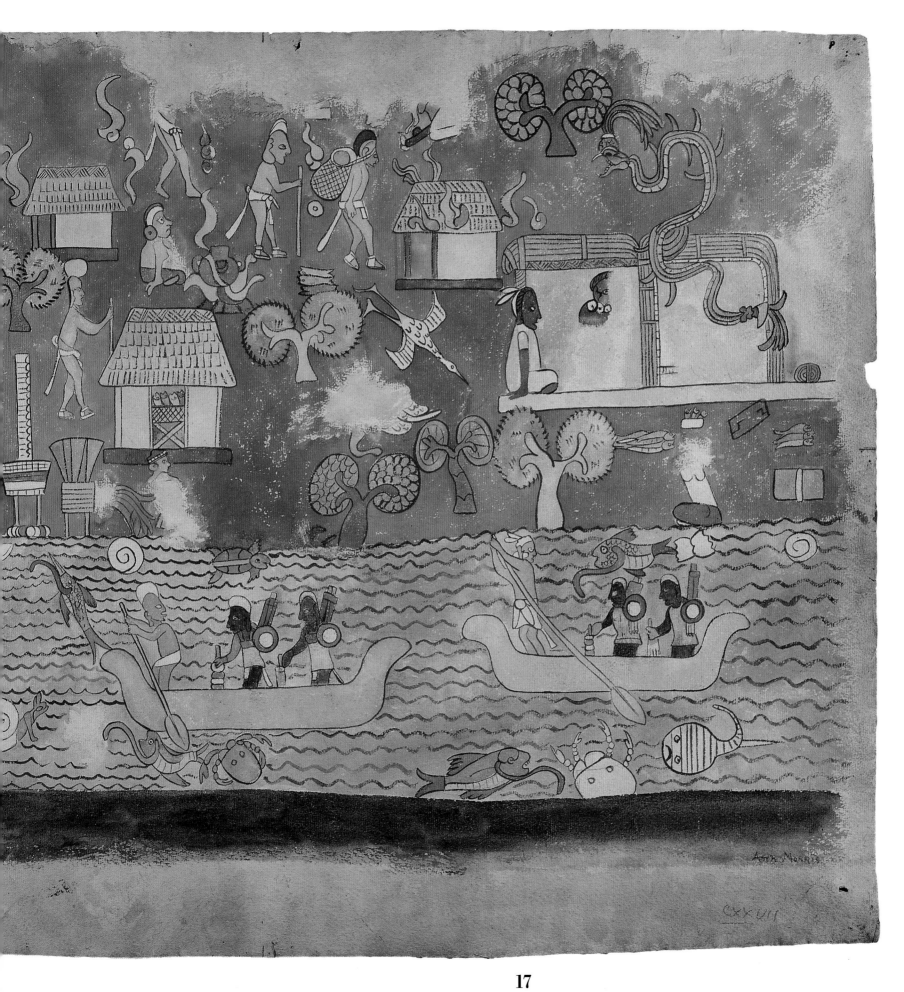

The Eternal Sea

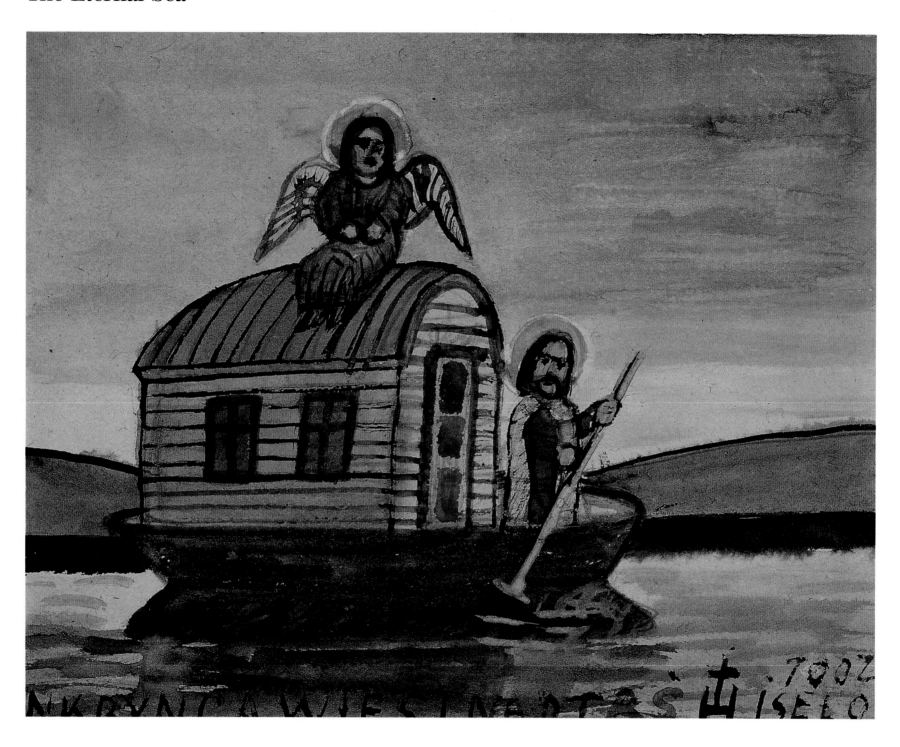

A whimsical angel perches atop the ark with Noah at the helm in this painting by Nikifor-Matejko, a self-taught Polish artist whose works are distinguished by simple forms and vibrant color.

Noah's Ark, ca. 1935
Nikifor-Matejko
Watercolor on paper
16.5 x 21.6 cm. (6.5 x 8.5 in.)
The Anthony Petullo Collection of Self-Taught and Outsider Art
Milwaukee, Wisconsin
Photo: Efraim Lev-er

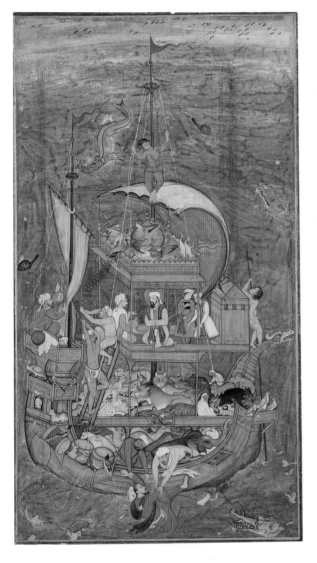

We have seen these signs before. In our youth we might have scrawled those same glyphs ourselves on a sandy beach. Incredible! We confront our shared humanity, more so than in formal portraits of ladies and their gentlemen in period dress or vivid landscapes where the flora and fauna can be specifically of that setting alone. We transcend time and place. We recognize each other in a universal guise. We acknowledge the recombinant power of the eternal sea through its consistent inconstancy, its constant insistence — and we marvel.

Does knowing this transcendence imply responsibility? I think it does. Those who know the sea seem stronger in the face of challenge and adversity. They are able, as one accomplished seaman wrote, "to lean forward into life." They are calm when the waves are high and rough. They are never at a loss when the wind is still. They have fortitude and endurance; they are alive in the vicissitudes of the natural world. They are moralists and believers; they are superstitious and romantic. They live hard; they get things done. ✿

A very different rendition of Noah's ark is this one from 16th century India. An example of the transference across time and place of biblical stories, it shows an ark so crowded that one crew member has fallen overboard, while another clings precariously to the mast.

Noah's Ark, ca. 1590
Attributed to Miskin
Mogul, Akbar Period
Color and gold on paper
28.1 x 15.6 cm. (11 x 6.14 in.)
Arthur M. Sackler Gallery,
Smithsonian Institution, Washington, D.C.

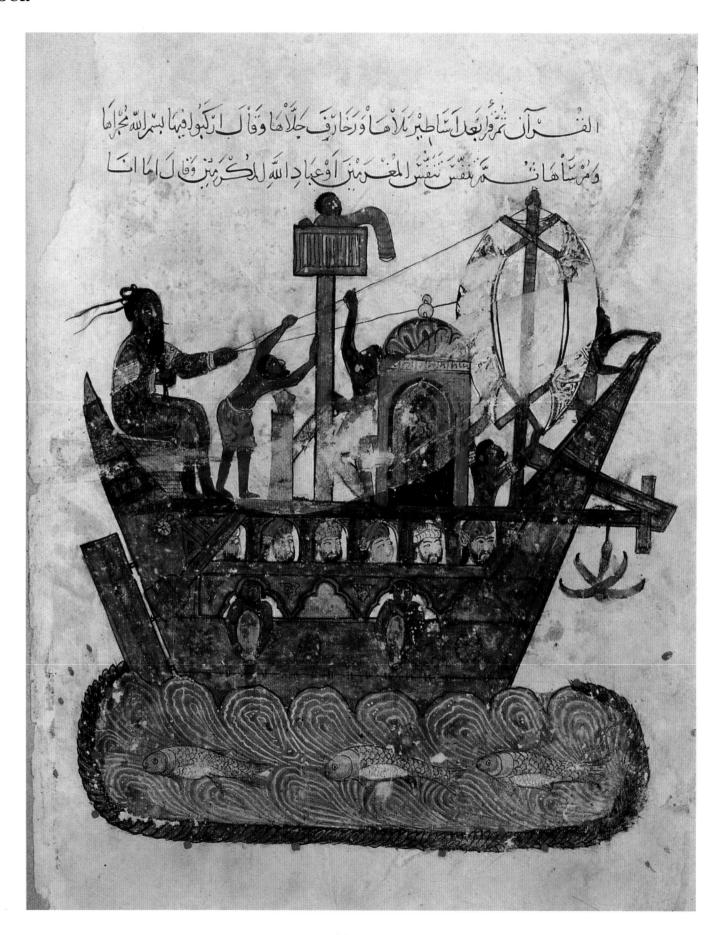

A merchant vessel from the 13th century – the era of greatest maritime power on the Arabian peninsula – sails on a stylized sea. Mariners from Arabia voyaged around Africa in 600 B.C., and by A.D. 671 had reached Serendip (Sri Lanka), Champa (Vietnam) and China.

In this scene from a 12th century illuminated manuscript, Angles, Jutes and Saxons invade England, which is represented as a fortress on a circular island between two trees. The invasion by warriors from Denmark and Germany occurred almost simultanously in the 6th century A.D. and changed forever the language, customs and ethnic makeup of England.

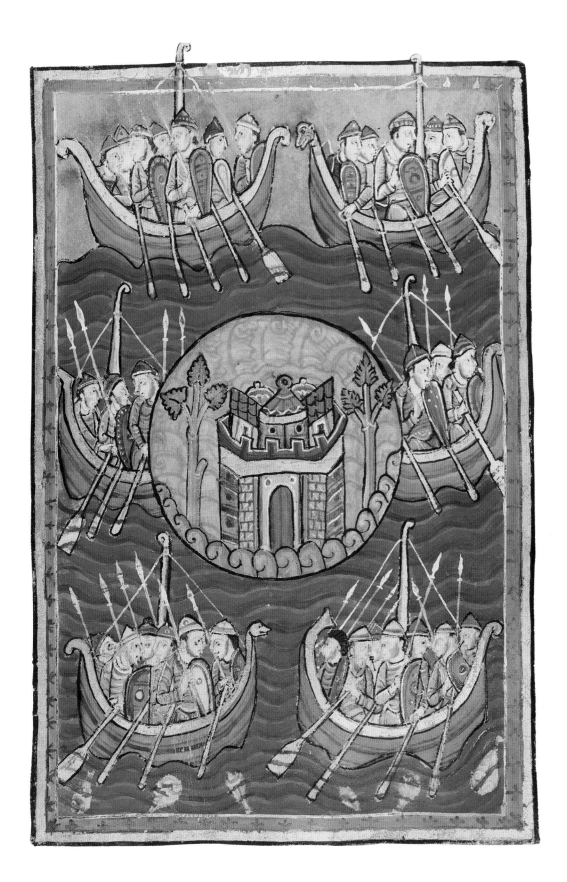

(left) Arabian Boat, ca. A.D. 1200
Anonymous
Detail of an illuminated manuscript page
Bibliothèque Nationale de France, Paris

(right) *Barbarians Arriving in Britain by Sea*
From *The Life, Passion and Miracles*
of St. Edmund, King and Martyr, ca. A.D. 1130
Color on vellum
27.3 x 19 cm. (10.75 x 7.5 in.)
The Pierpont Morgan Library/Art Resource, New York

The Eternal Sea

The turbulence of the
sea and the agony of
drowning Egyptian soldiers
(portrayed here in the
armor of feudal knights
with a medieval town in
the background) are vividly
rendered in this 16th cen-
tury print of the biblical
story of the parting of the
Red Sea.

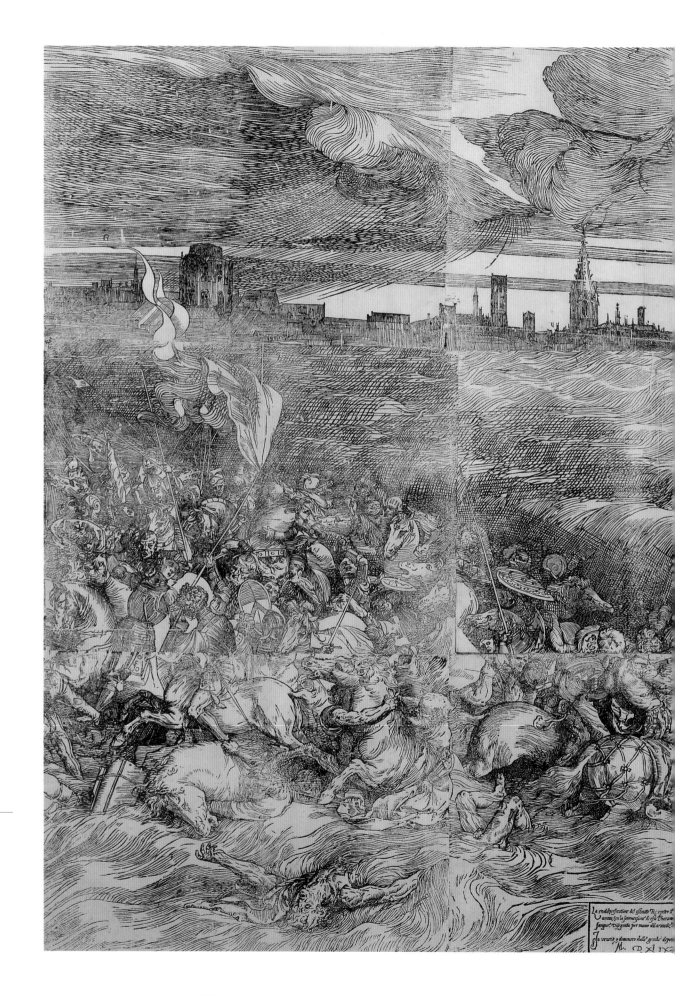

Passage of the Red Sea, 1549
Domenico dalle Greche
Woodcut
118 x 215 cm (46 x 84.6 in.)
Harvard University Art Museums
Fogg Art Museum, Cambridge, Massachusetts
Gift of W.G. Russell Allen

The Eternal Sea

This 14th century version of Jonah and the whale is unusual because it is of Islamic origin. It depicts a shipwrecked Jonah and a "whale" that looks suspiciously like a carp. Nonetheless, it's a significant work as it may have influenced later European versions of the biblical story.

Jonah and the Whale, ca. A.D. 1307
From *The Universal History of Rashid al-Din*, Tabriz, Persia
Islamic manuscript painting
Watercolor on paper
10 x 15 cm. (4 x 6 in.)
Edinburgh University Library, Edinburgh, Scotland

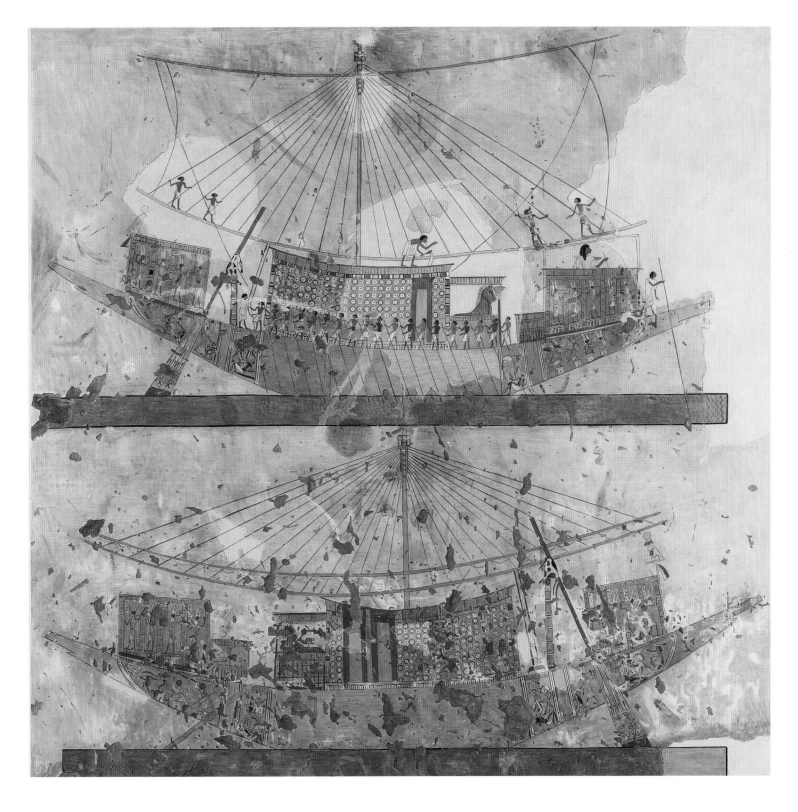

A painting from the tomb of Huy in Egypt is notable for the details it provides about seamanship thousands of years ago. In the top image, sailors man the rigging and oars, and a pilot at the bow takes a sounding with a long stick. Huy, Pharaoh Tutankhamen's viceroy to Nubia, is in an ornate cabin near the bow. The bottom image depicts the envoy's ship after it arrived in Nubia.

State Ship of Huy, ca. 1360 B.C.
Wall painting copied from the tomb of Huy
111.3 x 111.3 cm. (43.8 x 43.8 in.)
Egyptian Expedition of The Metropolitan
Museum of Art, New York
Rogers Fund, 1930

The Eternal Sea

This delicately painted marine scene is all that survives of what was an elaborate example of the fishbowl-atop-birdcage combinations that were popular curiosities in 19th century England. As a medium for the depiction of marine life, the fishbowl is both unusual and a graphic example of how artists used unconventional means to portray images of the sea.

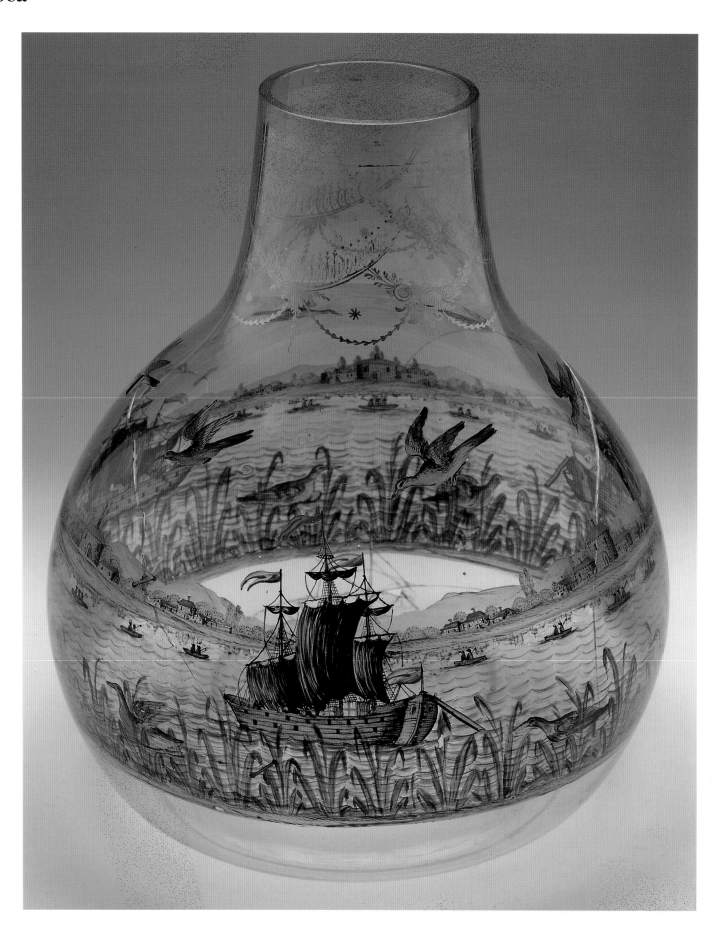

"Ship's chaplain Sweder Hoyer" preaches amidships in this portrait of a warship adorned with heraldic shields. Such paintings immortalized ships and their officers, and were especially popular in the 16th century.

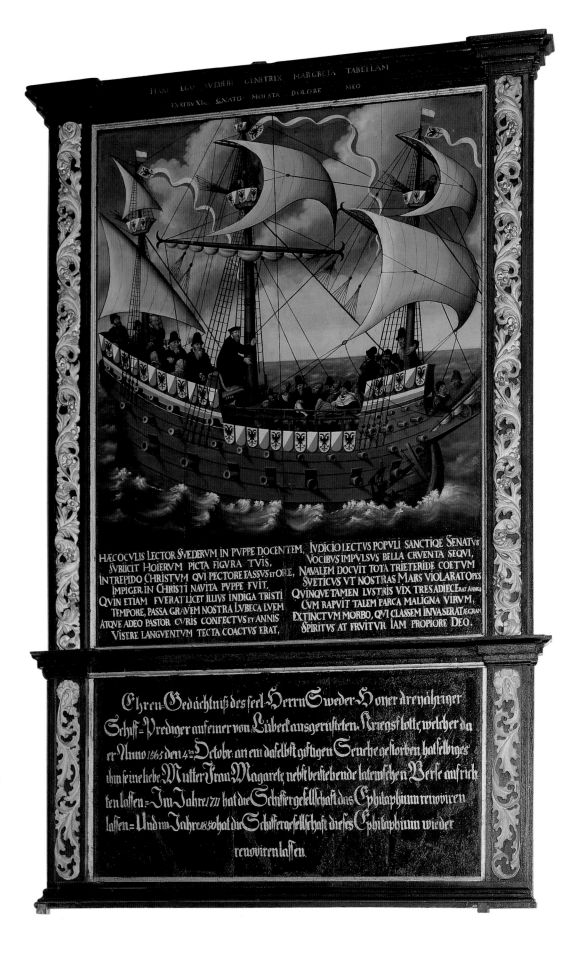

(left) Fishbowl, ca. 1790-1820
Blown glass with enamel and gilded decoration
Height: 32 cm. (12.62 in.)
Warner House Association, Portsmouth, New Hampshire
Bequest of Mrs. Henry G. Vaughan
Photo: Bruce Alexander

(right) *Gedenkbild für den Schiffsprediger Sweder Hoyer,* 1566
Lübecker Meister
Oil on wood
139 x 108 cm. (54.7 x 42.5 in.)
Jakobikirche, Lübeck, Germany

The Eternal Sea

A recumbent figure with an anchor and other marine implements at his feet, representing the "revival of Ligurian genius," is an allegorical study by the 17th century Italian artist Bernardo Veneroso. Prominent in the background are the seagoing vessels responsible for the resurgence of this region on Italy's Ligurian Sea.

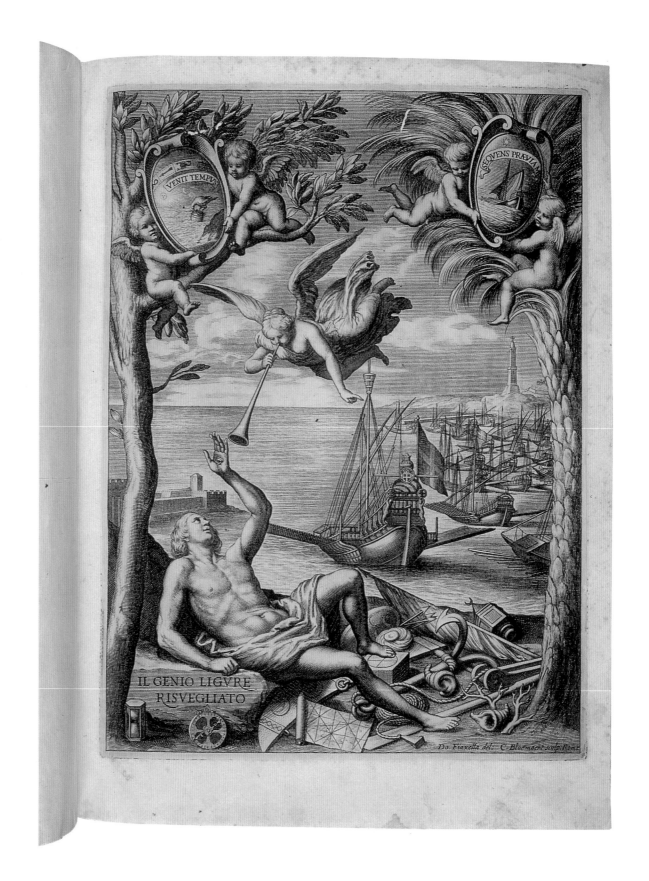

Il Genio Ligure Risvegliato, ca. 1650
Gio Bernardo Veneroso
Manuscript drawing
35 x 25 cm. (13.8 x 9.8 in.)
N.I. Museo Navale, Genoa, Italy

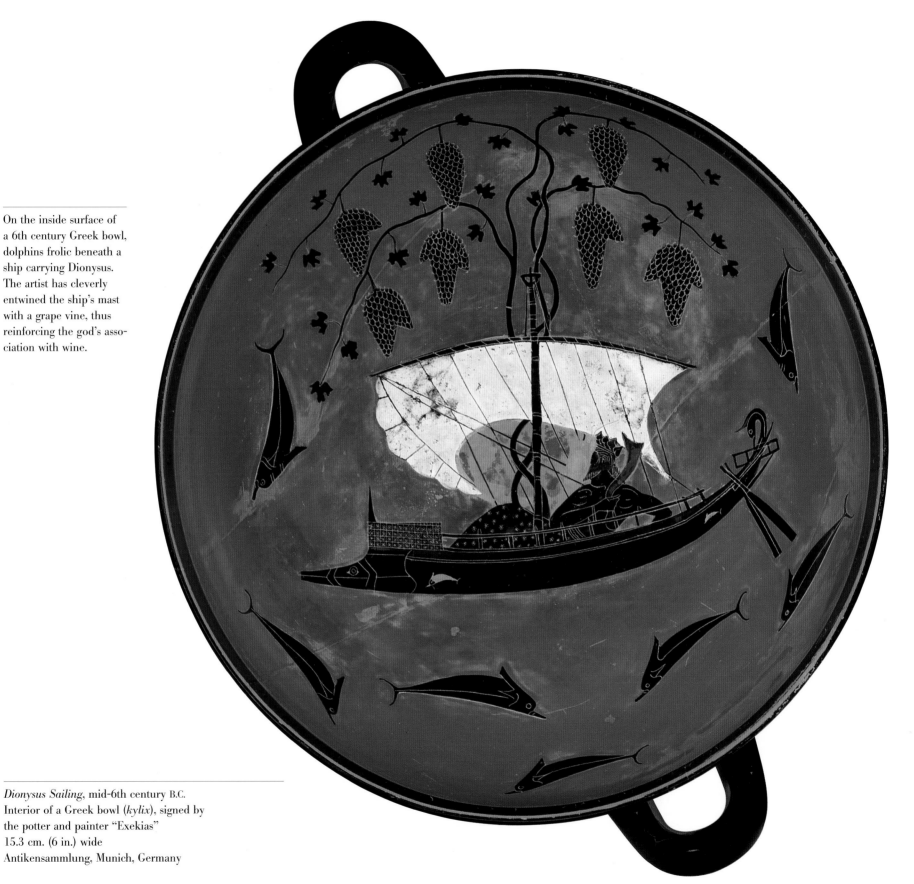

On the inside surface of a 6th century Greek bowl, dolphins frolic beneath a ship carrying Dionysus. The artist has cleverly entwined the ship's mast with a grape vine, thus reinforcing the god's association with wine.

Dionysus Sailing, mid-6th century B.C.
Interior of a Greek bowl (*kylix*), signed by the potter and painter "Exekias"
15.3 cm. (6 in.) wide
Antikensammlung, Munich, Germany

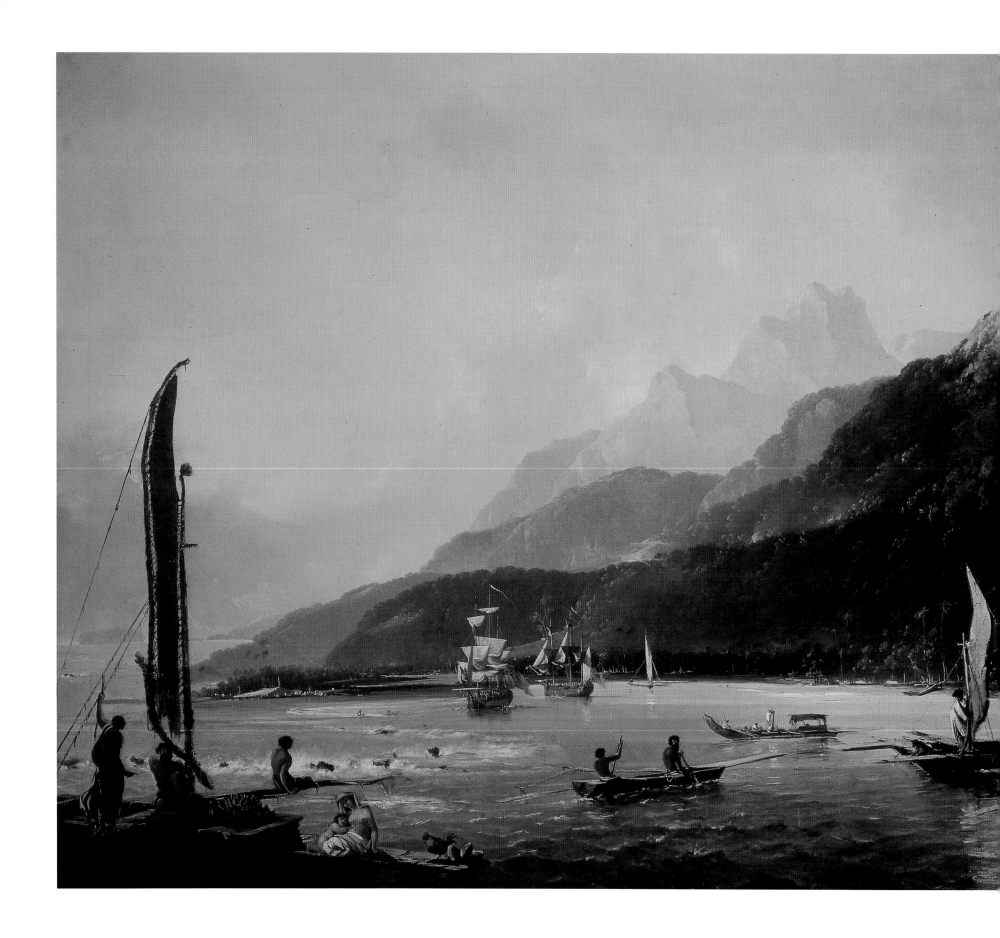

Expanding Horizons

*Contrary wind still. This evening the moon being near full,
as she rose after eight o'clock, there appeared a rainbow in
a western cloud to windward of us. The first time I ever saw
a rainbow in the night caused by the moon.*

Benjamin Franklin
From *Journal of a Voyage*

*T*HE SEA DEMANDS KNOWLEDGE. Success is based
on retained experience and repetition, a confident
hand at the helm, the integrity of a splice or knot.
A sail out is not the same sail back. In fact, each
departure is the beginning of a line, placed on a
chart that may have no edge or notable marks by
which to steer. Today we laugh at the notion that
the world was once perceived as flat and a sailor
could fear falling off into nothingness.

Seamen have a tremendous ability to visualize
and remember. Captains in the Royal Navy were
expected to recall in complete detail the horizontal
profile of every landfall. Maps were made, records
were kept — notations of wind and weather, current
and tide — all were accumulated and used. Sailors
stood long watches on longer passages and
observed the stars. Such observations are the basis

The scientific research
ships *Resolution* and
Adventure, commanded by
British explorer James
Cook, dry their sails in
Matavi Bay, Tahiti, in 1773.
William Hodges, an artist
who traveled with Cook on
his voyages, also recorded
Tahitian outrigger boats
similar to those that sailed
the Pacific long before
Europeans ventured there.

The Resolution *and* Adventure *in Matavi Bay, ca. 1773*
William Hodges
Oil on canvas
136 x 193 cm. (53.5 x 76 in.)
National Maritime Museum, London

Expanding Horizons

This exquisitely detailed Japanese screen is one of two that chronicle the arrival in 1543 of the *nam-bam,* or "southern barbarians" as Portuguese seamen were called. Japan did not fully open its doors to Western traders until after the arrival of Commodore Matthew Perry's "black ships" in 1853.

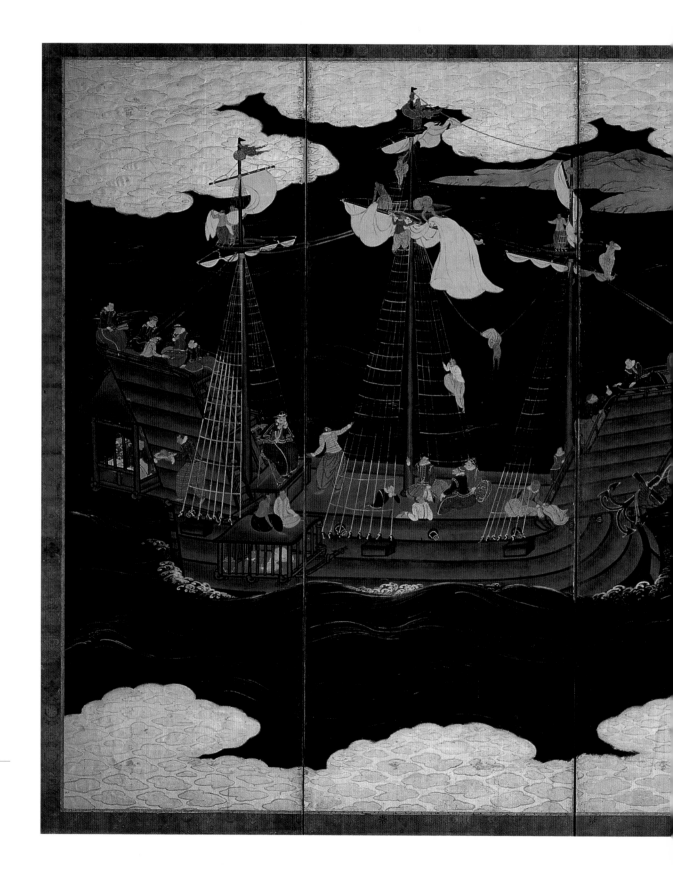

Southern Barbarian Screen, 1543
Attributed to Kano Sanraku, Late Momoyama Period
Color on paper, six-fold screen
182 x 371 cm. (71.6 x 146 in.)
Suntory Gallery, Tokyo

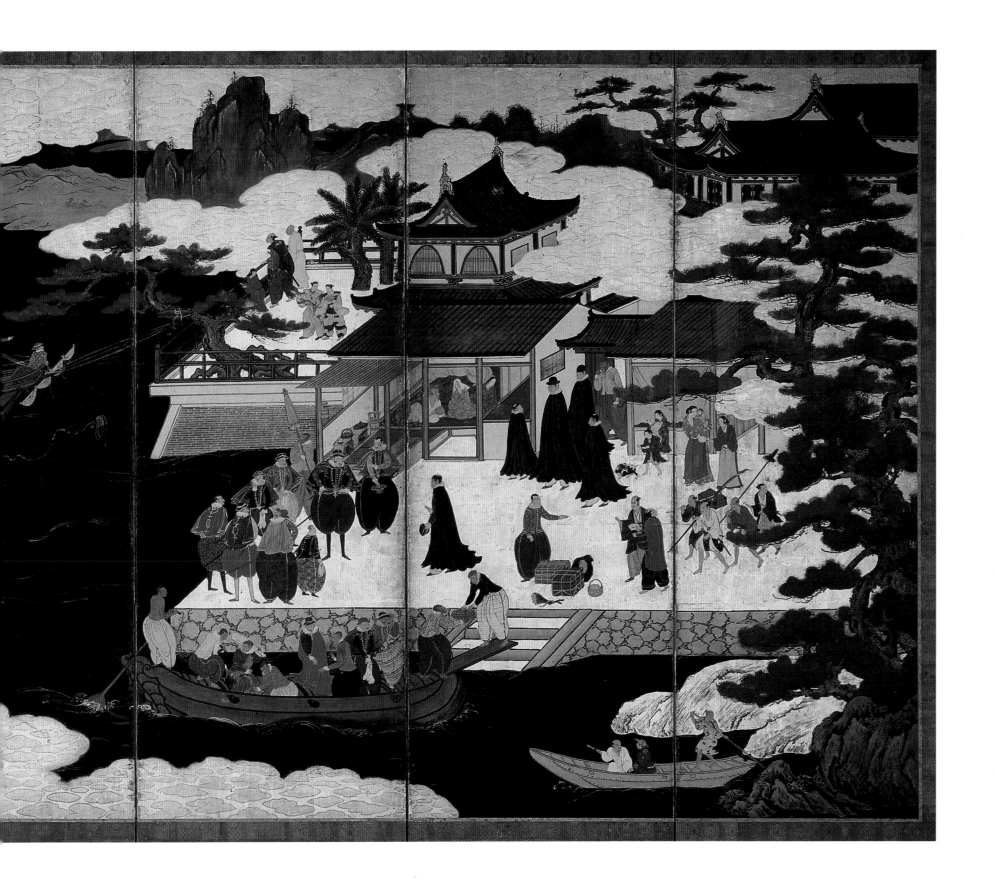

Expanding Horizons

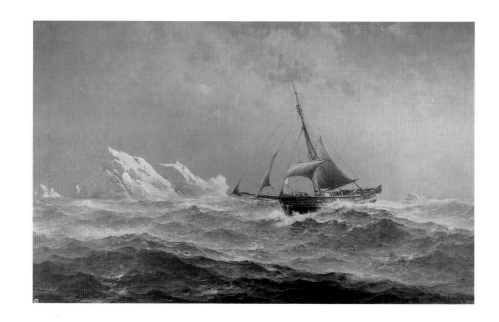

(below) *The* Resolution *and* Adventure *in Nootka Sound,
April 1778*, undated
John Webber
Pen and ink with watercolor
59.8 x 148.6 cm. (23.5 x 58.5 in.)
National Maritime Museum, London

of much of modern science. Seamen were naturalists as well as navigators, hydrologists as well as astronomers, cartographers as well as inventors. Many were accomplished artists. These sailors recorded our only images of these early explorations. Nor does it seem unusual that one, his canvas a journal, could note his initial sighting of a rainbow caused by the moon.

The lines laid down by voyages are the marks that transformed our world from ignorance to knowledge. The charts became more elaborate, the navigation more precise, until today, of course, we can steer from the air-conditioned bridge and know our position via satellite to within a few meters, anywhere on the globe. Those lines are longitude and latitude, measures of depth and contour and temperature, prevailing winds and invisible subsurface streams; they criss-cross until what was once a void is replete with information. Seamen were the first encylopedists.

They were also the first anthropologists. As they traveled from sea to sea, sailors indulged their curiosity and were themselves frequently objects of great wonder. Customs were exchanged; tatoos, for example, were brought back from faraway places as souvenirs, along with carved masks, narwhal horns, stuffed birds, and exotic butterflies pinned on boards. New tastes were discovered – spices, coffee, tea. Diseases were passed.

(top left) The Norwegian polar sloop *Gjøa* sails past icebergs in rough seas. Commanded by famed polar explorer Roald Amundsen, in the summer of 1906 she became the first ship to successfully navigate the Northwest Passage, completing a three-year, east-to-west voyage.

(left) Native inhabitants in canoes greet the *Resolution* and *Discovery* in Nootka Sound, Vancouver Island, in 1778, while scientists on a cliff above the sound set up astronomical instruments. The drawing was made during Cook's third and final voyage while searching in vain for the Northwest Passage between the Atlantic and Pacific oceans.

Expanding Horizons

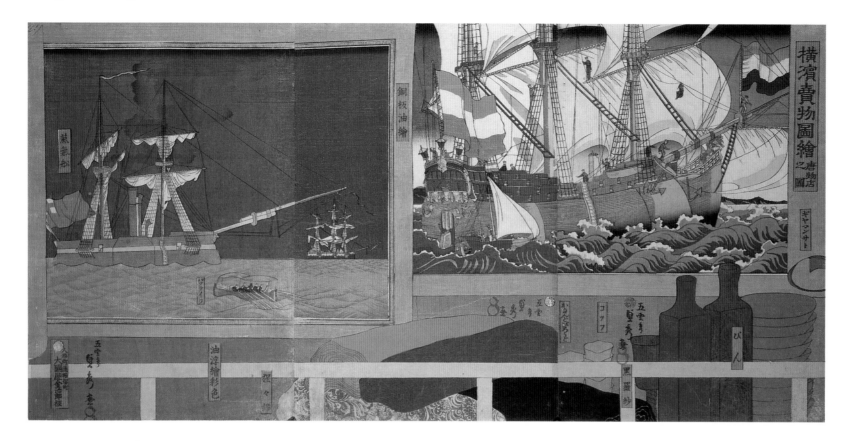

An unusual view of foreign ships – through the windows of a Japanese shop stocked with European goods – is the theme of this painting of Yokohama. It dates to 1860, just one year after the port was opened to European trade, transforming East-West relationships.

The sea was a place of expanding horizons where Europeans could barter with natives of Nootka Sound or the Sea of Japan. The world grew smaller as the ships traversed impossible waters – the Northwest Passage, for example, or the white sea of Arctic ice in search of whales. Ships were fouled by great floating islands of weed or by sands or rocks or coral that shoaled where deep water had seemed to be. Many were lost to these dangers; the logbooks bear witness to each of them as waypoints in the history of exploration and the charts marked with sites of wrecks record a tragic consequence of the era of discovery.

The horizon expanded through the essential human longing to understand chaos and to turn it to advantage. This knowledge provided the arsenal, often inadequate, in our effort to shape our destiny. ✿

(above) *Picture of Merchandise at Yokohama,* 1860
Sadahide Gountei
Colored woodcut, triptych
25.4 x 36.2 cm. (10 x 14.25 in.)
The Mariners' Museum, Newport News, Virginia
Carl E. Boehringer Collection of Japanese Prints

(right) Folding Domestic Screen, after 1800
Anonymous
Distemper on canvas
219.2 x 184 cm. (86.3 x 72.4 in.)
The Australian National Maritime Museum, Sydney

This rare screen depicts the first voyage by Europeans to "Terra Australis" in 1767, and the hostile reception from Otahitians (Tahitians) in war canoes. The screen reflects Europeans' keen interest in Pacific exploration, culminating in Capt. James Cook's 1770 landfall in Australia and the subsequent British colonization of the island-continent.

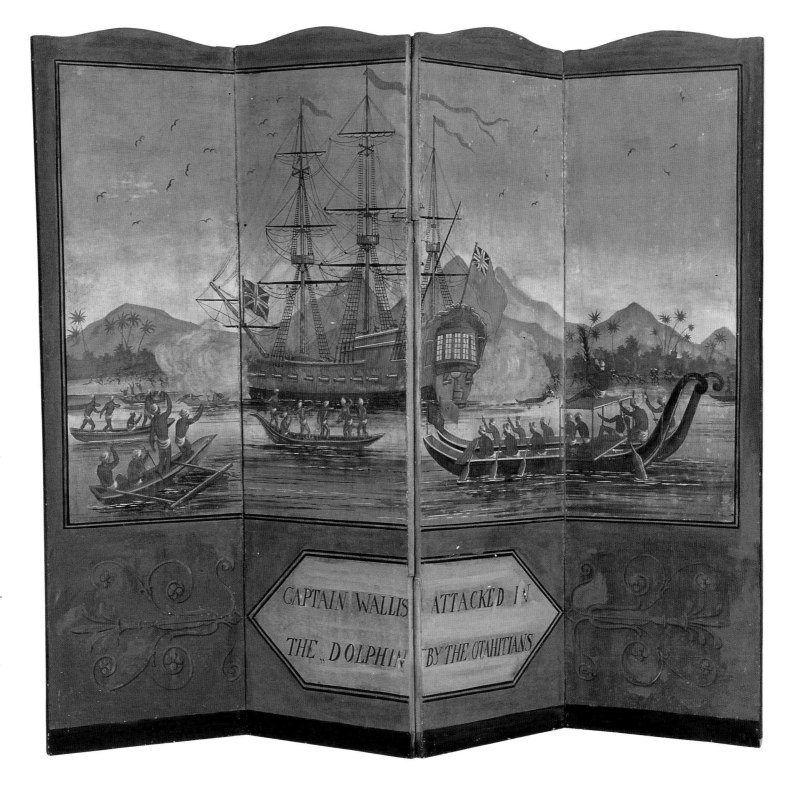

CAPTAIN WALLIS ATTACKED IN THE „DOLPHIN" BY THE OTAHITIANS

Expanding Horizons

A page from the famous 1628 world atlas of Gerardus Mercator depicts Mercator, at left, with a globe of the world. He devised the Mercator Projection, a map on which parallels and meridians are rendered as straight lines, spaced to produce at any point an accurate ratio of latitude to longitude.

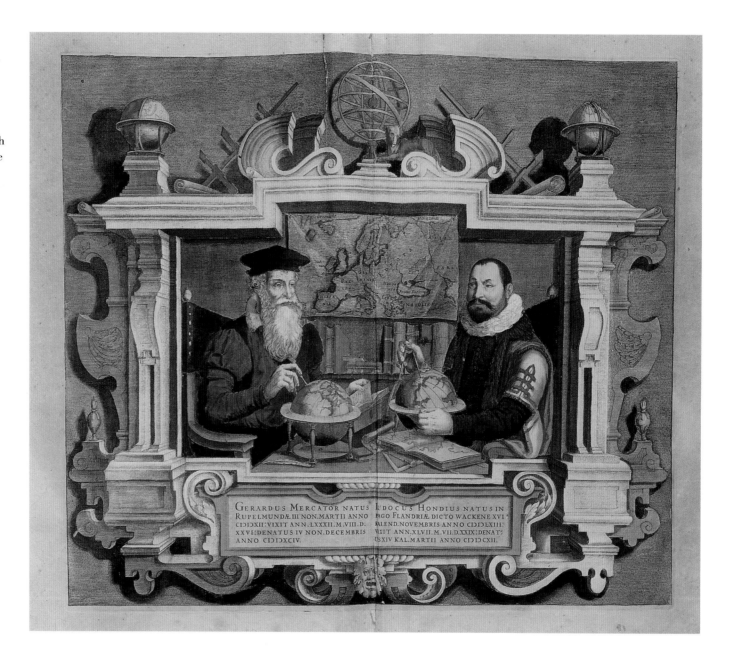

(above) *Atlas Sive Cosmographicae Meditationes de Fabri ca Mundi et Fabricati Figura*, 1628
Gerardus Mercator, Editor Decima
Manuscript page
N.I. Museo Navale, Genoa, Italy

(right) Map of the Americas, ca. 1513
Piri Reis
Paint on deerskin
90 x 65 cm. (35 x 25.6 in.)
Topkapi Palace Museum, Istanbul, Turkey

This map drawn by Turkish
Admiral Pirî Reis in 1513
is the earliest known to
portray the Americas. More
than that, the contours of
the portions of North and
South America shown in
this fragment, of what was
probably a world map, are
almost identical to those on
modern-day maps.

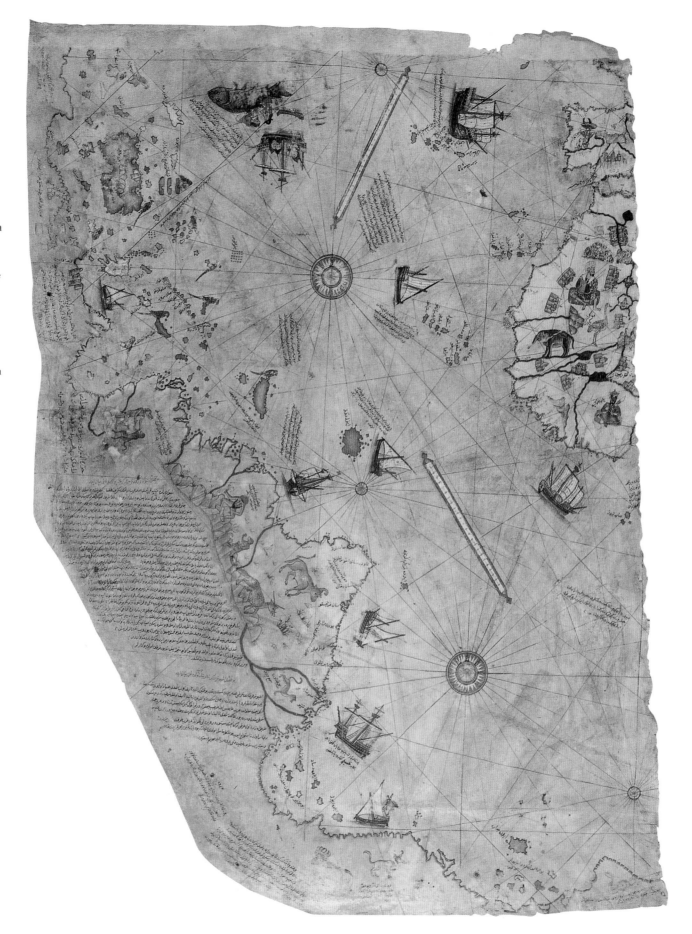

Expanding Horizons

The seagirt city of Amsterdam is shown in its prime in this 17th century map. Wharfs, harbor and canals are crowded with the ocean-going ships that spurred Holland's great age of exploration and commerce.

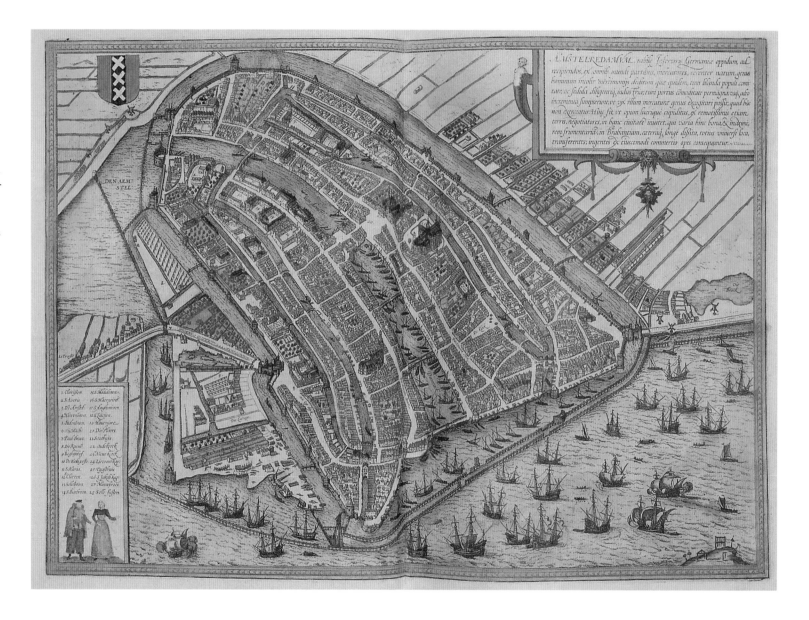

(above) *Civitates Orbis Terrarum,* 1612-1618
Braun and Hogenberg
Paint on parchment
N.I. Museo Navale, Genoa, Italy

Passengers sail on a 17th century Japanese junk. The influence of European vessels is reflected in the cloth sails, which supplement the traditional battened mainsail. The ship, owned by a wealthy merchant named Sueyoshi, was authorized by the Shogunate of Kyoto to engage in trade as far west as Indochina – lands that had been opened to Japan by its trader-explorers.

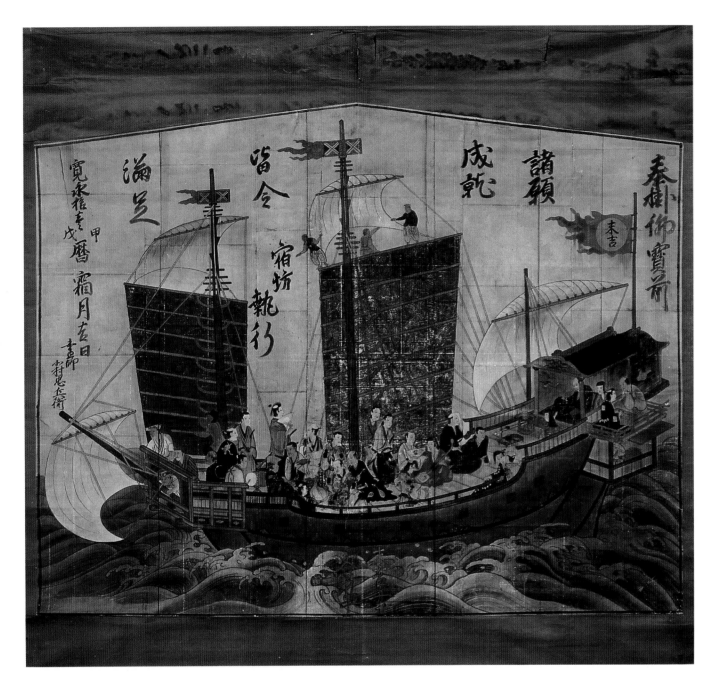

Trade Ship – Sueyoshi, 1634
Copy of an original wall hanging by Kitamura Chubei
187 x 235 cm. (73.6 x 92.5 in.)
University Art Museum of Kyoto City University of Arts, Kyoto, Japan

Expanding Horizons

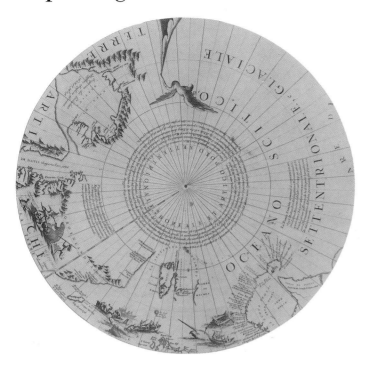

(above) This late-17th century circular overlay depicts the northern polar region. It was one of two such "caps" that could be placed on a world globe. (The other covered the southern polar region.) This one is engraved with scenes of whaling and bear hunting. To aid explorers, the cartographer included everything then known about these portions of the Earth.

(right) Icebergs tower like giant white sculptures in this dramatic painting of a sailing ship trapped in arctic ice. In the 19th century, before the advent of ice-breakers, hundreds of ships and thousands of seamen were lost while expanding northern frontiers in ice-clogged seas.

(above) *Terre Artiche*, ca. 1688
Vincenzo Coronelli
North Polar calotte or circular cap for a globe of the world
Diameter of image: 37.1 cm. (14.62 in.)
The Kendall Whaling Museum, Sharon, Massachusetts

(right) *Whalers Trapped in Arctic Ice*, ca. 1870-1880
William Bradford
Oil on canvas
71 x 111.7 cm. (28 x 44 in.)
Manoogian Collection, Taylor, Michigan

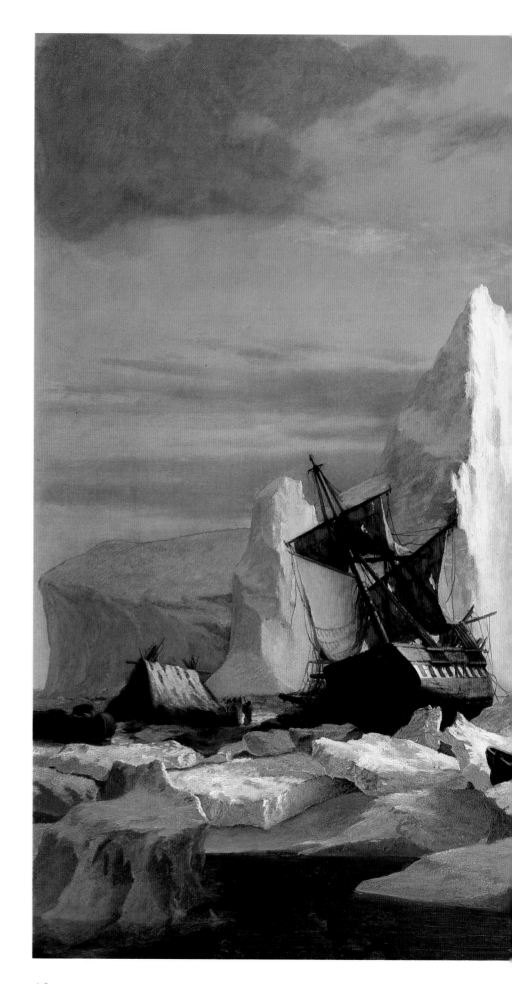

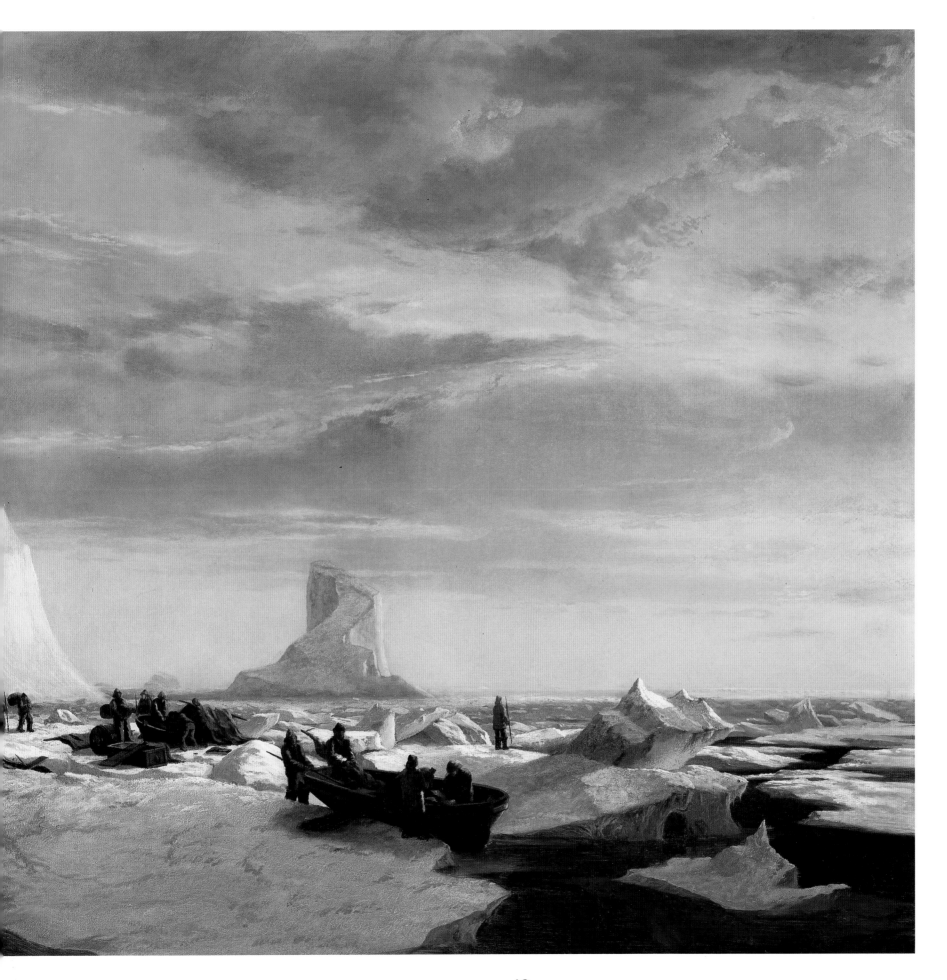

Expanding Horizons

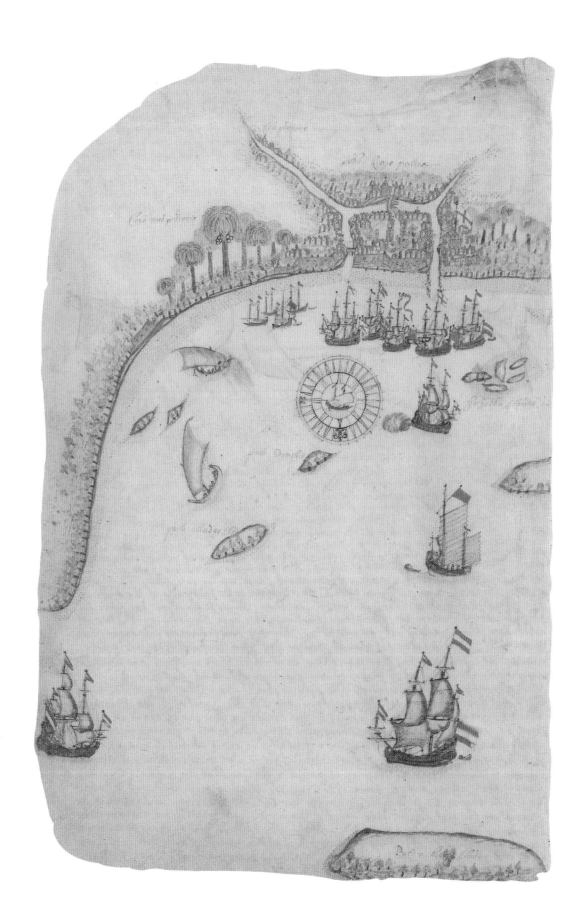

Bantam, Java, as it appeared in the 17th century, was already a busy port used by both European and Javanese boats (to the left of the compass rose). The drawing is from Edward Barlow's journal, which chronicles the explorer's visits to Java and other Asian countries between 1659 and 1703.

Bantam Java (detail), 1659-1703
From Edward Barlow's "Journal"
Manuscript page, watercolor on paper
National Maritime Museum, London

Maps place us in concrete space. When integrated in a work of art, as in this late-20th century lithograph using an old French map, they evoke a sense of other places, other times. The use of maps in art also indicates our fascination with cartography and the explorers who enabled the maps to be drawn.

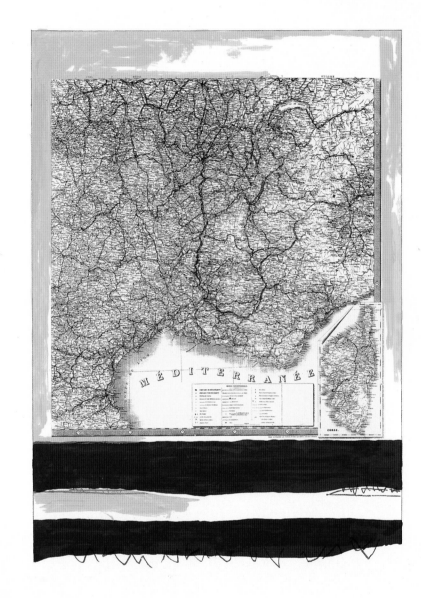

Mediterranean (State I, White), 1975
Robert Motherwell
Lithograph, screenprint
118.1 x 80 cm. (46.5 x 31.5 in.)
Printed and published by Tyler Graphics Ltd.
© Robert Motherwell/Tyler Graphics Ltd., 1975
© 1995 Daedalus Foundation/Licensed by VAGA, New York
Photo: Steven Sloman

War At Sea

Roll on, thou deep and dark blue Ocean—roll!
Ten thousand fleets sweep over thee in vain;
Man marks the earth with ruin—his control
Stops with the shore;

Lord Byron
From "Childe Harold's Pilgrimage"

Portuguese warships fire their cannon to salute the arrival in 1540 of the Infanta Beatriz, daughter of King Manuel of Portugal, at the walled town depicted here. This work is one of the earliest and most accurate representations of carracks, which in addition to their role as warships, were the type of vessel that made the first voyages of discovery in the New World.

AR. The sound of drumbeats and cannon roll across the waters. Paradoxically, as the world grew smaller, conflict increased and the sea became a scape for strife. Control of the high seas was synonymous with power, and the western nations—Spain, Portugal and England, among others—exchanged their knowledge for the pursuit of wealth and territory. The riches of the East and the vast expanses of the New World became objects for global competition.

Governments waxed and waned with the success or failure of their fleets. Ships were the tools of siege, invasion, occupation and evacuation—crucial encounters essential to the execution of military strategies and the advancement of national policies. Port cities flourished not only as centers for trade but also as dockyards for the construction and repair of ever-larger, more complicated, more heavi-

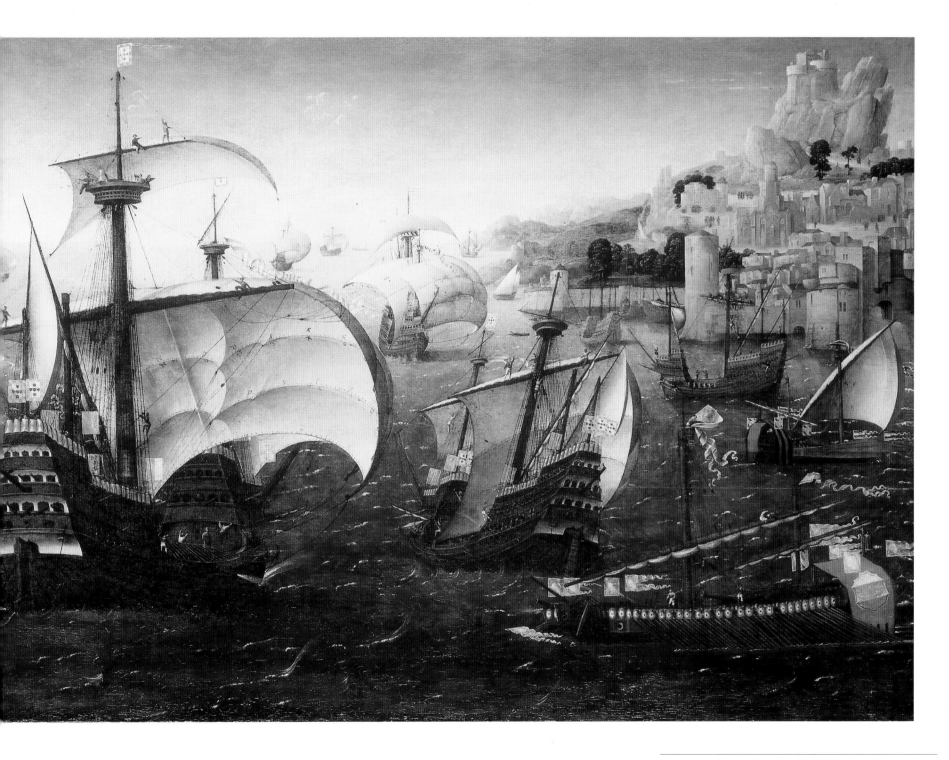

Portuguese Carracks Off a Rocky Coast, ca. 1540
In the style of Joacum Patinir
Oil on panel
78.5 x 145 cm. (31 x 57 in.)
National Maritime Museum, London

War At Sea

An unusual oval painting shows three views – the transom, bow and stern profiles – of an ornately decorated 18th century English warship of the second rank, armed with 70 cannon. Such ships, and even larger 100-cannon ships of the line, were the battlewagons of their day.

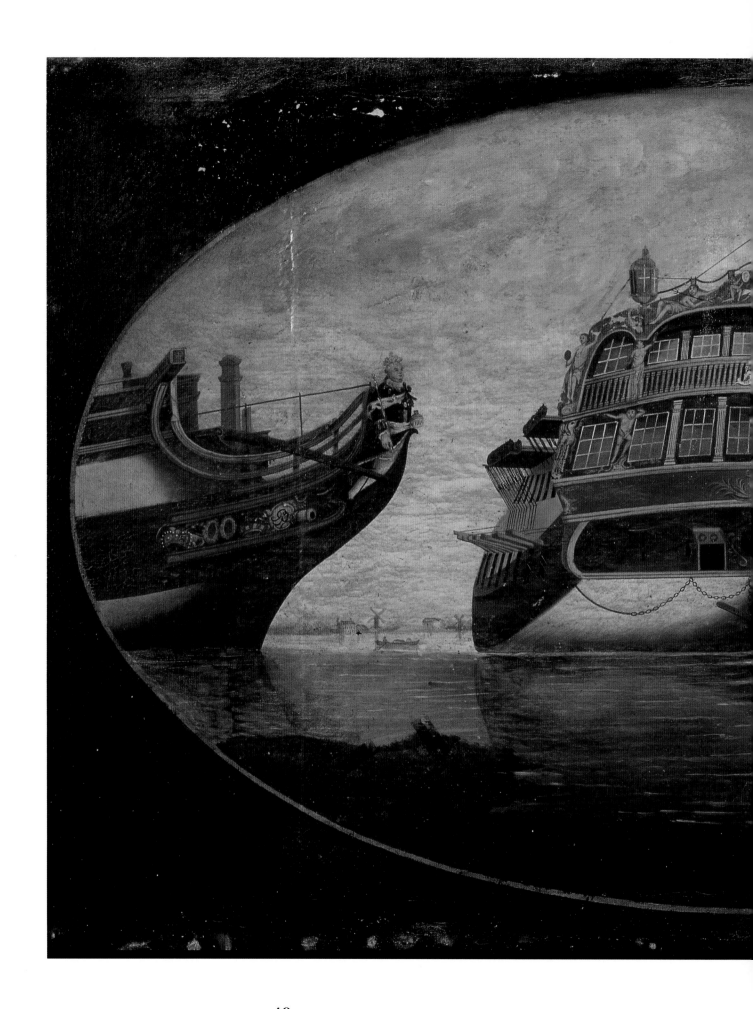

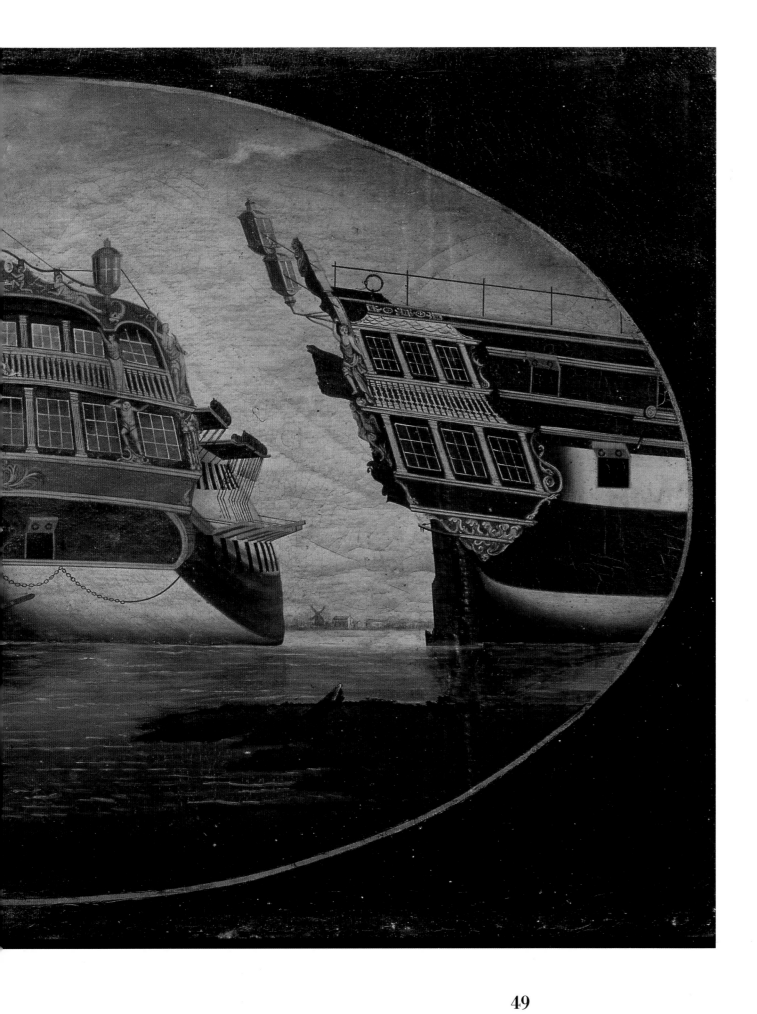

A Danish man-of-war is anchored off the English coast on water so still that it mirrors the ship's hull. When not at war, naval ships such as this one often paid courtesy calls on ports around Europe.

ly armed ships of war along with all the ancillary vessels and services required. Ships of the line carried ever more powerful cannon on multiple decks requiring larger crews and enormous quantities of gunpowder and shot. The men were frequently pressed—convicts, unwary landsmen, or sailors captured from foreign vessels, whom the navies requisitioned to meet an insatiable need to keep their ships at sea.

Marine art reflected this enormous change and resulted in some of our most spectacular images which, while not always accurate, were nevertheless the only visualizations of these extraordinary events. The engagement between the English fleet and the Spanish Armada is perhaps the most familiar of these pictures, but depictions of fleet encounters elsewhere—in the Mediterranean, the Baltic or the Sea of Japan, for example—were equally evocative.

The increased numbers of ships, and the violence of their broadsides, explosions and human losses, captured the public imagination. Battles were reported in detail in the popular press, fleet

(preceeding page)
Vascello Inglese di Secondo Rango, da 70 Cannono, 1768
Anonymous
Oil on canvas
45.5 x 78.5 cm. (17.9 x 30.9 in.)
N.I. Museo Navale, Genoa, Italy

Dansk Orlogsskib til Auhers ved Englands Kyst, 1859
C. Neumann
Oil on canvas
134 x 100 cm. (52.75 x 39.37 in.)
Orlogsmuseet, Copenhagen, Denmark

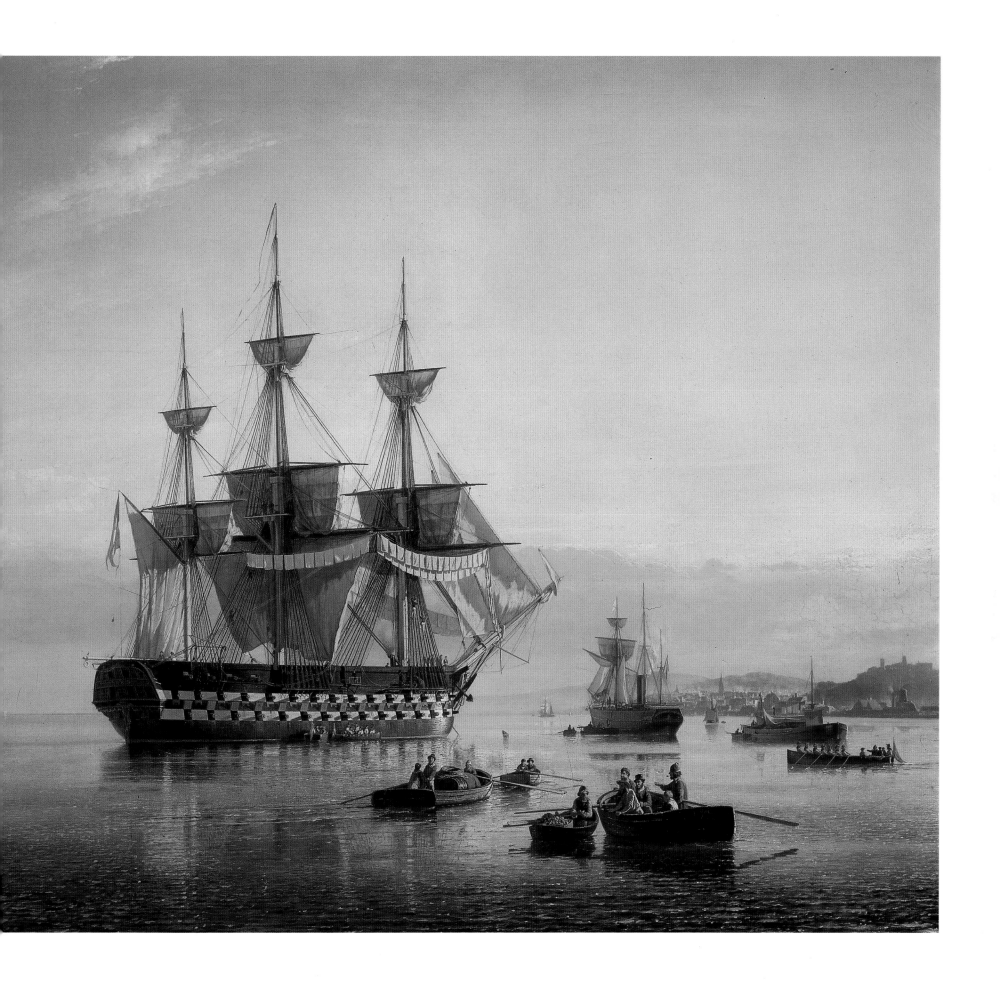

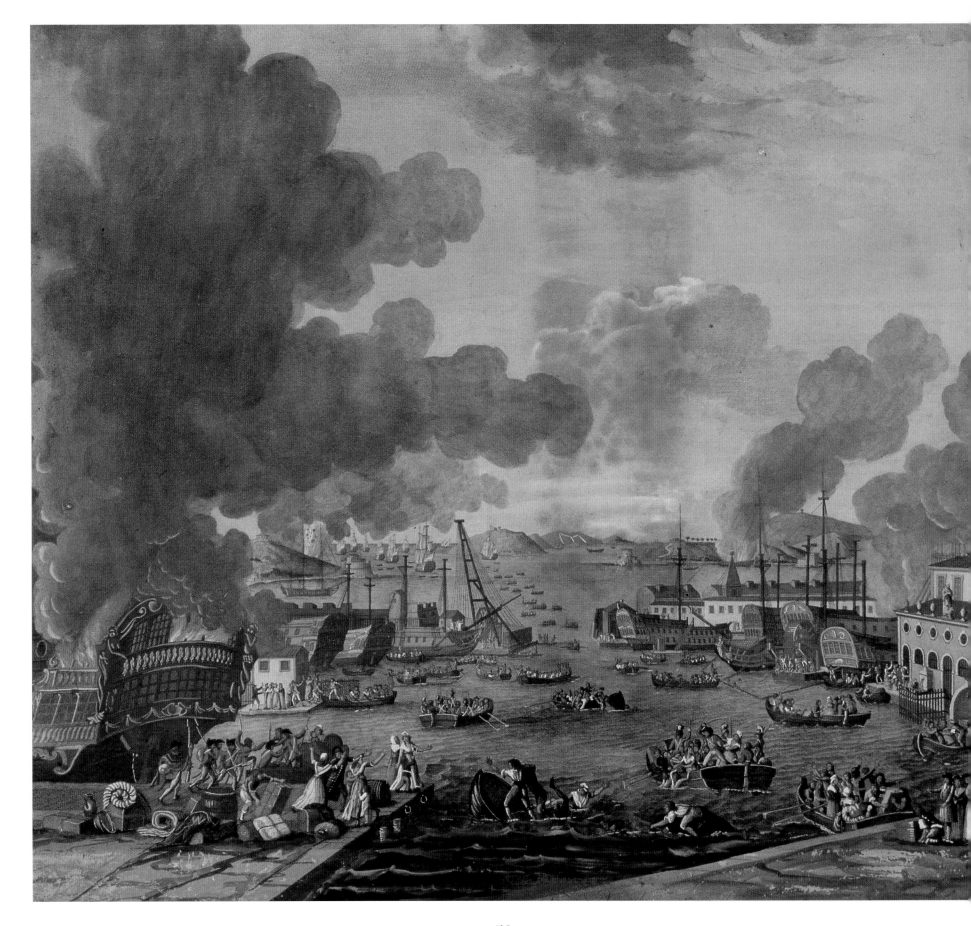

tactics analyzed, sailors mourned, reputations made and ruined. Heroes emerged, such as Lord Nelson in England or John Paul Jones in the United States, and became objects of adoration. They were embodiments of exploit, adventure and national pride; the death of Nelson was comparable to the death of a king.

The sea, then, can be seen as a setting for glorious deeds in the name of territorial aspirations. Resistance, whether in Brazil, New Zealand or on the flowing Mississippi, brought cultures into conflict and determined the fate of nations. Some see these pictures as romantic and inspirational. Look more closely, however, and you also see cruelty and false pride, greed and tremendous human loss. Cities burn. Fire by night reduces a ship to wreck. Desperate men debate the last defense of their homeland. An admiral dies on the quarterdeck. A young nation establishes itself through victories at sea. An ironclad begins a revolution. At Gibraltar, ships collide; the powder magazines explode, and toss heavenward fragments of our lives. ✺

A warship burns as British troops evacuate panicked civilians during the bombardment of Toulon on December 18, 1793, after a four-month siege. A young artillery officer named Napoleon Bonaparte was instrumental in forcing the Anglo-Spanish force, which had occupied the port, to withdraw.

Evacuazione Degli Inglesi da Tolone il 18 Decembre, 1793,
18th century
A. Feraud, G. Calendi, A. Lapi
Oil on canvas
55 x 74 cm. (21.6 x 29 in.)
N.I. Museo Navale, Genoa, Italy

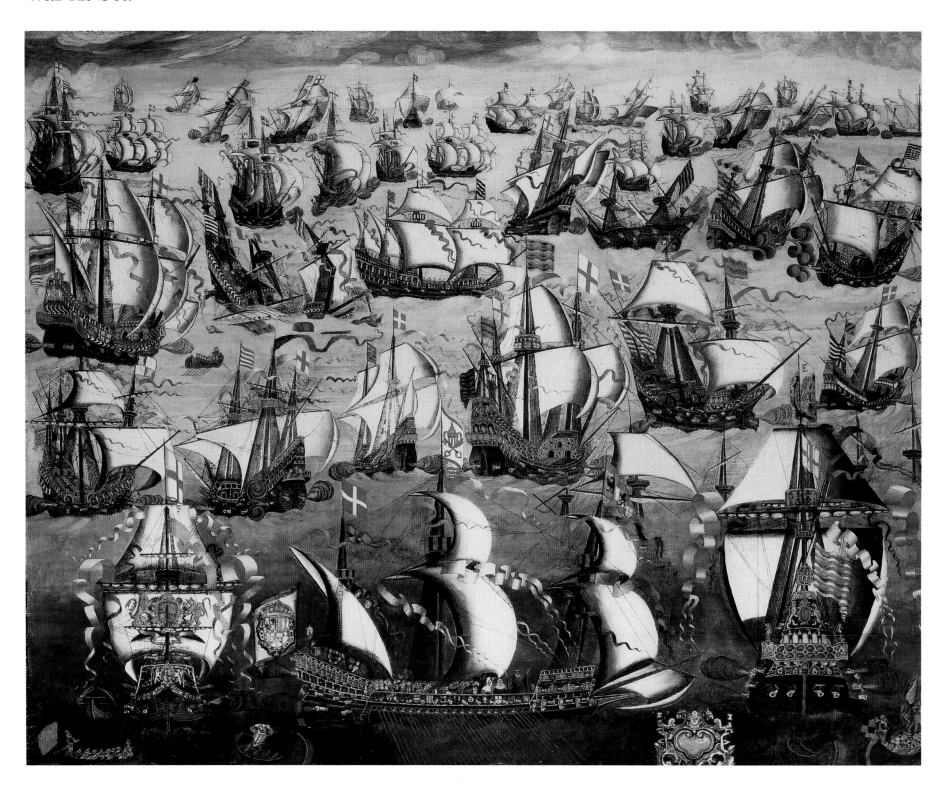

English Ships and the Spanish Armada, August 1588
English School, 16th century
Oil on panel, 112 x 143.3 cm. (44 x 56.4 in.)
National Maritime Museum, London

(left) Like a scene from a heraldic tapestry, battling ships of the English fleet and the Spanish Armada fill this 16th century composition. Though highly stylized, it accurately depicts the stormy weather and the combatants. In the foreground, the galleass of the Duke of Medina Sidona, commander of the Armada, is flanked by the flagships of Sir Francis Drake (left) and Lord Howard of Effingham.

(below) In the first battle between ironclads, on March 9, 1862, the Union Navy's *Merrimac* and the Confederate Navy's *Monitor* engage in a point-blank duel, which ended in a draw. But the *Merrimac* withdrew, enabling the Union blockading fleet to hold strategic Hampton Roads, off Virginia's coast. While neither vessel survived the war, both proved the worth of ironclads, and the *Monitor*'s revolutionary revolving turret anticipated modern warship design.

(right) Genoese troops swarm down gangplanks during an amphibious assault on Koróni, a city on Greece's Gulf of Messiniakós, during the siege of the Turkish stronghold in the 16th century. The Genoese forces, which included contingents of Sicilian and Spanish troops under the command of famed Admiral Andrea Doria, defeated the Turks.

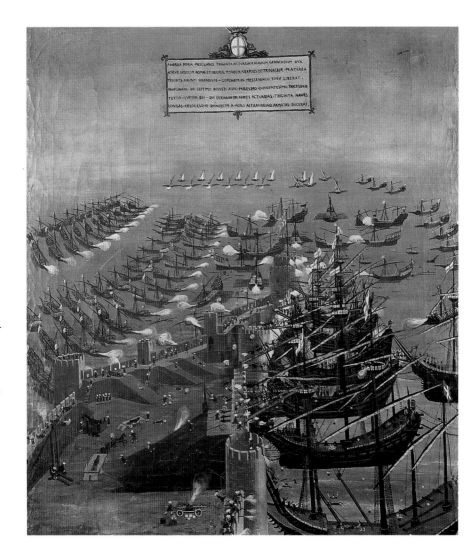

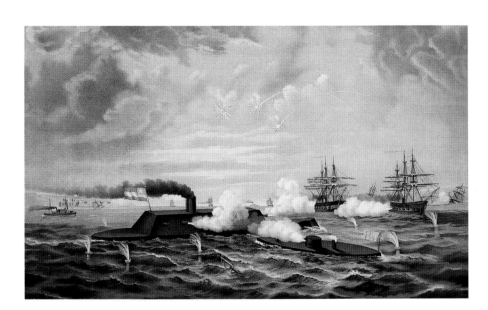

(above) *Assedio alla Citta' di Coroni*, 1532
Attributed to L. Calvi
Color wash on board
91 x 81 cm. (35.8 x 31.8 in.)
N.I. Museo Navale, Genoa, Italy

(left) Monitor *and* Merrimac *in Hampton Roads, 9 March 1862*, undated
Anonymous
Hand-colored lithograph
Published by Chicago Lithograph Co.
Peabody Essex Museum, Salem, Massachusetts
Photo: Mark Sexton

War At Sea

Convegno Navale, first half 17th century
Anonymous
Oil on canvas
64 x 82 cm. (25 x 32 in.)
N.I. Museo Navale, Genoa, Italy

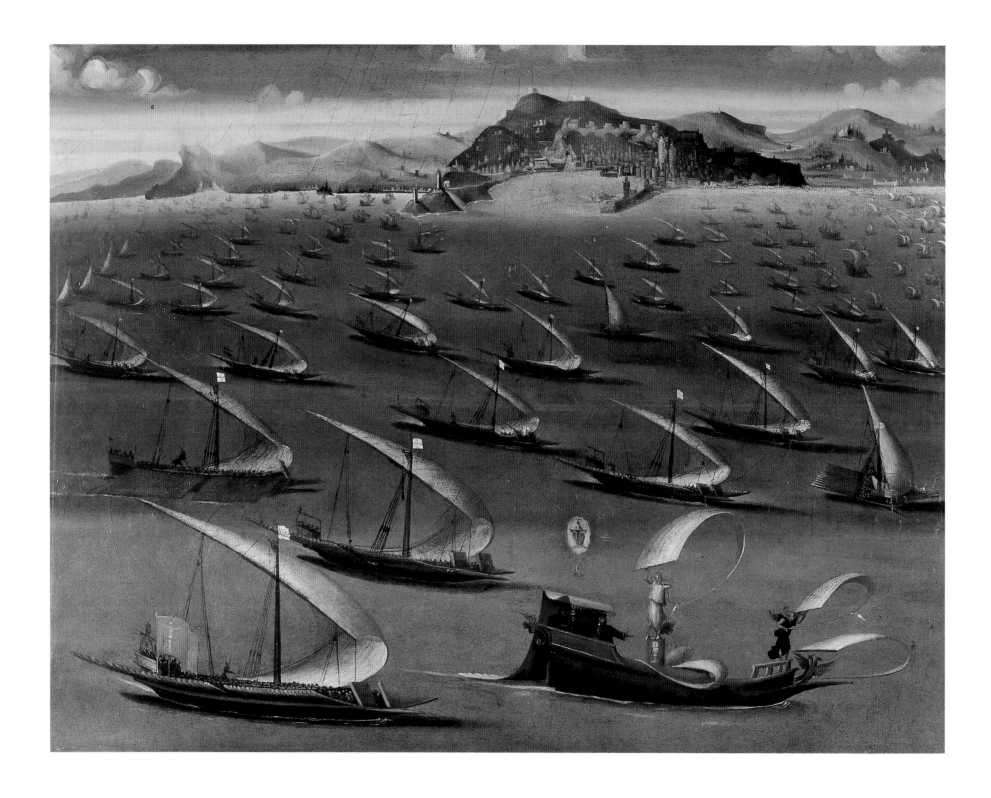

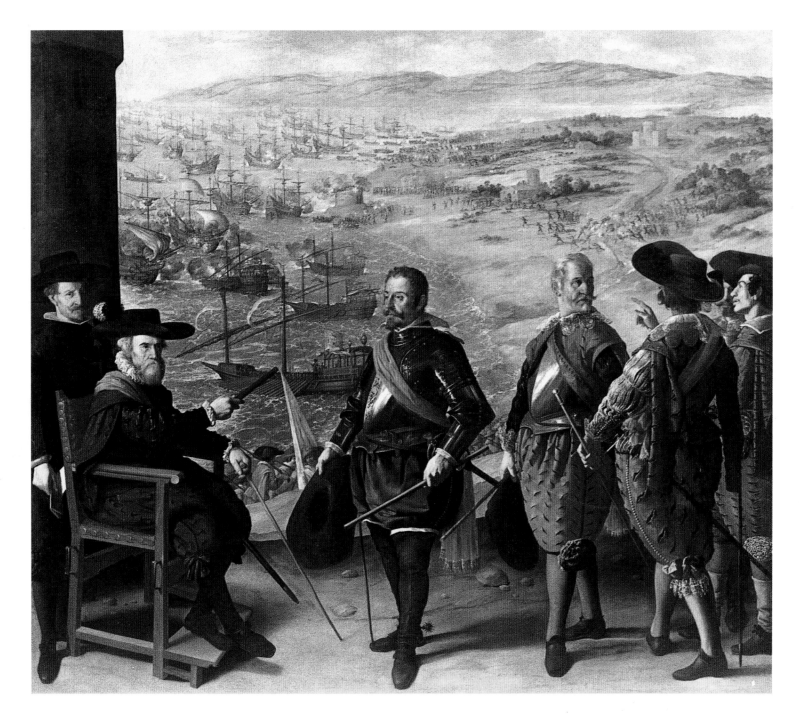

Don Fernando Girón, governor of the fortress at Cádiz, instructs his generals on the defense of the strategic port, which was attacked by an English fleet in 1625. In the background, English warships and Spanish galleons clash, while Spanish soldiers attack English troops disembarking from landing craft.

(left) A seascape of ships whose sails billow like graceful swallows' wings belie the fact that these are Italian warships, jammed to the gunwales with troops.

Defending Cádiz Against the English, 1634
Francisco de Zurbarán
Oil on canvas
3.02 m. x 3.23 m. (9.9 x 10.6 ft.)
Museo del Prado, Madrid

War At Sea

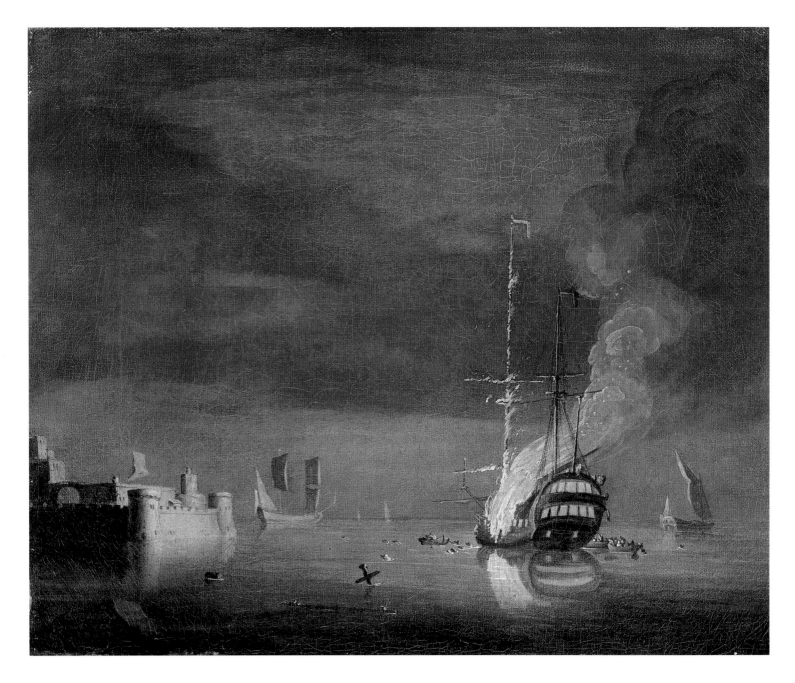

(left) A spectacular blaze lights the nighttime sky as a warship burns at its mooring off a fort. In the 18th century, wooden warships could be floating pyres. Even a spark could set them on fire, or worse, ignite their magazines, causing great loss of life.

(right) Ships of a Swedish-Finnish flotilla, flying the blue-and-gold Swedish ensign and led by Sweden's King Gustav III, defeat a Russian fleet in the battle of Svensksund in 1790. The battle, fought near the present-day city of Kotka in southern Finland, was painted by a petty officer who served aboard Swedish ships during the war between Sweden and Russia

A Two-Decker on Fire at Night Off a Fort, ca. 1740
Charles Brooking
Oil on canvas
24.5 x 30.2 cm. (9.62 x 11.87 in.)
Yale Center for British Art, New Haven, Connecticut
Paul Mellon Collection

The Battle of Svensksund, 1790
Johan Tietrich Schoultz
Oil on canvas
42 x 67 cm. (16.5 x 26.4 in.)
Private Collection, Finland

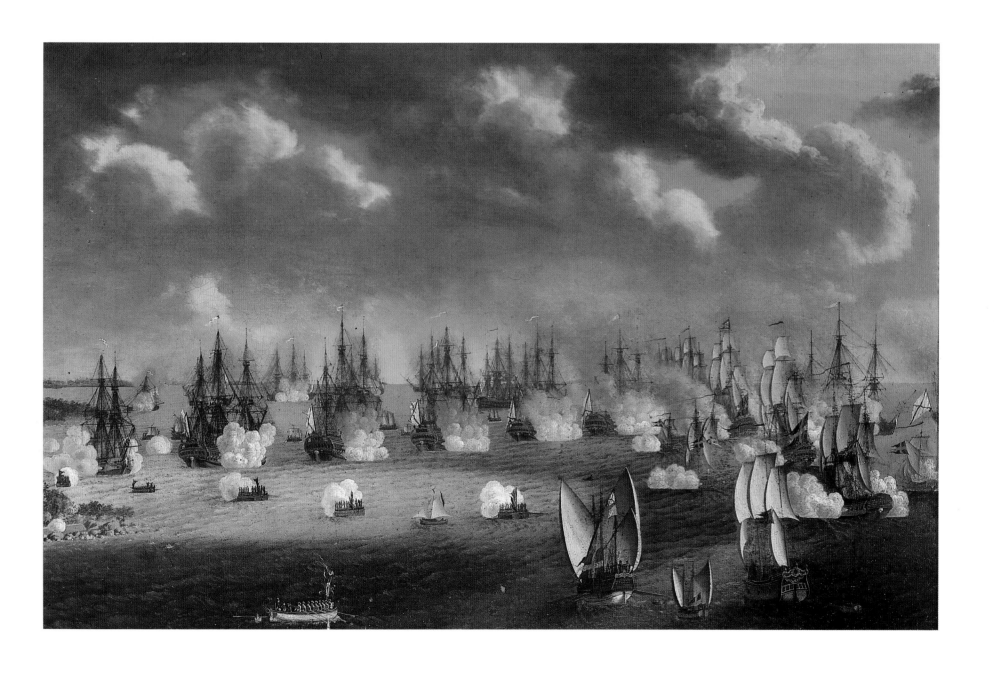

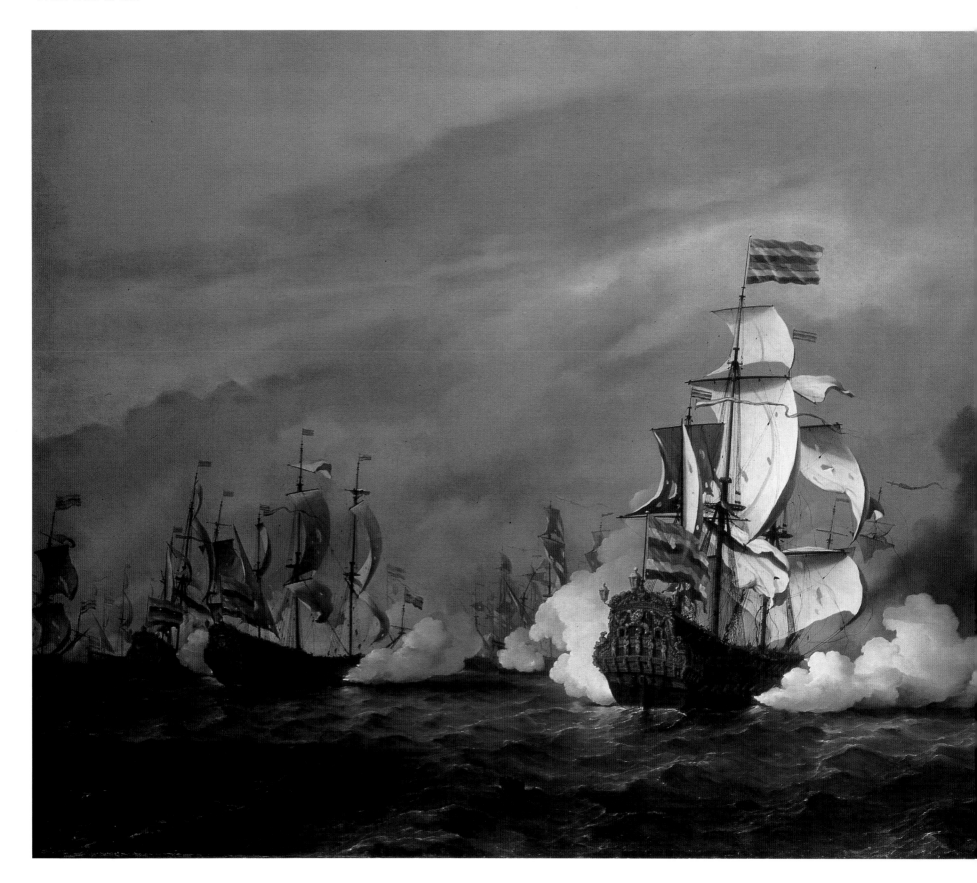

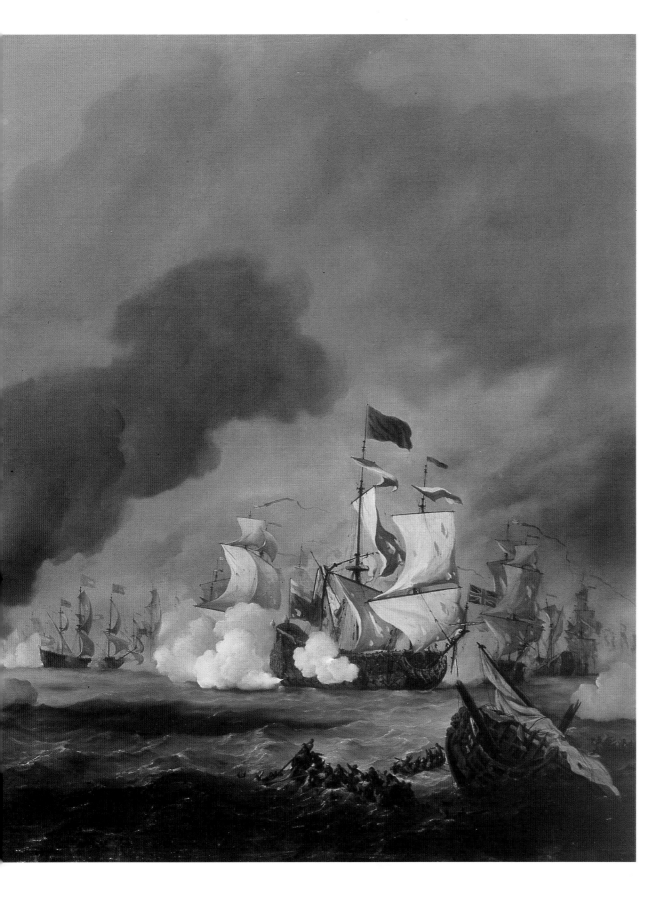

As rendered by one of the greatest marine painters, the Dutch artist Willem van de Velde the Younger, the Battle of the Texel in 1673 is transformed into a panorama of fire and destruction, with the Dutch flagship in the center of the action. The last major battle between the Dutch and English navies ended in a draw.

The Battle of the Texel, 11-21 August 1673, 1678
Willem van de Velde the Younger
Oil on canvas
150 x 299.5 cm. (59 x 118 in.)
National Maritime Museum, London

War At Sea

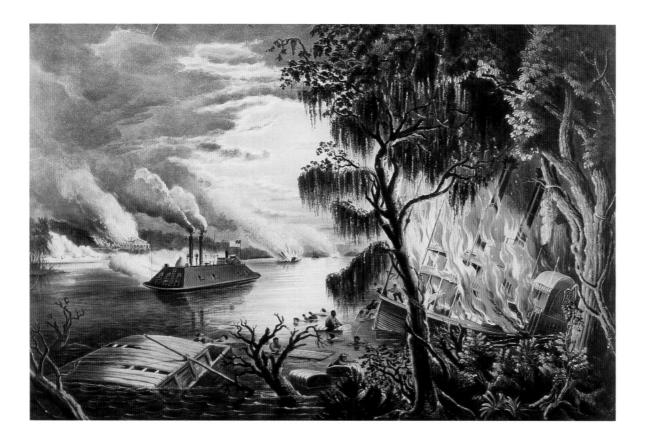

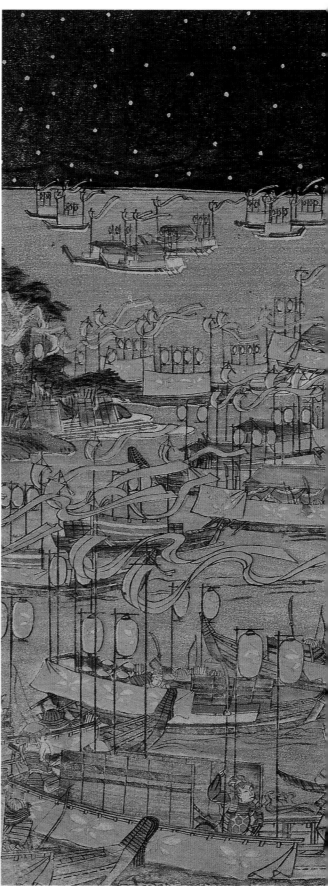

A Union Navy gunboat steams along the Mississippi, leaving burning riverboats in its wake. By using the Mississippi and other rivers to strike deep behind Confederate lines, Union Navy ironclads weakened Southern commerce and undermined Southern morale.

Striking at night, an invasion fleet sweeps ashore in this dramatic scene from the civil war between Japan's powerful Minamoto and Taira clans in the 18th century. The painting is meticulous in its rendering of samurai warriors and their mounts, and of the invasion fleet – small, shallow-draft boats with high sides to protect against missiles.

(above) *The Mississippi in Time of War*, 1865
Frances F. Palmer
Published by Currier & Ives
Hand-colored lithograph
Museum of the City of New York
The Harry T. Peters Collection

(right) *The Battle of Yashima, Dan-no-ura*, 1775-1780
Utagawa Toyoharu
Uki-e print
24.7 x 37.5 cm. (9.7 x 14.8 in.)
The British Museum, London

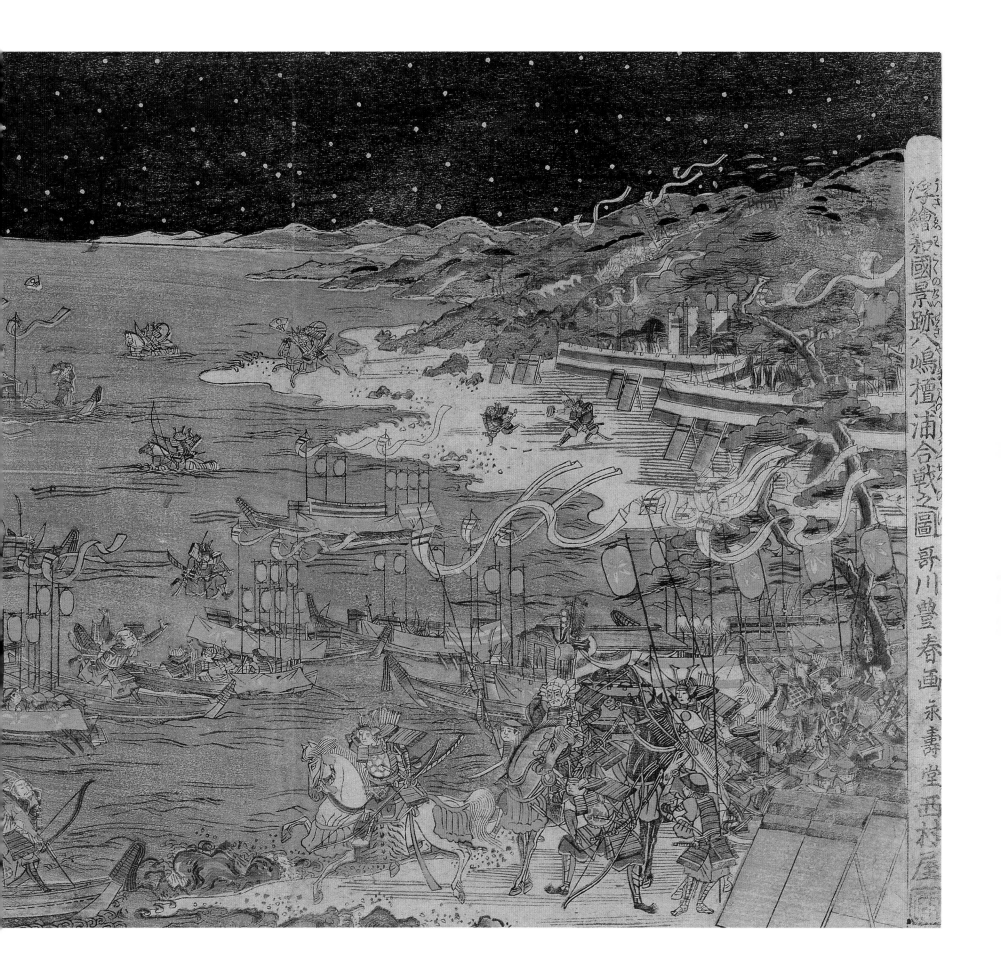

浮繪和國景跡八嶋檀浦合戰之圖　歌川豊春画　永壽堂西村屋

War At Sea

English warships bombard the Danish fleet in this depiction of the 1801 Battle of Copenhagen, set against a skyline that looks much the same today. England considered Denmark's neutrality during the Napoleonic wars a hostile act and ordered Admiral Horatio Nelson to attack the capital. The Danes fought bravely, but most of their fleet was destroyed in the harbor. So, too, was their neutrality, though thereafter they managed to avoid the conflicts that engulfed much of Europe.

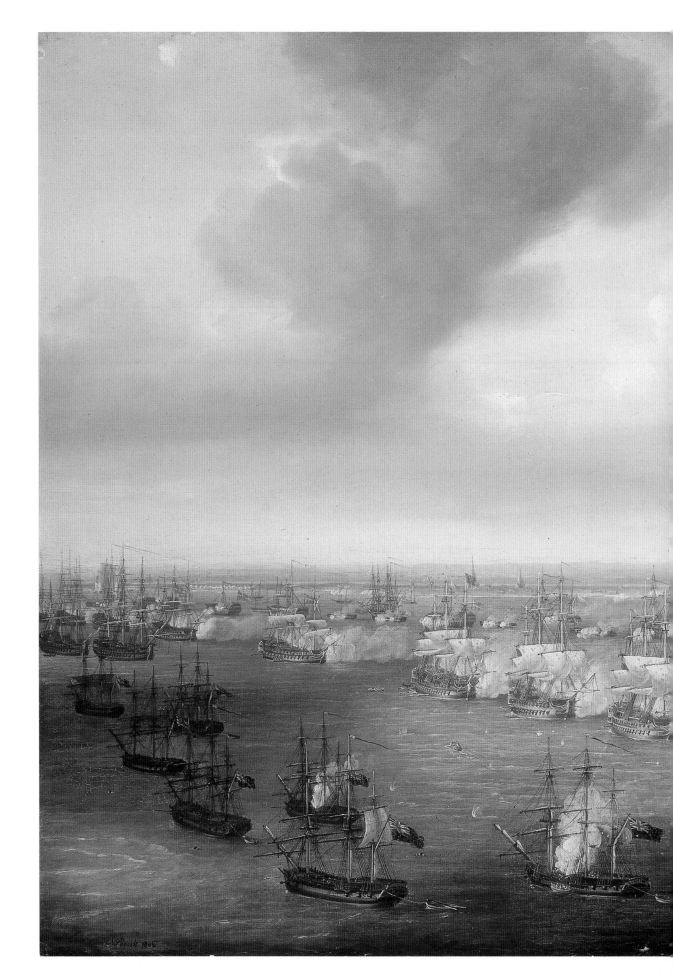

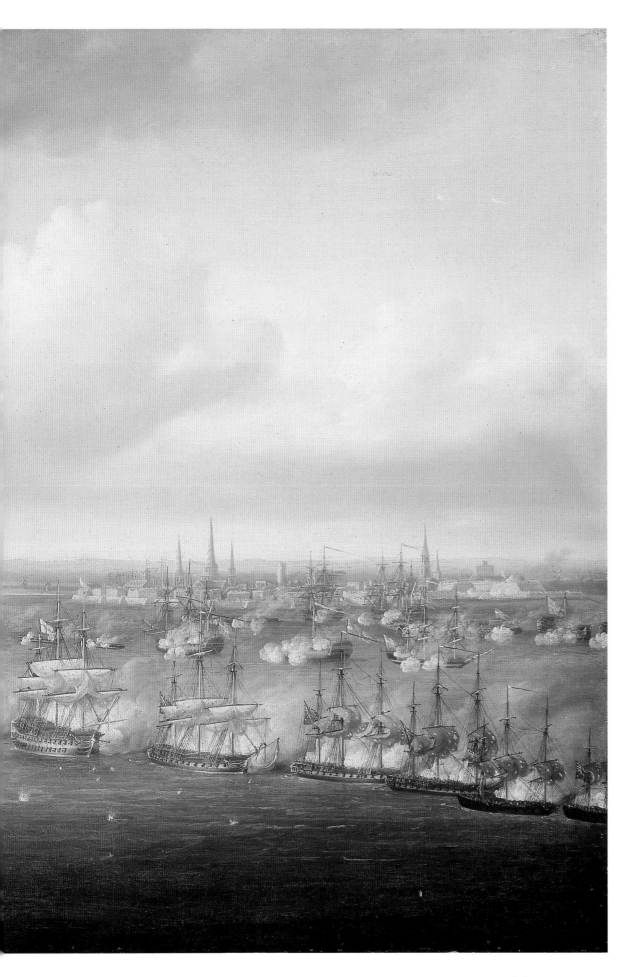

The Battle of Copenhagen, 2 April 1801, 1806
Nicholas Pocock
Oil on canvas
71 x 203 cm. (28 x 80 in.)
National Maritime Museum, London

War At Sea

(below) A furious battle rages in 1862 as Union Navy warships fire into a Confederate fortress on the Mississippi River. Using tactics honed during this battle, the Navy bottled up Southern ports, which severed the lifeline of the Confederacy and hastened the end of the war.

(right) As a saint watches serenely overhead, Genoese, English and Dutch warships blast away at each other. In the shifting alliances of 18th century Europe, it was not unusual to see ships from a number of navies engaged in the same battle.

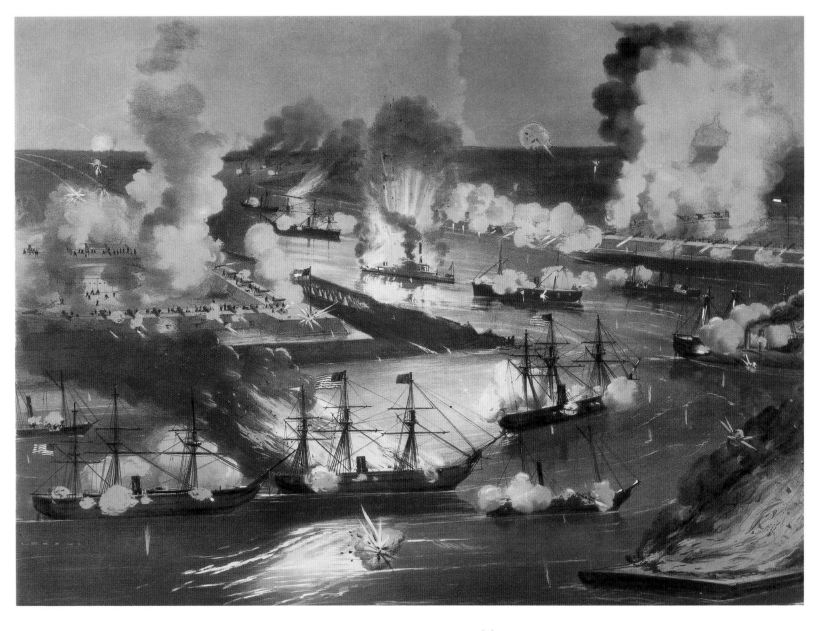

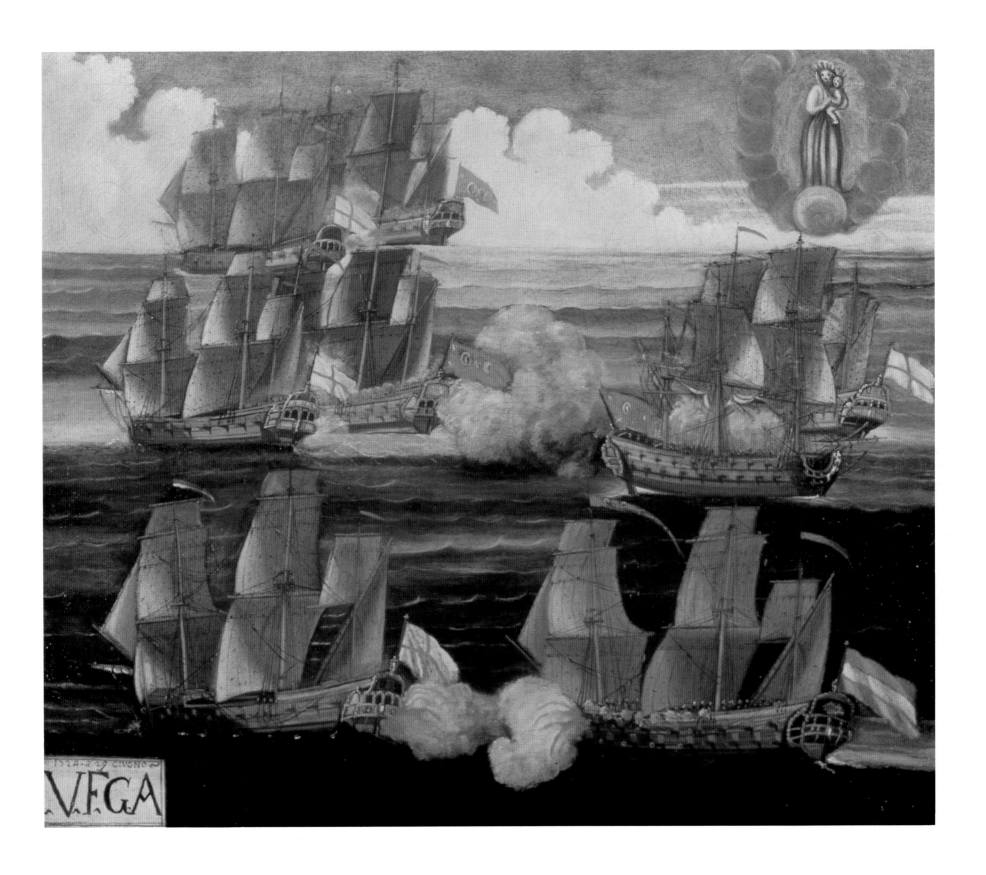

(left) *The Splendid Naval Triumph
on the Mississippi, April 24th, 1862*
Published by Currier & Ives
Hand-colored lithograph
Museum of the City of New York
The Harry T. Peters Collection

(above) *Scontro tra Quattro Vascelli Genovisi, Tre Vascelli
Inglesi ed Uno Olandese, 1724*
Anonymous
Oil on canvas
58.5 x 71.5 cm. (23 x 28 in.)
N.I. Museo Navale, Genoa, Italy

War At Sea

Battaglia Navale, first half 17th century
Cornelis de Wael
Oil on canvas
123 x 162 cm. (48.4 x 63.8 in.)
N.I. Museo Navale, Genoa, Italy

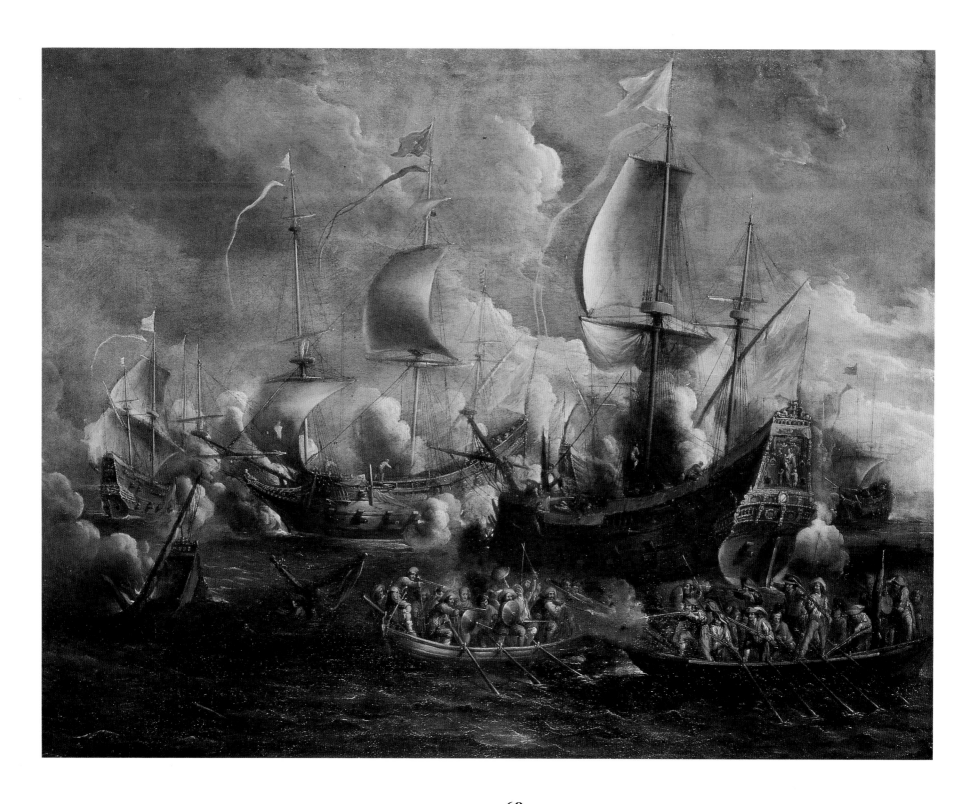

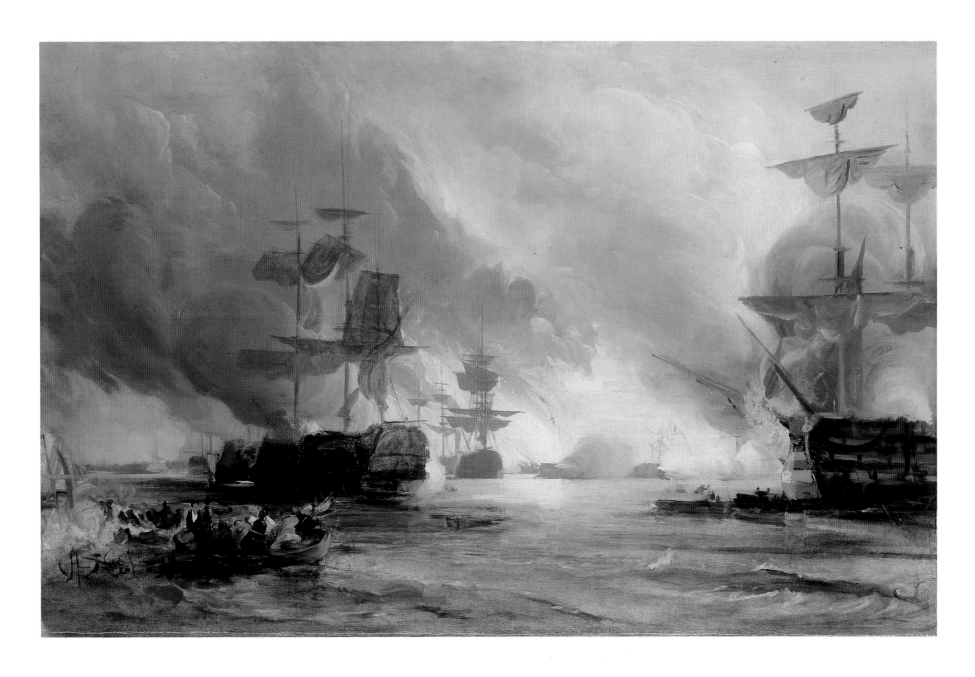

(left) The artist adds human drama to a major sea battle by focusing on combatants in small boats whose fierce, point-blank musket fusillades mirror the battle between the gargantuan warships ranged behind them.

(above) This loosely painted, almost impressionistic 19th century work commemorates the bombardment of Algiers that culminated with the freeing of 3,000 Christian slaves held by the Dey of Tunis. The successful British assault weakened the ability of the Barbary states to attack European shipping, which had been menaced by Barbary pirates since the 17th century.

The Bombardment of Algiers, 1816
George Chambers
Oil on canvas
47 x 72.5 cm. (18.5 x 28 in.)
National Maritime Museum, London

War At Sea

(below) In an extraordinarily vivid rendition of a sea battle fought off Gibraltar in 1607, bodies fly through the air as a Spanish galleon, its hold set ablaze by Dutch warships, explodes with devastating effect. In the days of wooden ships such catastrophic explosions were commonplace. So, too, were deaths and maimings caused by flying splinters.

(right) A rather bizarre group portrait has Lord Howe striking a heroic pose on the deck of his flagship, *Queen Charlotte*, while a sea battle swirls behind him, and a marine of the Queen's Regiment lies mortally wounded before him. The painting commemorates the defeat of a French fleet by an English fleet under Howe's command.

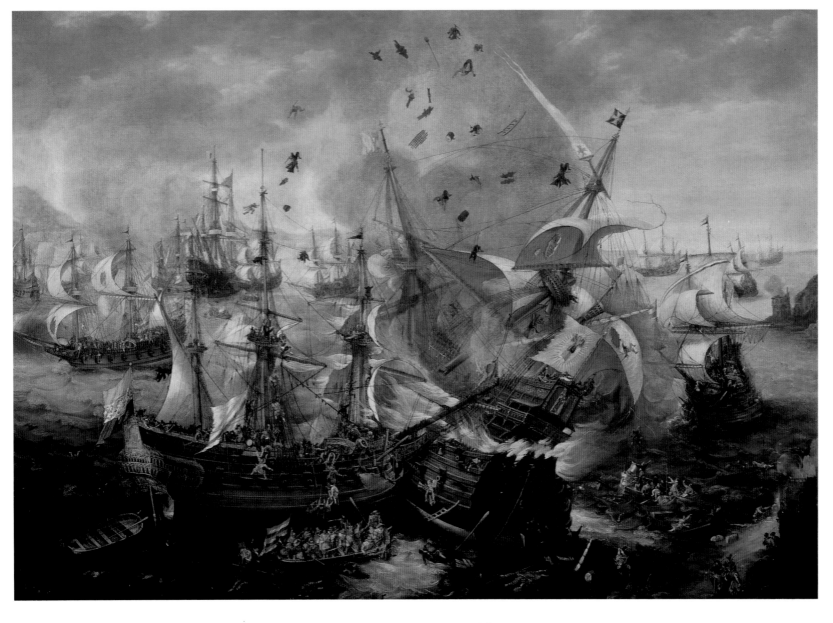

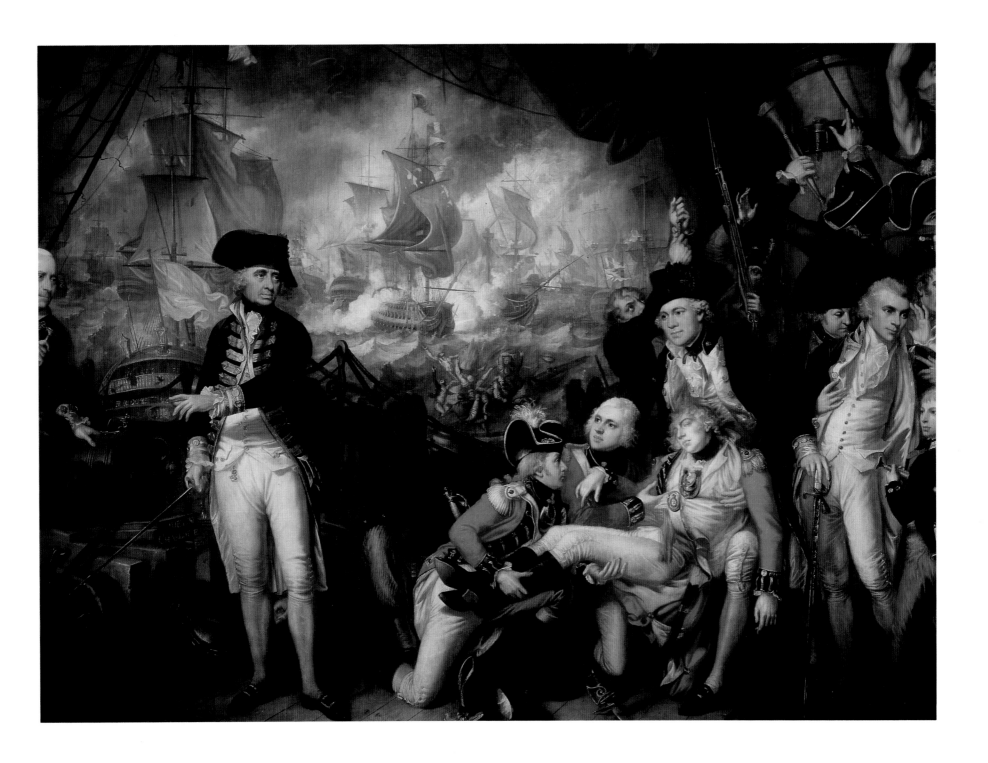

(left) *Slag bij Gibraltar*
(Battle of Gibraltar), 1607
H.C. Vroom
Oil on canvas
137.5 x 188 cm. (54 x 74 in.)
Rijksmuseum, Amsterdam

(above) *Lord Howe on the Quarterdeck
of the* Queen Charlotte, 1794
Mather Brown
Oil on canvas
259 x 366 cm. (102 x 144 in.)
National Maritime Museum, London

War At Sea

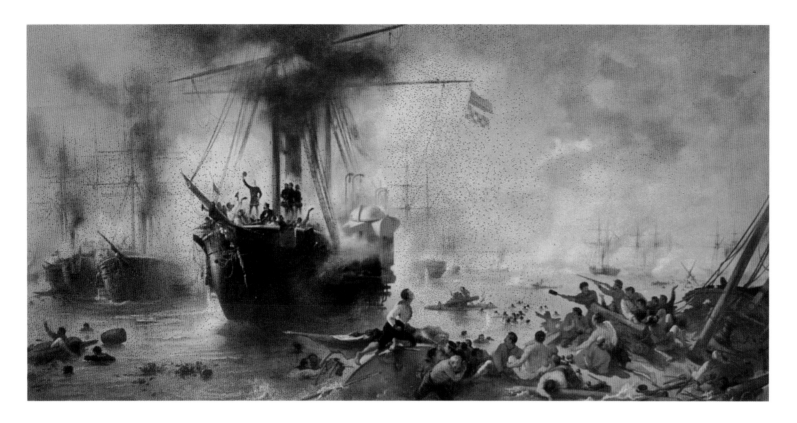

(left) An officer on the bow of the frigate *Amazonas* waves exuberantly as the battle swirls around him. The painting celebrates Brazil's victory over Paraguayan ships on June 11, 1865, during the War of the Triple Alliance that pitted Brazil, Argentina and Uruguay against Paraguay. The action was recorded from the Riachuelo cliffs overlooking the Paraná River that separates Brazil and Paraguay.

(right) The masts of the once-proud British warship *Guèrriere* are shattered and the warship lies dead in the water after a fierce duel fought with the U.S.S. *Constitution* off the coast of Halifax, Nova Scotia, on August 19, 1812. Though outnumbered, American seamen fought the Royal Navy to a standstill and wrested control of shipping lanes essential to American commerce.

A *waka taua* (war canoe), under full sail and filled with Maori warriors, passes Taranaki, also known as Mt. Egmont, on the west coast of New Zealand's North Island. Similar canoes, but with two hulls and two sails, carried warriors over vast stretches of the Pacific during the Maori's ocean-voyaging era of conquest and discovery.

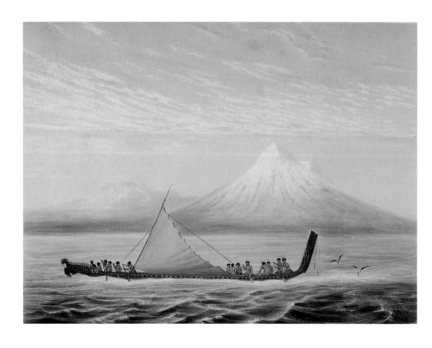

(above) *The Naval Battle of Riachuelo*, 1876
Vítor Meireles
Oil on canvas
460 x 820 cm. (181 x 322 in.)
Ministéiro da Marinha
Rio de Janeiro

(left) *Taranaki or Mount Egmont; War Canoes*, 1846
George French Angas in *The New Zealanders Illustrated*,
London: T. McLean, 1846, Pl. 2
Hand-colored lithograph
24.4 x 32 cm. (9.5 x 12.6 in.)
Alexander Turnbull Library
National Library of New Zealand
Wellington, New Zealand

The Constitution *and the* Guèrriere, undated
Thomas Chambers
Oil on canvas
62.9 x 87 cm. (24.75 x 34.25 in.)
The Metropolitan Museum of Art, New York
Gift of Edgar William and Bernice Chrysler Garbisch, 1962

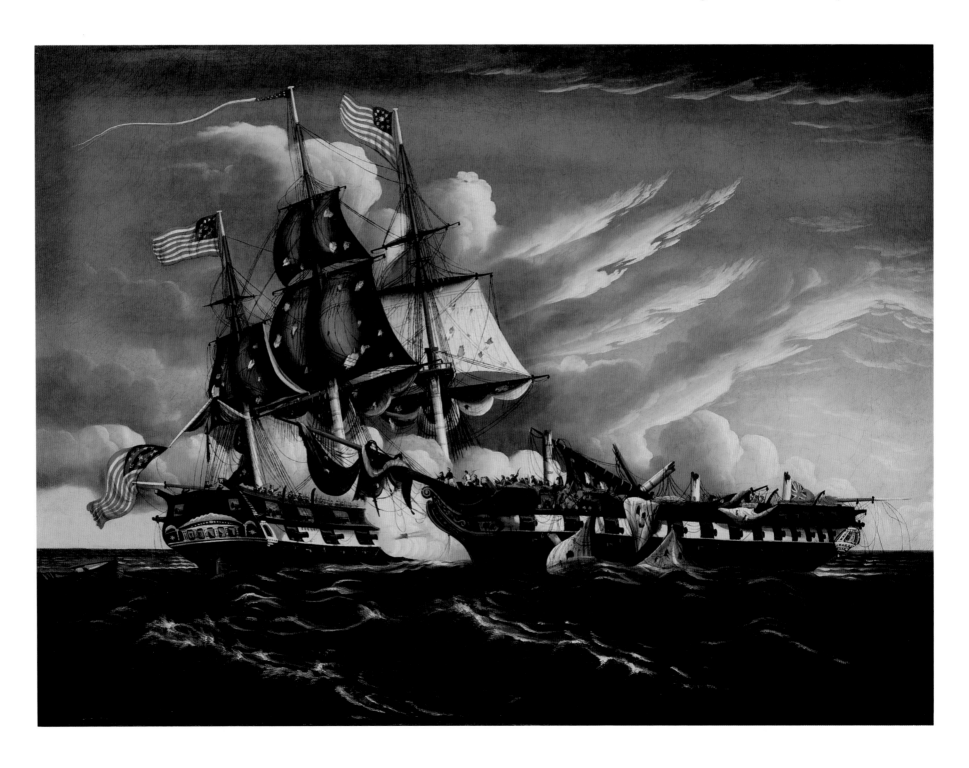

War At Sea

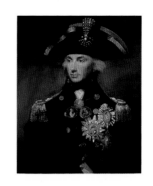

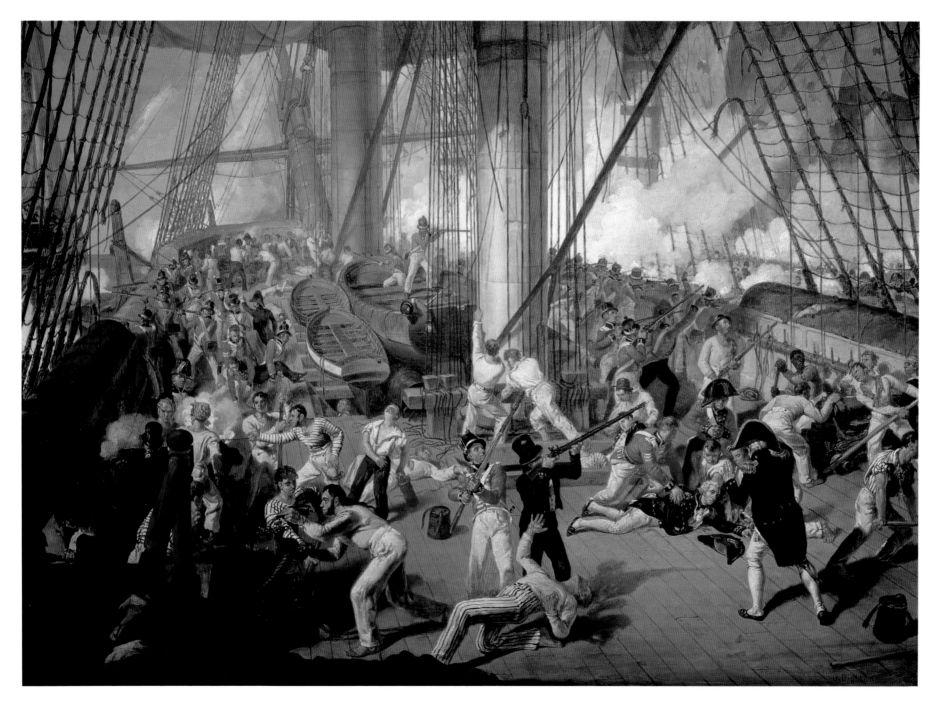

(left) Horatio Nelson, England's greatest naval hero, lies mortally wounded on the deck of his flagship *Victory*, the victim of a French sniper. Though Nelson (see portrait, above left), who lost an arm in a previous battle, lost his life on that day in 1805, his fleet had already defeated the French-Spanish fleet, securing for England a naval supremacy that would last for almost a century and a half.

(right) John Paul Jones and other American naval heroes are ranged around Jones's ship U.S.S. *Bon Homme Richard*, shown in the center of the battle scene with the defeated H.M.S. *Serapis*. Currier & Ives transposed the flags as they had appeared on earlier versions of the battle in order to place the *Bon Homme Richard* more prominently in the composition. But in doing so, the authenticity of the work was compromised.

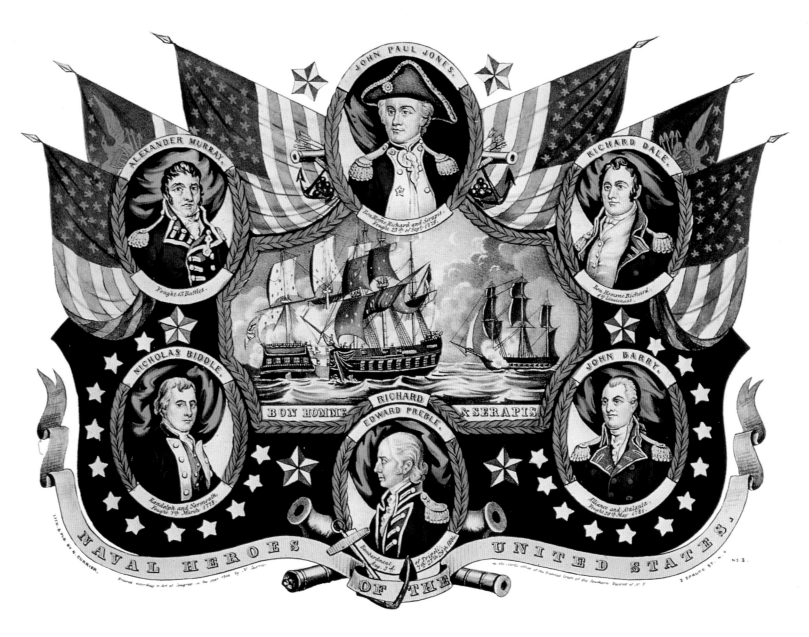

(left) *The Fall of Nelson*, 1805
Denis Dighton
Oil on canvas
76 x 106.5 cm. (30 x 42 in.)
National Maritime Museum, London

(above) *Naval Heroes of the United States*, 1846
Anonymous
Published by Currier & Ives
Hand-colored lithograph on stone
24.4 x 31 cm. (9.5 x 12.25 in.)
The Library of Congress, Washington, D.C.

Ocean Commerce

This interval of bondage in the docks rounds each period of a ship's life with the sense of accomplished duty, of an effectively played part in the work of the world.

Joseph Conrad
From *The Mirror of the Sea*

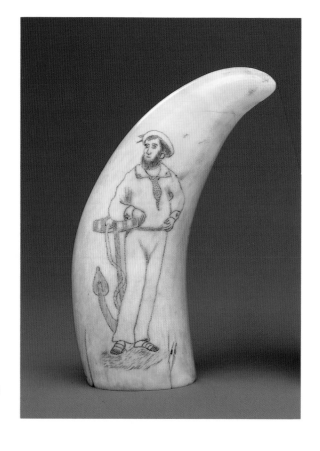

THE MOTIVE FOR EMPIRE has always been trade. Dominance at sea was intended to acquire foreign assets, to protect trade routes, and to facilitate transport of goods in support of individual fortune and the home economy. Besides the ship, the other significant contributor to this endeavor was the seaman, the Jack Tar whose labor was essential and cheap. The return for his sweat equity was minimal — danger, ill health, and little to carry home in his pocket to provide for his family or to squander in the inns and dockside dives so prevalent in port cities.

The captains and ship owners were another category altogether. They, too, placed assets at risk, however the chance for dividend was far greater and many prospered. The sailor is portrayed as happy-go-lucky far from home, while the captain stands at the window of his harborfront house, formally dressed, with his ship and the flag of empire displayed beyond. In both cases, however, the value derived from maritime enterprise — and its effect on the financial and social stability of the community — was a function of their collaboration.

Shipbuilding continued apace to fulfill the

Both the scrimshaw and its subject here recall the great age of expanding ocean commerce in the 19th century. The "jack tar," or sailor, jauntily depicted here, was an essential part of any commercial maritime endeavor. And scrimshaw – the hand engraving of whale teeth or bones – helped many a seaman pass the time and record his adventures on a long voyage.

(above) Scrimshaw – "Jack Tar," ca. 1840
Anonymous
Engraved whale ivory
22.86 cm. high (9 in.)
South Street Seaport Museum

Portrait of John Clarke, 1744
John Greenwood
Oil on canvas
89 x 70 cm. (35 x 27.5 in.)
Peabody Essex Museum, Salem, Massachusetts
Photo: Mark Sexton

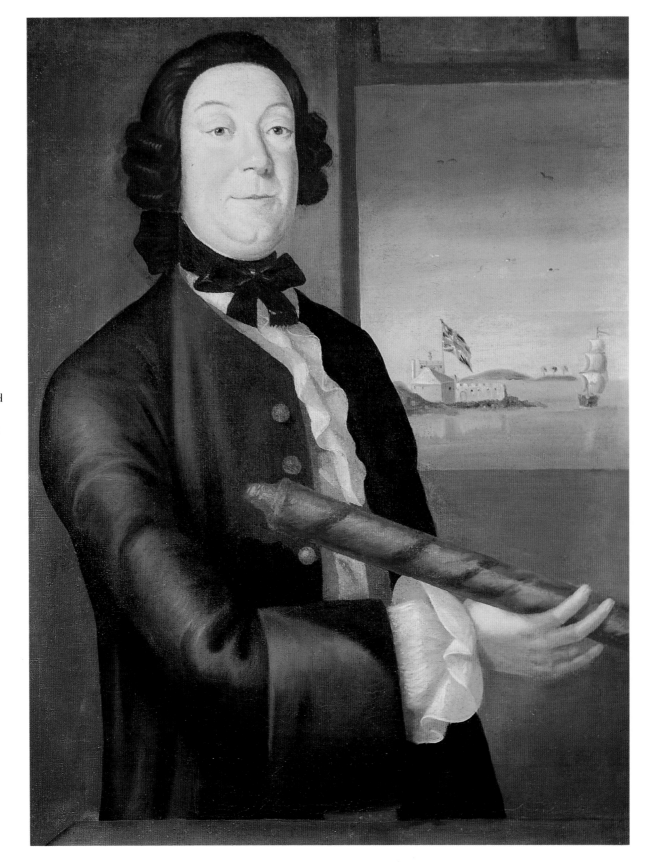

An air of supreme self-assurance radiates from John Clarke, a U.S. colonial-era merchant. Behind Clarke is Salem Fort, which he commanded in the 1740s, and a sailing ship, perhaps like one that carried his goods.

Ocean Commerce

The Packet Ship Orpheus *Off Liverpool*, 1833
Samuel Walters
Oil on canvas
70.5 x 115.6 cm. (27.75 x 45.5 in.)
South Street Seaport Museum, New York

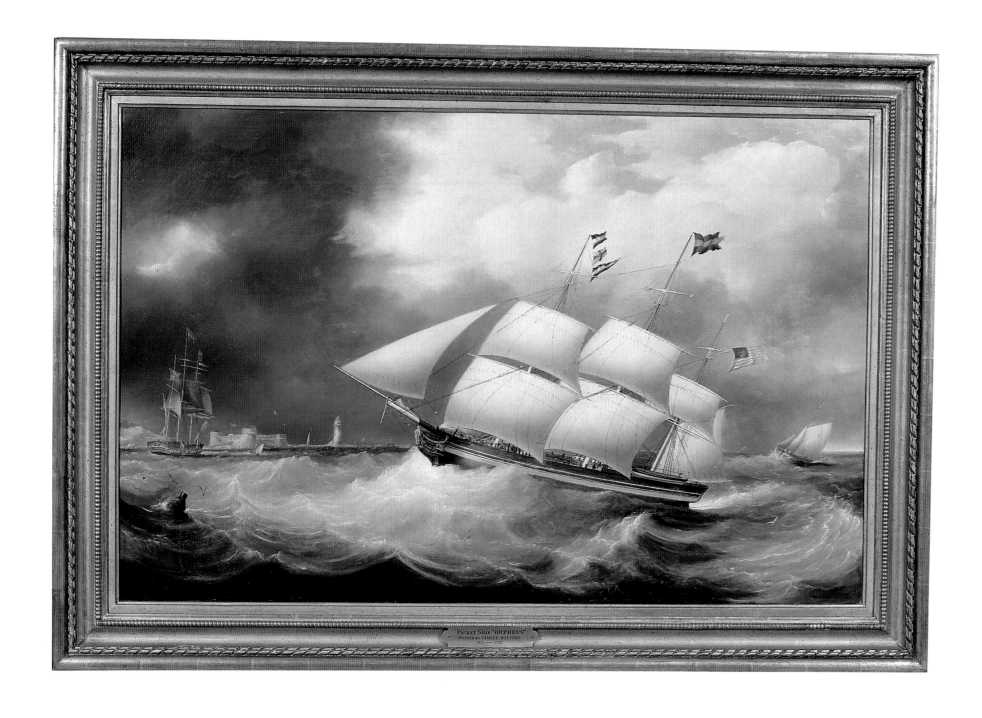

PACKET SHIP "ORPHEUS"
PAINTED BY SAMUEL WALTERS
1843 — 1882

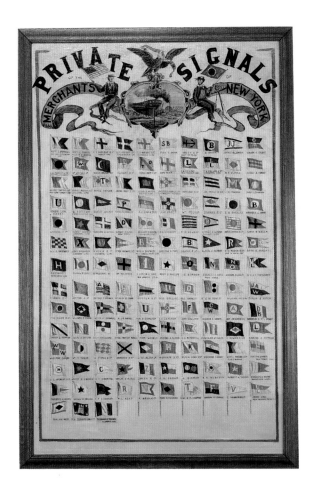

Record of the Private Signal Flags – Merchants of New York, undated
Anonymous
Oil on canvas
153 x 96.5 cm. (60.25 x 38 in.)
South Street Seaport Museum, New York

demands of world trade. Drydocks and construction facilities continued to expand; new designs produced technological advancements like the faster, more commodious American clipper ship. Emigration began in order to populate, administer and exploit the vast resources of proliferating colonies. However primitive, passenger accommodations became a valuable alternative use of 'tween-deck space and regularly scheduled packet service was inaugurated to foment and feed increasing demand. Ships and shipowners became powerful shipping companies with far-flung operations and outposts in places like Singapore and Macao. The Dutch East India Company, for example, became an international presence and a political power equal to the degree and extent of its financial strength.

Cargoes were varied. Heavy goods like stone, sand, lumber and hay moved as coastwise trade. Other commodities like cotton, coffee, tea, tobacco, molasses, spice, textiles, even ice and guano, were transported long distances from east to west, west to east. Ferries connected coastal communities, workboats moved goods within the ports, barges transferred product to and from the hinterlands. Tragically, one such cargo was human, and lucrative – Africans transported from homeland to foreign lands where, if they survived the passage, at best they existed as slaves.

The Suez Canal, the Erie Canal, the Panama

(left) "Private signal flags" – 133 flags with corresponding names of ship owners – attest to the strength of New York City's maritime industry in the 19th century. The empty spaces may indicate that the piece was not completed or to allow for expansion.

(far left) Heeling in a choppy sea, the packet ship *Orpheus* is depicted on her maiden voyage in 1832 as she enters Liverpool Harbor. The landmarks Perch Rock Light and Fort are in the background. In 1838 this Black Ball Line ship sailed from New York to Cork, Ireland, in a record twelve-and-a-half days.

Ocean Commerce

Canal—projects of monumental imagination and engineering—were justified by the reduced interval of time between buying and selling, source and market. And the laying of the transatlantic cable revolutionized ocean commerce in a quantum leap. Where messages crossing the sea were once measured in weeks, they were now measured in minutes.

With so much wealth afloat on the high seas, it was inevitable that pirates and privateers would take opportunistic advantage. While this has provided entertaining literature and, in a few cases, notorious success, piracy ultimately proved not to be a commercial enterprise of long-standing.

Commerce is a cumulative business. It begins with the work of one, the solitary trader in his lateen-rigged boat, feeding a system of transfer and added value until the cargo, the bags of grain like yellow gold, arrives in the great port to be stored in the warehouses of the merchant princes. In their fancy hats and brocaded robes, these gentlemen—not always gentle—have made the world go round. ✿

Between Decks, 1827
Joseph Mallord William Turner
Oil on canvas
30.5 x 48.6 cm. (12 x 19 in.)
Clore Collection, Tate Gallery,
London / Art Resource, New York

A 'tween-decks passenger looks out through a gunport in this evocative treatment of 19th century ocean travel. With emigration to America soaring, ships of all types were pressed into service to handle paying customers in what one observer called "the human horde" crossing the Atlantic.

Ocean Commerce

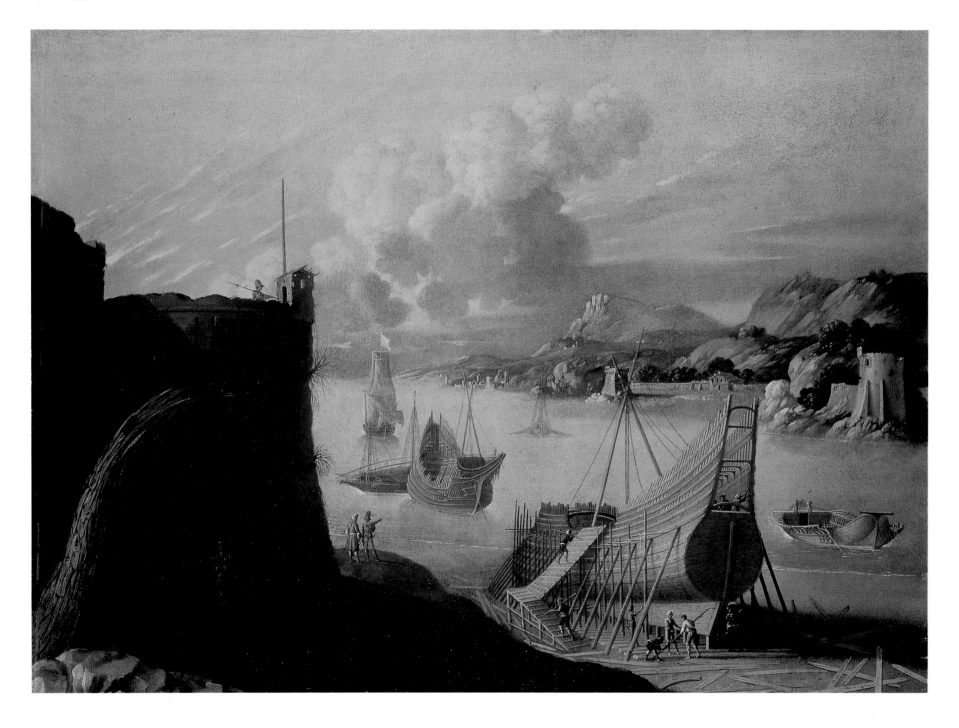

Navi in Construzione, first half 17th century
Agostino Tassi (attributed)
44.5 x 87 cm. (17.5 x 34.2 in.)
N.I. Museo Navale, Genoa, Italy

(left) This painting depicts naval vessels in various stages of construction in an Italian seaport town. The painting is realistic, as it shows how workers are building the hull of the carrack in the foreground. Another oceangoing ship is moored offshore during construction.

(right) An 1833 scene of a sailing ship under construction at the Smith and Dimon Shipyard on New York City's East River depicts workers engaged in various tasks and stacks of lumber to be used for the hulls of other ships. Building a large ship consumed scores of trees.

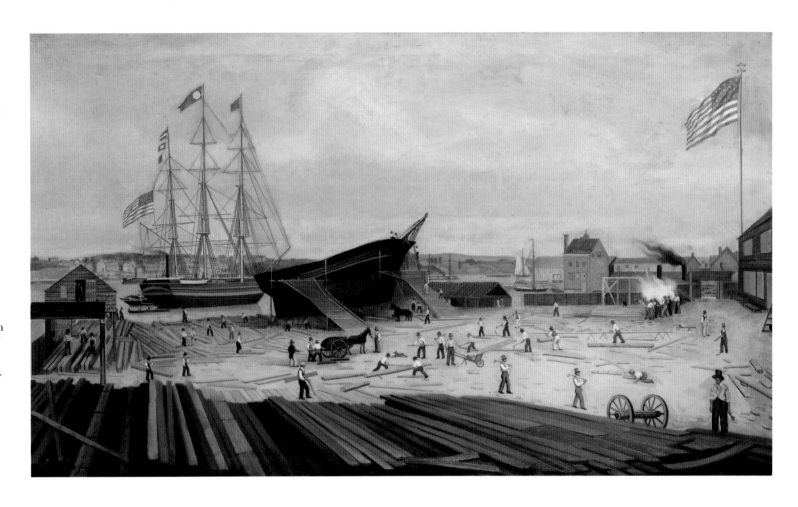

Smith and Dimon Shipyard, ca. 1944
Emmett O. Smith,
after an 1833 painting by James Pringle
Oil on canvas
71.4 x 122 cm. (28.12 x 48.12)
Original: Collection of the
New York State Historical Association,
Cooperstown, New York

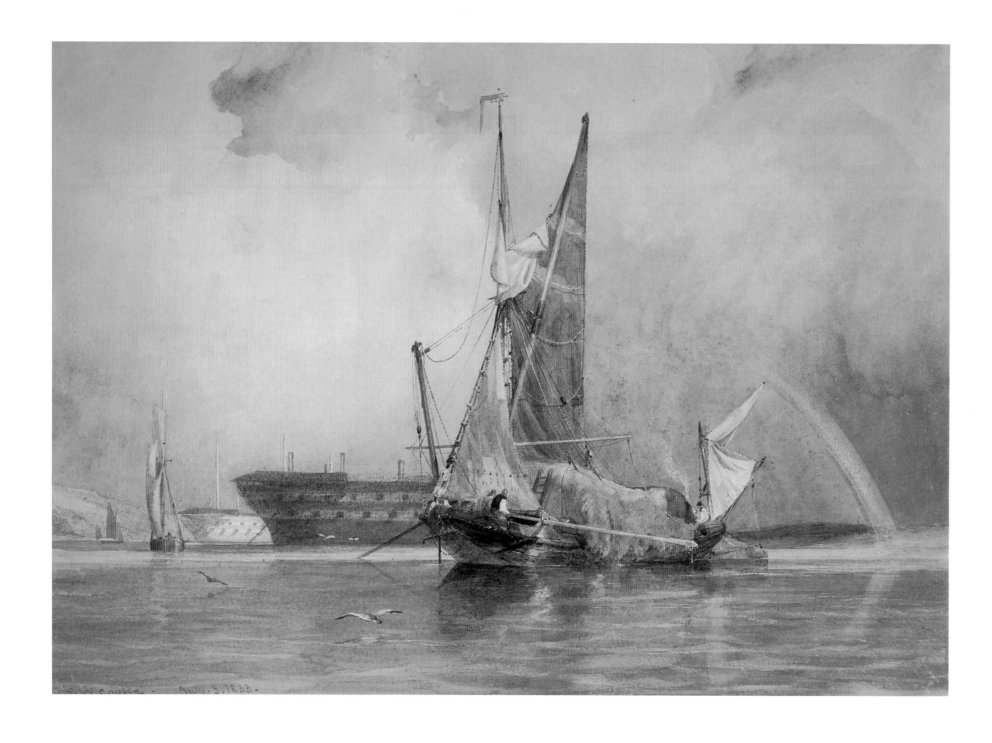

(left) A rainbow frames a hay barge anchored near Royal Navy men-of-war in this evocative study of seaborne commerce in early 19th century England. In the absence of a nationwide network of roads or rails, bulk cargoes most often moved on rivers and other waterways.

(right) Subtle gradations of paint and glaze turn a seemingly graceless theme – schooners stacked high with lumber – into a serene rendering of the ships that transported this essential building product in 19th century America.

(left) *Hay Barge and Men-of-War on the Medway*, 1833
Edward William Cooke
Watercolor and body color on paper
21.7 x 32.5 cm. (8.5 x 12.6 in.)
National Maritime Museum, London

(above) *Lumber Schooners at Evening*
on Penobscot Bay, 1860
Fitz Hugh Lane
Oil on canvas
62.5 x 96.8 cm. (24.62 x 38.12 in.)
National Gallery of Art, Washington, D.C.
Andrew W. Mellon Fund
Gift of Mr. and Mrs. Francis W. Hatch, Sr.

Ocean Commerce

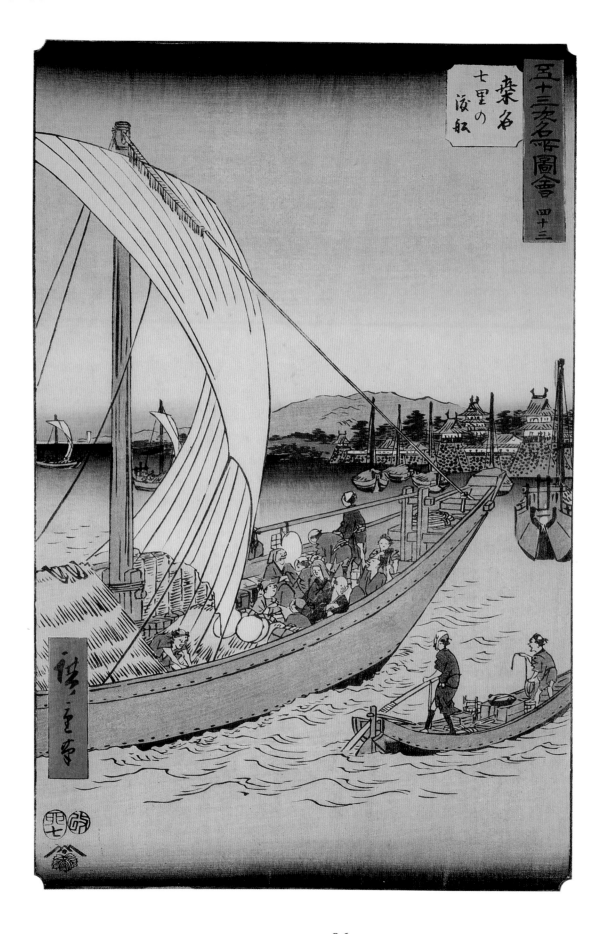

五十三次名所圖會

桑名
七里の渡口

四十三

A ferryboat filled with passengers approaches Kuwana in 1855. This woodcut is one in a series depicting the stations in Japan at which such ferryboats stopped.

An artist painted this view of a ferryboat and passengers on the landing at McMahon's Point on the north shore of Sydney Harbour in 1890, when the fare was just a penny. The ferry traveled to the west side of an inlet called Lavender Bay. Ferries still operate from McMahon's Point, but travel to the south side of Sydney Harbour.

Vertical Tōkaidō Series: Kuwana, No. 43, 1855
Ichiryusai Hiroshige
Woodcut on paper
37 x 25.2 cm. (14.56 x 9.94 in.)
Allen Memorial Art Museum
Oberlin College, Oberlin, Ohio
Mary A. Ainsworth Bequest, 1950
© Allen Memorial Art Museum

From McMahon's Point – Fare One Penny, 1890
Arthur Streeton
Oil on canvas
90.1 x 70.5 cm. (35.8 x 27.7 in.)
National Gallery of Australia, Canberra

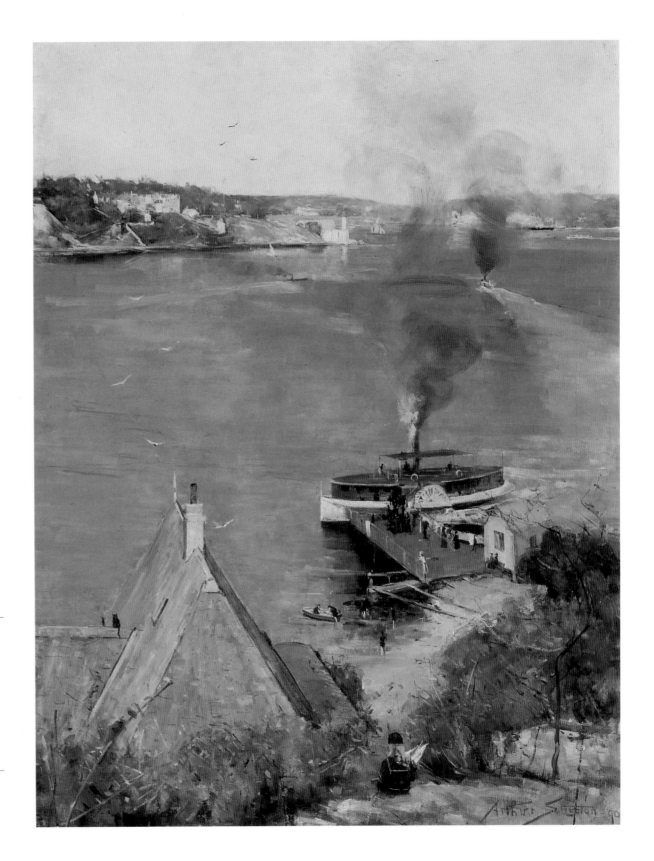

Ocean Commerce

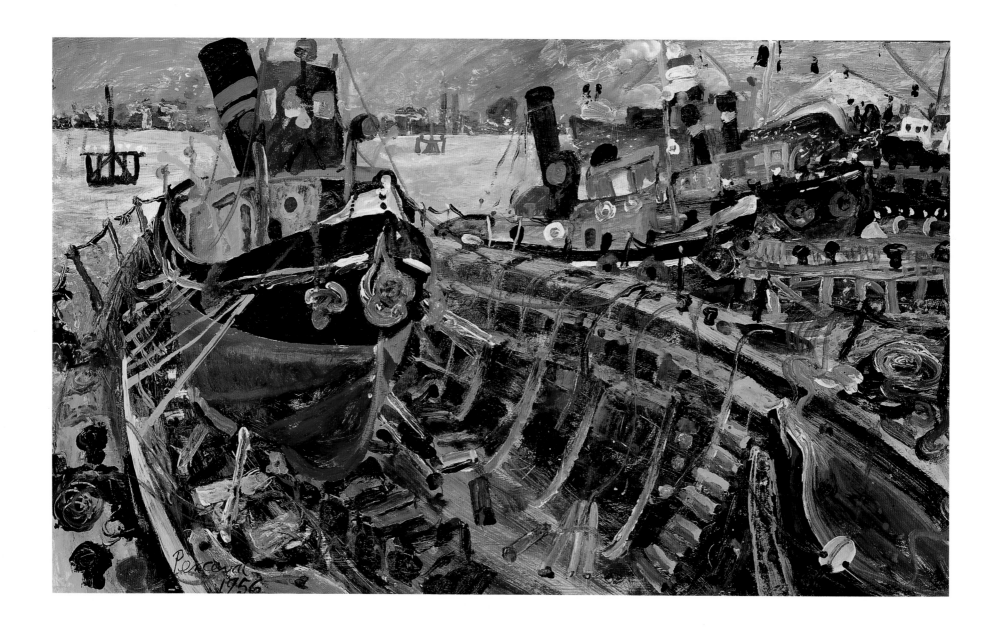

(left) This painting depicts a rather unusual scene—a boat hauling a tugboat for repairs in an Australian port. As ocean commerce became more vital to trade in the 20th century, tugboats emerged as the ubiquitous workhorses of the maritime industry.

(right) The exuberance of the 19th century American West is evident from this celebrated painting of flat-boatmen cavorting on the deck of their vessel. With few railroads or highways, goods arriving at coastal ports from abroad were shipped inland on river boats like this one, which helped open a continent.

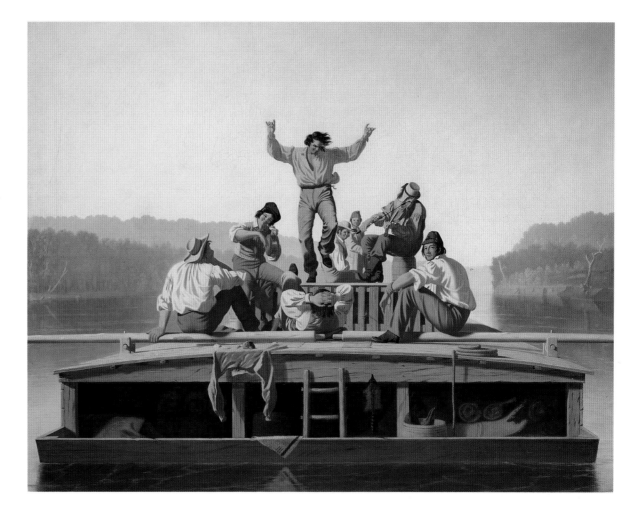

(left) *Tug Boat in a Boat*, 1956
John Perceval
Enamel and tempera on composition board
121.9 x 73.7 cm. (48 x 29 in.)
National Gallery of Victoria
Melbourne, Australia

(right) *The Jolly Flatboatmen*, 1846
George Caleb Bingham
Oil on canvas
96.5 x 123.2 cm. (38 x 48.5 in.)
Manoogian Foundation, Taylor, Michigan

Ocean Commerce

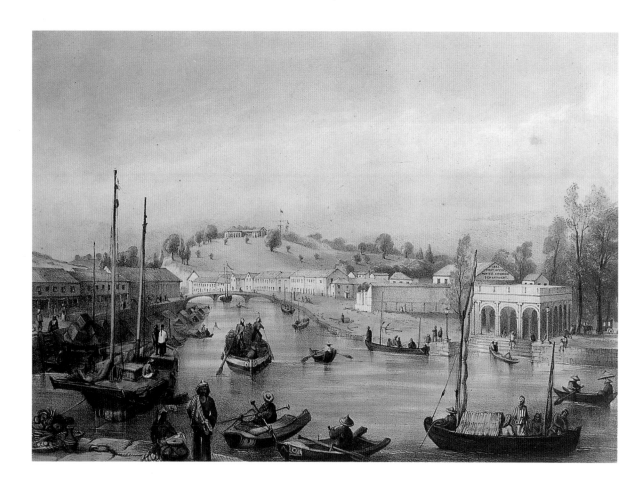

(left) Cargo-laden vessels of various kinds are depicted in this historically correct 19th century view of the Singapore River. Thomson Bridge is upriver, and beyond it on the hill is Government House, seat of British colonial power in Singapore. The colony was one of the busiest ports in the Far East when this scene was produced in 1853 and is one of the world's busiest today.

(right) This highly detailed painting shows the busy port of Macao, a Portuguese enclave in China, with foreign-owned factories lining a waterfront crowded with Chinese junks and European vessels. The international scene attests to the importance of Macao as a center of maritime trade in the 19th century.

(above) *The Singapore River with Thomson Bridge,*
ca. 1849–1853
Edwin Augustus Porcher
Colored lithograph engraved by Vincent Brooks
25.7 x 32.2 cm. (10 x 12.8 in.)
The National Museum, Singapore

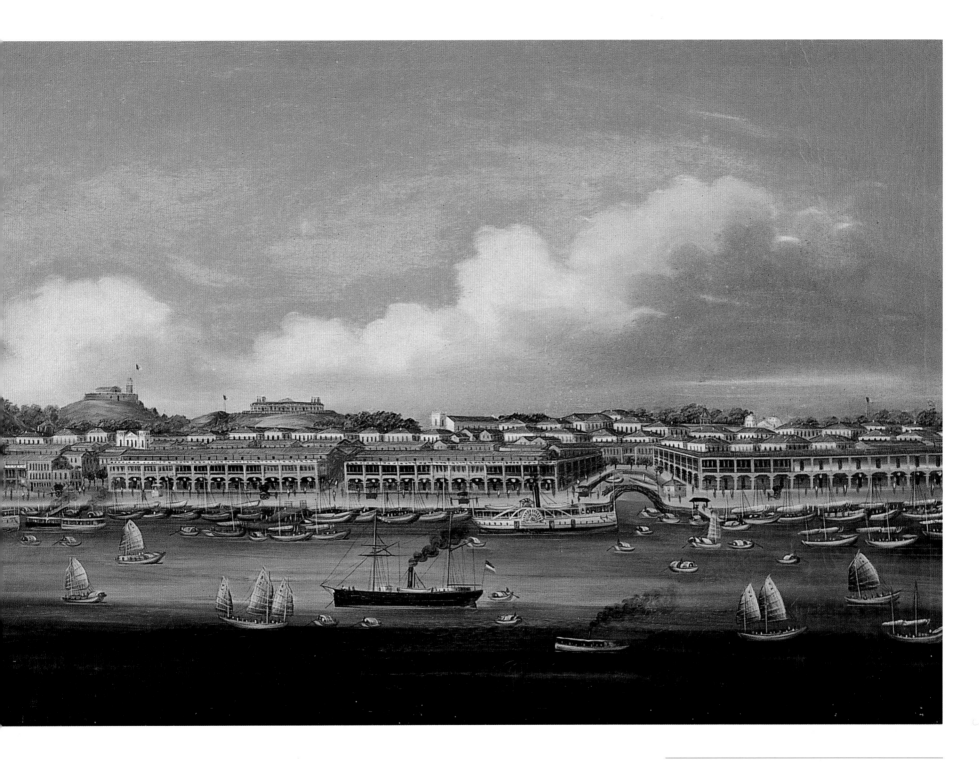

(above) *Port of Macao*, late 19th century
Anonymous
Oil on canvas
44 x 77 cm. (17 x 30 in.)
Museo Marinha, Lisbon, Portugal

Ocean Commerce

The Inauguration of the Suez Canal, 1869
M. Riou
Manuscript page: color on paper
Cairo Library, Cairo, Egypt
© National Geographic Society, Washington, D.C.
Photo: Jonathan Blair

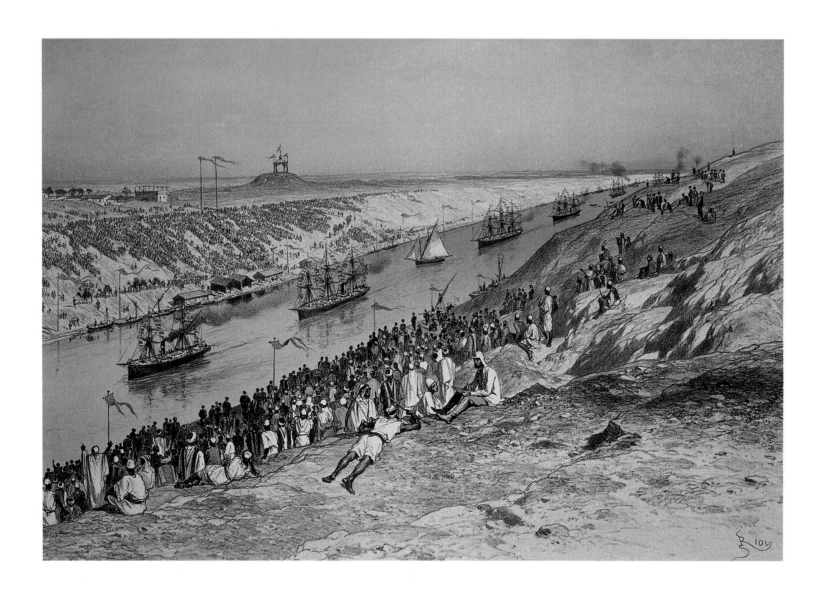

(right) Dockworkers load ivory, cotton and other goods onto North African ships at the port of Kiloa, in this depiction of trade among Africans before the arrival of Europeans in Cameroon. From the 12th to 15th centuries, Kiloa was the most important seaport in West Africa.

(below) Another, grimmer kind of trade is depicted here, as shackled Africans led to ships on the "Slave Coast" pass the bodies of those who died before they could board. Between 1620 and 1860, more than five million Africans were shipped from the west coast of Africa to North America—a lucrative "commerce" that for a time constituted the largest segment of seaborne trade across the Atlantic.

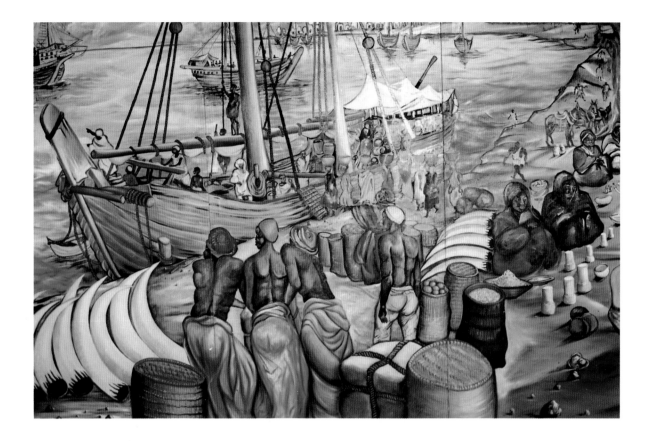

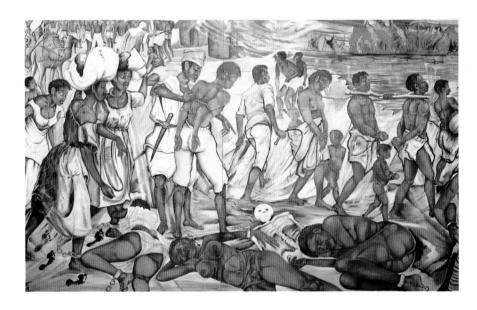

(above) *Loading Ships at Kiloa*, 1988
Jacob Yakouba
Oil on wood
283 x 666 cm. (111 x 262 in.)
© Cameroon National Shipper's Council,
Cameroon Maritime Museum, Douala

(left) *The Trade in Blacks*, 1988
Jacob Yakouba
Oil on wood
282 x 422 cm. (111 x 166 in.)
© Cameroon National Shipper's Council,
Cameroon Maritime Museum, Douala

Ocean Commerce

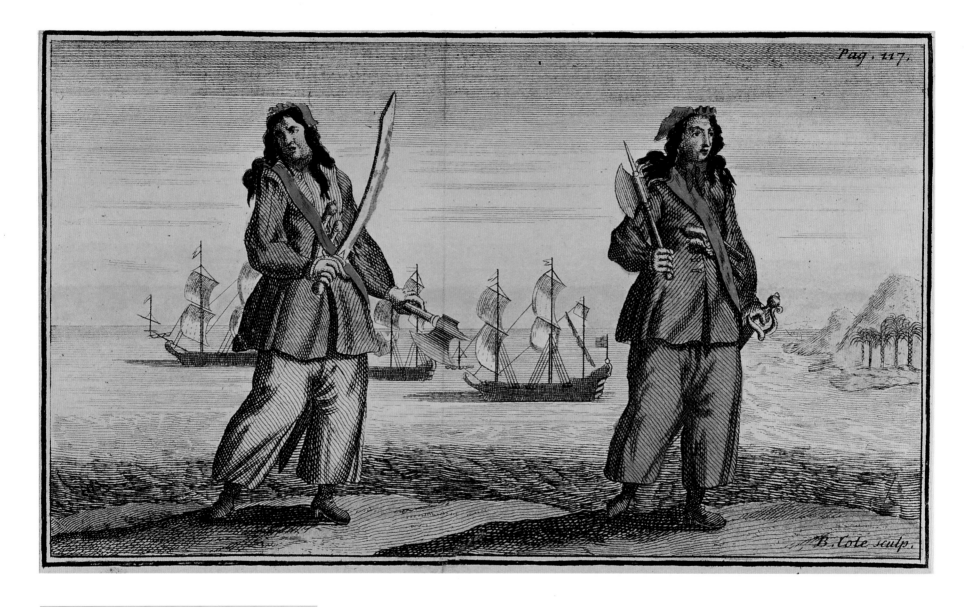

(left) Armed to the teeth, the famous female pirates Ann Bonny and Mary Read strike defiant poses in this 18th century engraving. Piracy was the scourge of seaborne commerce from the 15th to 18th centuries, attracting men – and some women – to the Skull and Crossbones.

(right) The notorious Captain Kidd is portrayed here by American artist Howard Pyle, whose paintings did much to popularize pirates and piracy. Kidd, a minister's son, supposedly buried a Bible when he turned to piracy.

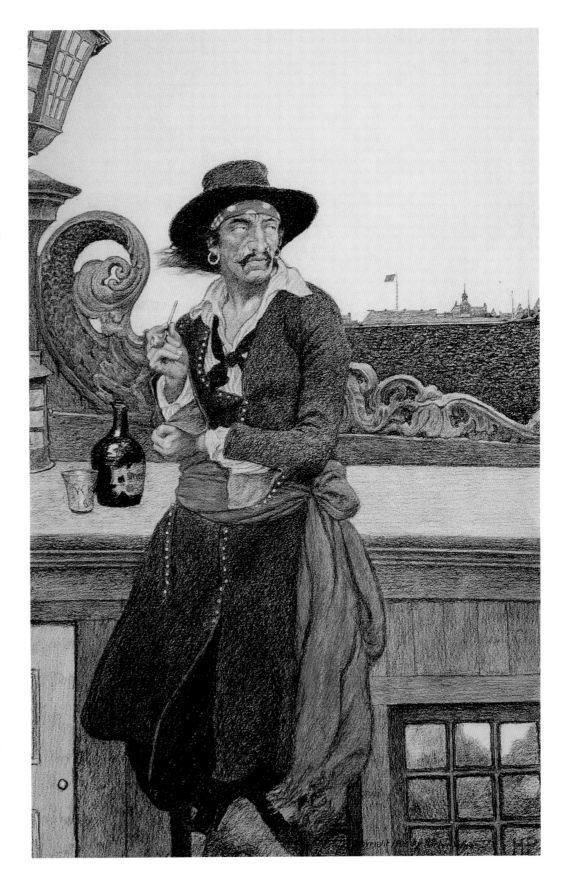

Kidd on the Deck of the Adventure Galley, 1902
Howard Pyle
Watercolor
42.5 x 27.3 cm. (16.75 x 10.75 in.)
Delaware Art Museum, Wilmington
Howard Pyle Collection, Museum Purchase, 1912

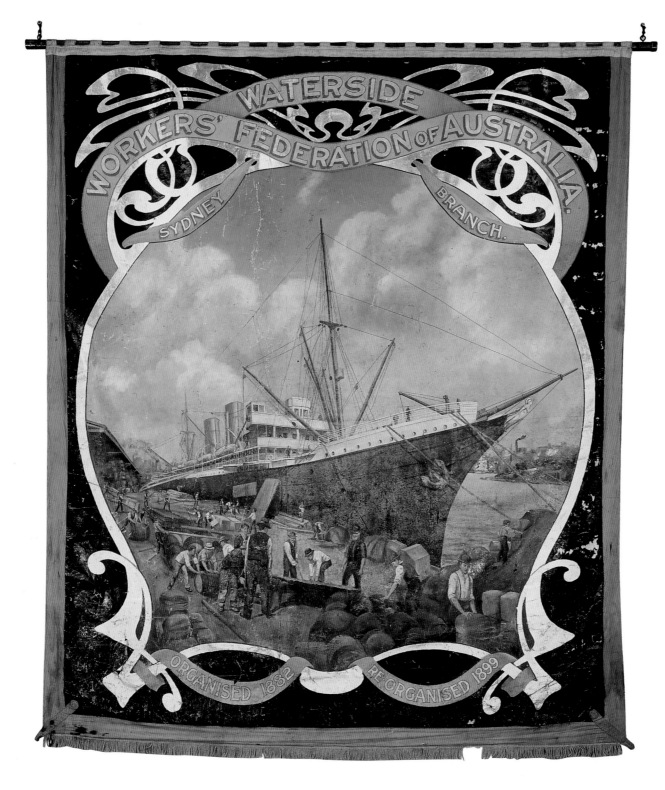

A 1903 trade-union banner, one of the most powerful symbols of identity for Australian unions since the 1850s, depicts workers discharging cargo in Sydney. The prominence of the maritime unions and their symbols was no doubt a reflection of the island-continent's almost total dependence on ports and seaways in the early 20th century.

A lavish engraving commemorates the completion of the transatlantic cable between Valencia, Ireland, and Heart's Content, Newfoundland, in 1866. The cable, funded by the United States and England, revolutionized commerce between North America and Europe, as it allowed users to send messages and money in minutes rather than the 12 to 14 days it normally took steamships to cross the Atlantic.

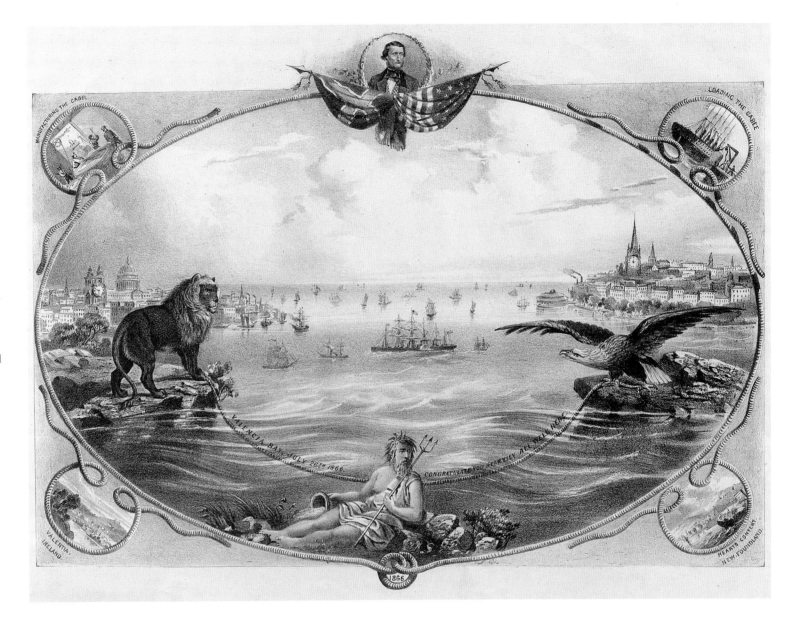

(left) *Banner of the Waterside Workers'*
Federation of Australia, Sydney Branch, ca. 1903
Edgar Whitbread
Oil on canvas
3.15 x 3.73 m. (10.3 x 12.2 ft.)
Australian National Maritime Museum, Sydney

(above) *The Eighth Wonder of the World.*
The Atlantic Cable, 1866
Lithograph
36.8 x 46 cm. (14.5 x 18.1 in.)
Published by Kimmel & Forster
Museum of the City of New York

Ocean Commerce

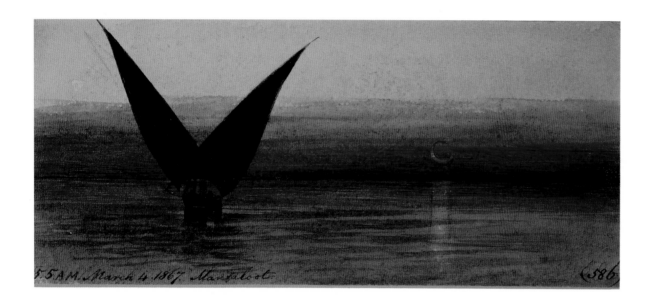

5.5 AM March 4 1867 Manfalot

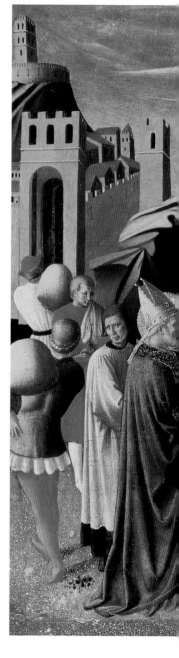

(above) *Sunrise at Manfalut with a* Dahabeeh, 1867
Edward Lear
Watercolor
7.5 x 17.5 cm. (3 x 7 in.)
National Maritime Museum, London

(right) *Bringing of Grain to Myra*, 1437
Fra Angelico
Paint on panel
33 x 60.5 cm. (13 x 23.08 in.)
Vatican Picture Gallery, Rome

In an unusual gesture, the artist noted on the canvas the day, month, year and early-sunrise hour when he sighted and began painting this Egyptian cargo boat. The result is a stunning study of a *dahabeeh*, whose sails billow like black wings as she glides along the Nile.

This brilliantly colored painting depicts the 4th century Saint Nicholas of Bari (wearing the miter) with grain that has been unloaded from cargo ships in famine-stricken Myra, a city in Asia Minor. The stores of those who provided the grain were miraculously replenished, thanks to the divine intervention of the saint. Many miracles were attributed to Saint Nicholas, who was later associated with Christmas.

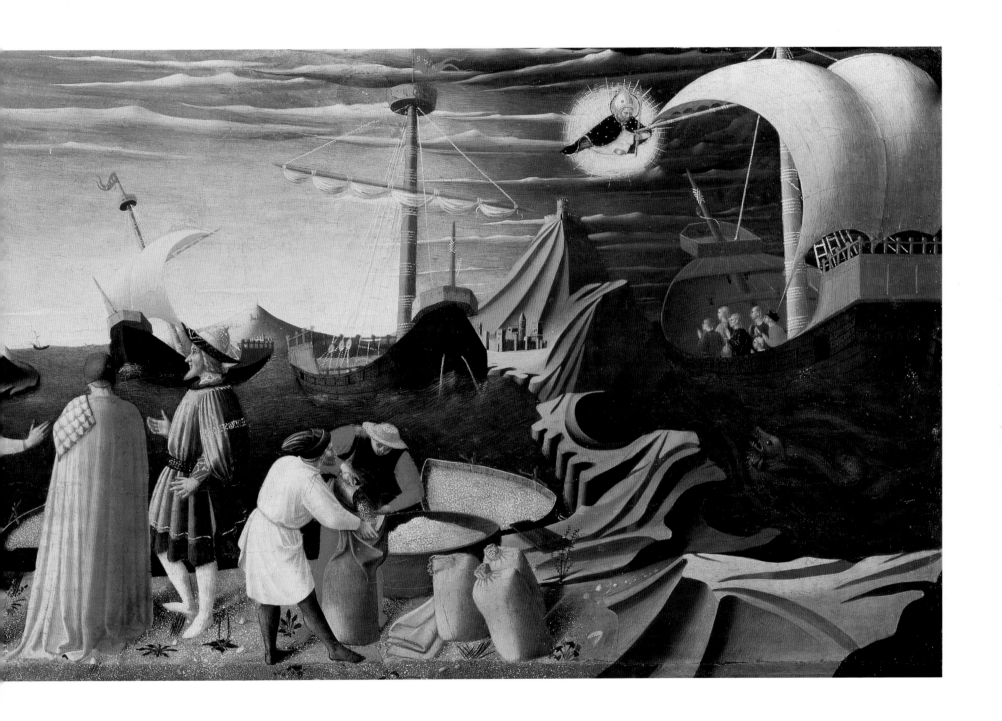

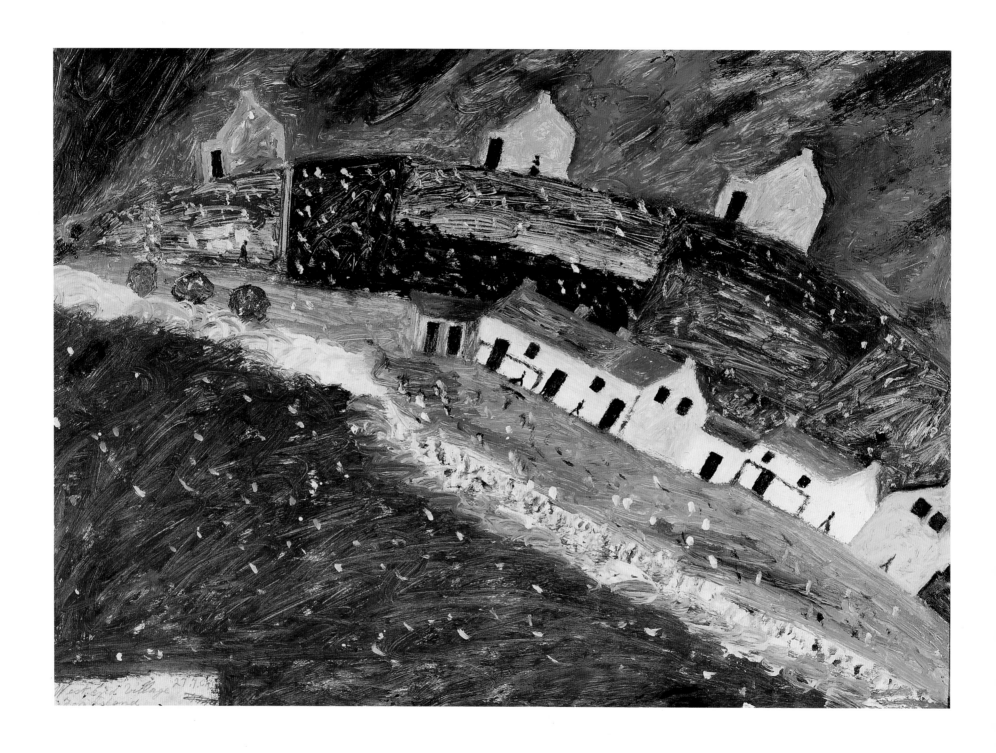

Ports of Call

Exultation is the going
Of the inland soul to sea,
Past the houses – past the headlands –
Into deep Eternity

Emily Dickinson
From "Exultation is the going"

A PORT MAY BE DEFINED as a place of exchange – of goods, people and ideas. It is important to think of a port as a synapse, a linkage charged with power, a point of transfer for product, personality and philosophy, a zone of interaction between the active energies of land and sea.

First of all, ports are home. They may be a great, bustling city or a simple, coastal village, but they are nevertheless a place to run away to sea from, to dream of while at sea, to return to safely. Ports are places where fires are lit and families dwell before the hearth. Ports are havens to anchor in behind a formidable breakwater until the storm abates. "Haven," in fact, is one German word for "harbor." Ports are also places to replenish stores of fresh water, bread and fruit in order to depart on a new passage filled with optimism.

Down through the ages, ports of call have drawn mariners to the commerce, safety and recreation they offer. Even the tiny fishing village of Tory Island off the northwest coast of Ireland drew mariners to its quiet shores, so artfully captured here by James Dixon. One of Ireland's best self-taught artists, Dixon's unorthodox painting tools included brushes made from donkey tails and boat paint salvaged from trash bins.

West End Village, Tory Island, 1964
James Dixon
Oil on board
55.9 x 72.2 cm. (22 x 30 in.)
The Anthony Petullo Collection
of Self-taught and Outsider Art,
Milwaukee, Wisconsin
Photo: Efraim Lev-er

Ports of Call

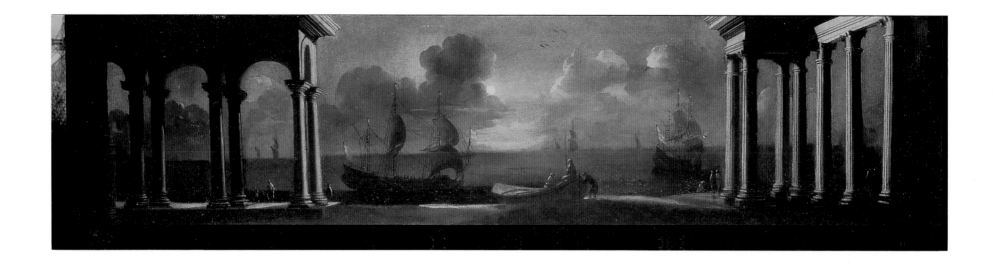

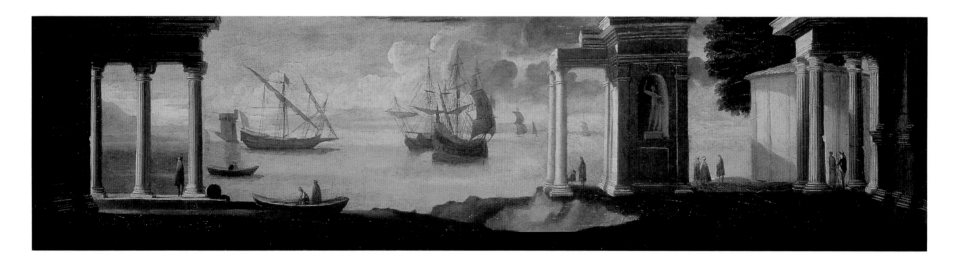

(top) *Partito Architettonico con Navi*
(Relevant Architecture with Vessels), 17th century
Anonymous
Oil on canvas
29 x 122.5 cm. (11.4 x 48.2 in.)
N.I. Museo Navale, Genoa, Italy

(above) *Partito Architettonico e Lido di Mare*
(Relevant Architecture and Seashore), 17th century
Anonymous
Oil on canvas
29 x 122.5 cm. (11.4 x 42.8 in.)
N.I. Museo Navale, Genoa, Italy

The paintings on this and the preceding page are part of a series of idealized scenes of seaports. All of the paintings, produced in the 17th century by artists whose names have long since been lost to the ages, are notable for their misty, ethereal quality.

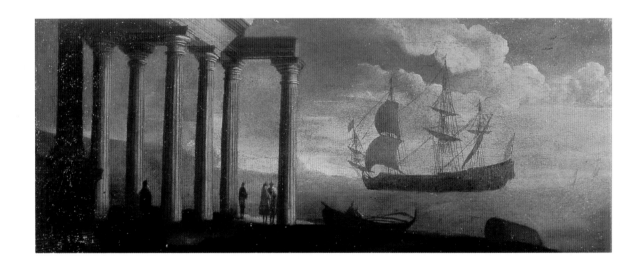

(top) *Navi ed altri Velievi Vista da Terra con Partiti Architett* (Sailing Ships and other Vessels Viewed from Land with Relevant Architecture), 17th century
Anonymous
Oil on canvas
29 x 122.5 cm. (11.4 x 42.8 in.)
N.I. Museo Navale, Genoa, Italy

(above) *Partito Architettonico e Lido Marine* (Relevant Architecture and Maritime Shore), 17th century
Anonymous
Oil on canvas
29 x 78.2 cm. (11.4 x 30.8 in.)
N.I. Museo Navale, Genoa, Italy

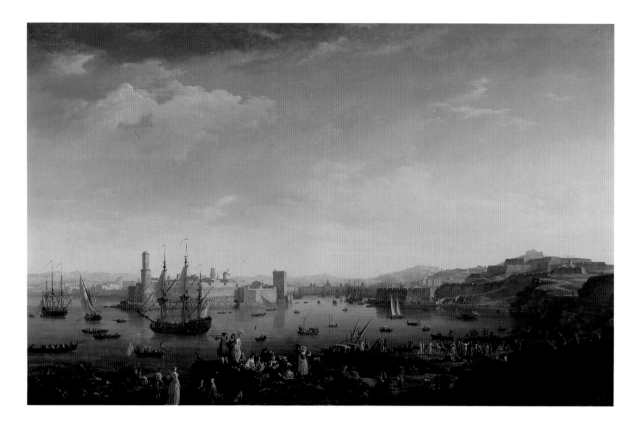

Secondly, ports are ports of call. To foreigners, these are foreign places, faraway destinations called "Kobe" or "Valparaíso" or "Marseilles" where the language and landscape are different, where the architecture is formal or fallen, where the view of the colorful harbor is framed by a hotel window or seen from an overlook to which we have climbed to exercise our sea-legs. In port, everyone is an alien from the other's point of view, everyone is in transit, and so ports are cosmopolitan, pluralistic, polyglot and unforgiving.

The goods for import are loaded into adjacent boats for transfer ashore; the goods for export are piled on the quay to be loaded into empty holds. The sails hang slack to dry. As in our modern airports, the machines of transport are grounded, at rest, seemingly awkward and useless, while around

them a bustle of small vessels busily spins.

This business, of course, requires conversation, negotiation, dispute. It is sealed by a handshake, a signature, a contract. This human interaction is the essence of port life. The passage of goods from ship to shore to marketplace is a picaresque novel in which the plethora of characters are stevedores and lightermen, customs agents, lawyers and moneylenders, fishwives and salesmen, and the boisterous, demanding, consuming public.

Throughout history, ports have been world cities—Alexandria, Venice, London, Hong Kong, New York—the ships careened against a backdrop of turrets and domes, the bowsprits canted against the facades of counting houses. The streets of ports have been filled with Africans and Europeans, Asians and Hispanics, their skills required, their languages intermingled, their bodies entwined, and their customs frequently in conflict. Ports have housed rich and poor side-by-side in a not always equitable arrangement of shelter, occupation or reward. They have welcomed immigrants, boarded emigrants, and fostered awareness, if not full acceptance, of human differences. Ultimately, they have assimilated belief and prejudice, knowledge and antagonism; they have nurtured the exchange of ideas—the most significant function of a port—and we are the richer for it. ✿

Scenes painted on large panels above fireplaces, called "overmantels," were popular decorative elements in New England in the mid-18th to early 19th centuries. This one, of unusual beauty and delicacy, depicts an imaginary harbor, complete with promenading figures and quaint houses.

Overmantel: Imaginary Harbor View, ca. 1800
Attributed to Michele Felice Corné
Oil on panel
99 x 150 cm. (39 x 59 in.)
Peabody Essex Museum, Salem, Massachusetts
Photo: Mark Sexton

(left) Leith, Scotland, was a busy seaport in the early 19th century, as seen here. Crowds on the quay watch as small boats sail alongside a British man-of-war entering port, and a veritable forest of ships' masts fills the background.

(right) An 18th century view of the port of Christianshavn, Denmark, centers on the towering, resplendently carved stern of the Danish Navy ship of the line *Friedericus Quintus*. The ornate barge with the figurehead, in the foreground, may belong to Danish royalty.

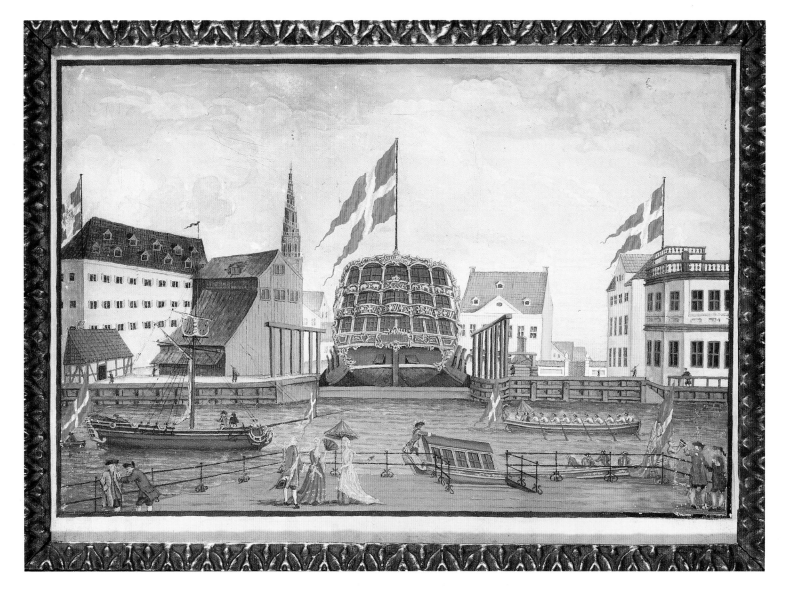

(left) *Leith, Scotland,* ca. 1830
Robert Salmon
Oil on panel
41.3 x 65.4 cm. (16.25 x 25.75 in.)
The Mariners' Museum
Newport News, Virginia

(above) *Dansk Orlogsskib* Friedericus Quintus, 1755-1756
Anonymous
Gouache
32 x 20 cm. (12.6 x 7.9 in.)
Orlogsmuseet, Copenhagen

Ports of Call

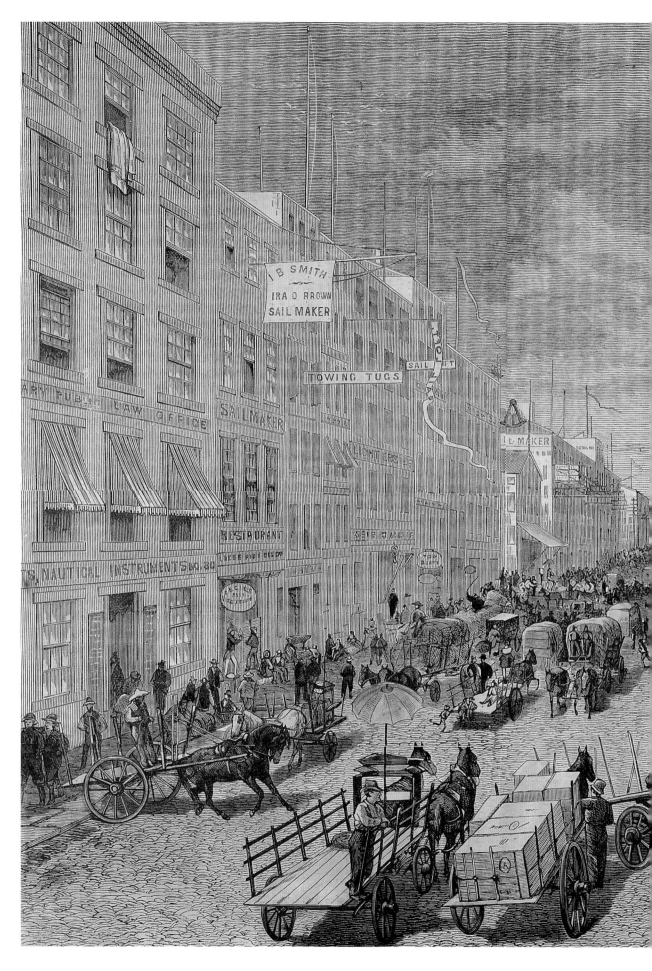

View in South Street, ca. 1875
I.A. Pranishnikosf
Published by *Harpers Weekly*, April 20, 1878
Colored ink on paper
23.5 x 34.6 cm. (9.25 x 13.62 in.)
South Street Seaport Museum, New York

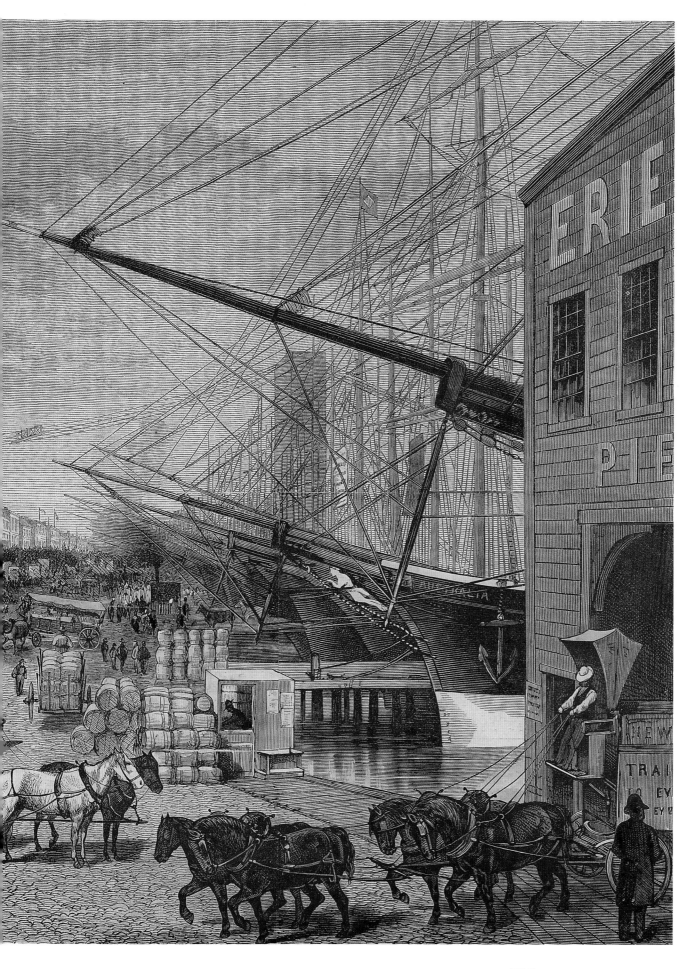

South Street when it was New York City's main waterfront thoroughfare in 1875 is a sea of humanity, cargo, horses and wagons. Glimpsed through the tangle of clipper-ship masts and rigging is the newly constructed Manhattan tower of the Brooklyn Bridge.

Ports of Call

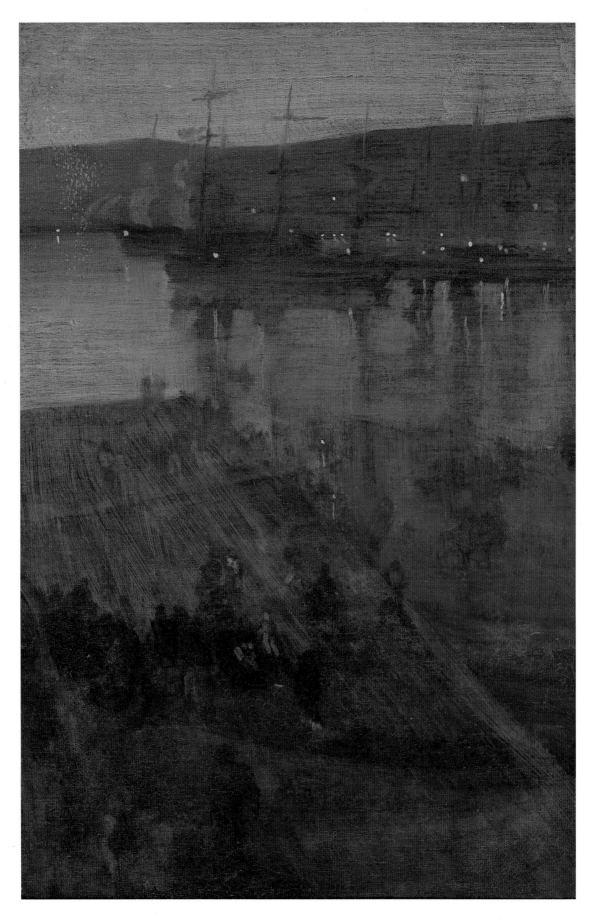

(left) The lights of sailing ships reflect on the water in this eerily atmospheric study of Valparaíso. The Chilean city was the major provisioning port for ships "rounding the Horn" in the 19th century – a position lost only with the opening of the Panama Canal in 1914.

(right) Ships of a French fleet, lying just offshore, bombard the walled city of Genoa in this detailed account of the siege of the Italian city in the 17th century. Genoa was one of the most important Mediterranean ports during this period, and thus was a bone of contention among several nations.

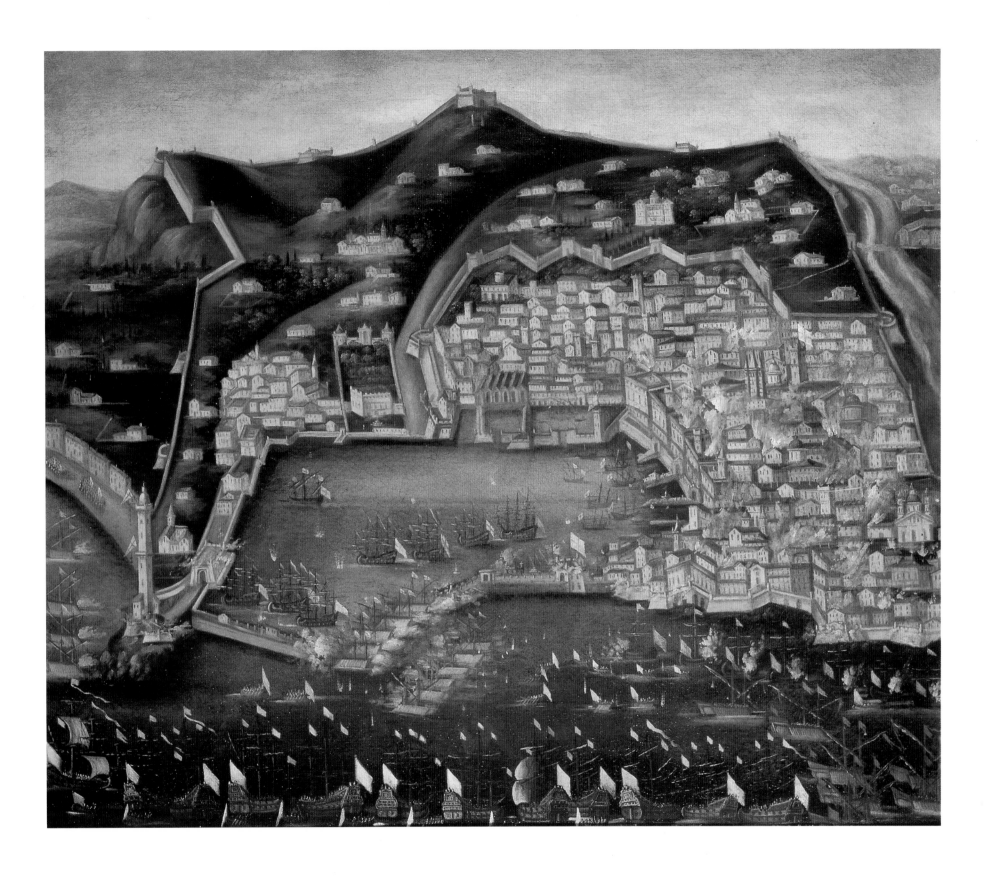

(left) *Nocturne in Blue and Gold – Valparaíso*, 1866
James Abbott McNeill Whistler
Oil on canvas
75.6 x 50.1 cm. (29.8 x 19.7 in.)
The Smithsonian Institution, Washington, D.C.
Arthur M. Sackler Gallery

(above) *Genova Bombardata Dalla Flotta Francese*, 1684
Anonymous
Oil on canvas
107 x 126 cm. (42 x 49.5 in.)
N.I. Museo Navale, Genoa, Italy

Ports of Call

In 1495, just three years after Christopher Columbus sailed to the New World, Vittore Carpaccio placed his *Meeting of St. Ursula and Her Fiance Ereo* in an idealized seaport depicting the great carracks — one of which is careened for cleaning — that helped open the Americas to Europe.

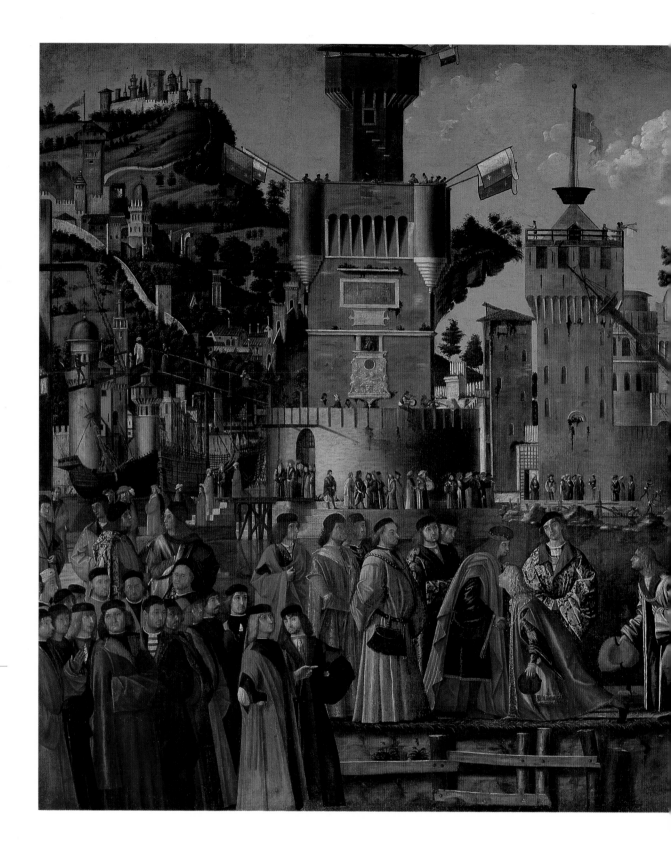

Meeting of St. Ursula and Her Fiance Ereo (detail), 1495
Vittore Carpaccio
Oil on canvas
280 x 611 cm. (110 x 240.5 in.)
Galleria dell' Accademia, Venice, Italy/
Art Resource, New York

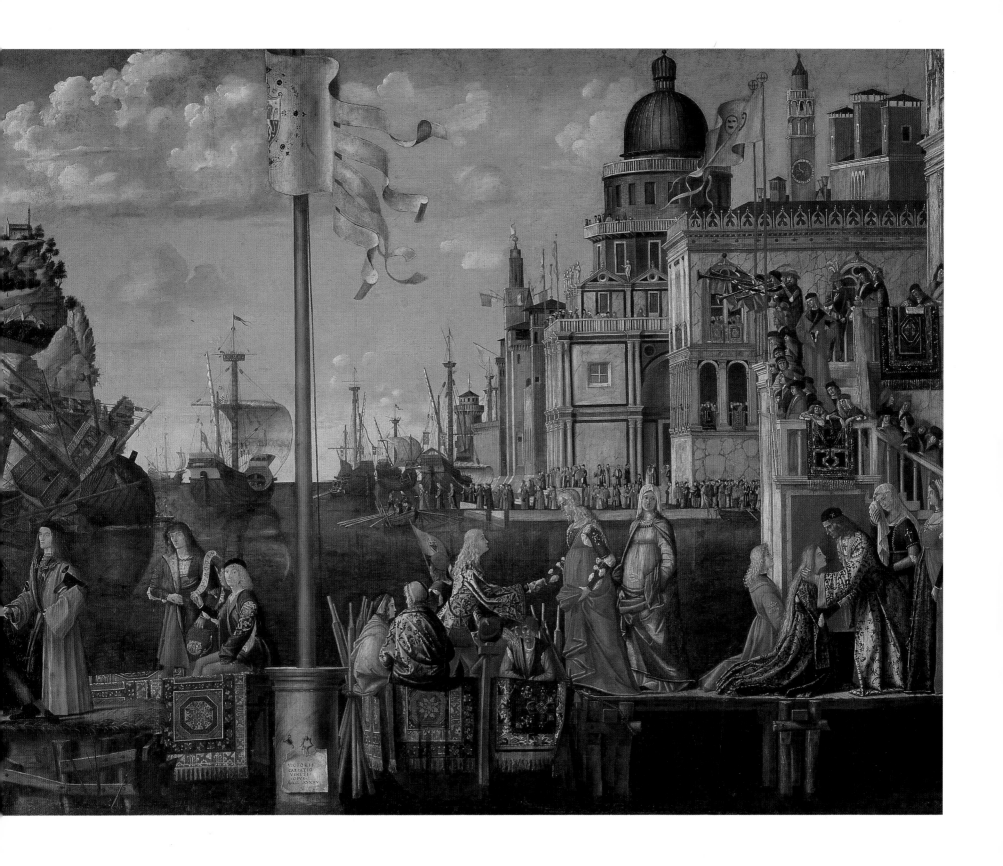

The Sea's Bounty

So the minute sea life becomes, in the dark, redoubtably visible, and the ship ploughs a deep furrow through miles of star dust — phosphorescence which will fill the last imaginative being as full of wonder and awe as it did the first who ever ventured out to sea.

William Beebe
From *The Arcturus Adventure*

*I*F THE OCEAN HAS BEEN an everlasting source of food, it has also provided an equally rewarding supply of aesthetic sustenance. Fishing of every sort has been a major theme of marine art from the first rock carvings to contemporary evocations, sometimes nostalgic, of a declining industry and tradition.

The magic of fishing is understandable; anyone who has felt the tug of a mackerel on a hand line can attest to the excitement generated by this gift from the sea. In the past, at least, the harvest seemed inexhaustible. While the work was difficult and dangerous, the nets were full and the trade sustainable. Codfish, for example, was a world-trade good linking Norway, Newfoundland, Italy and Portugal through a common foodstuff.

As fishing was at first an inshore occupation, the scale was less — smaller boats and smaller crews,

In his famous painting *The Herring Net*, Winslow Homer dramatizes the routine but essential work of hauling in a catch. He contrasts the shadowed fishermen and leaden sky with a light-washed sea and sparkling fish, which are painted with the quick, darting strokes reminiscent of his watercolors.

The Herring Net, 1885
Winslow Homer
Oil on canvas
73.3 x 120.2 cm. (28.5 x 47.3 in.)
The Art Institute of Chicago
Mr. and Mrs. Martin A. Ryerson Collection

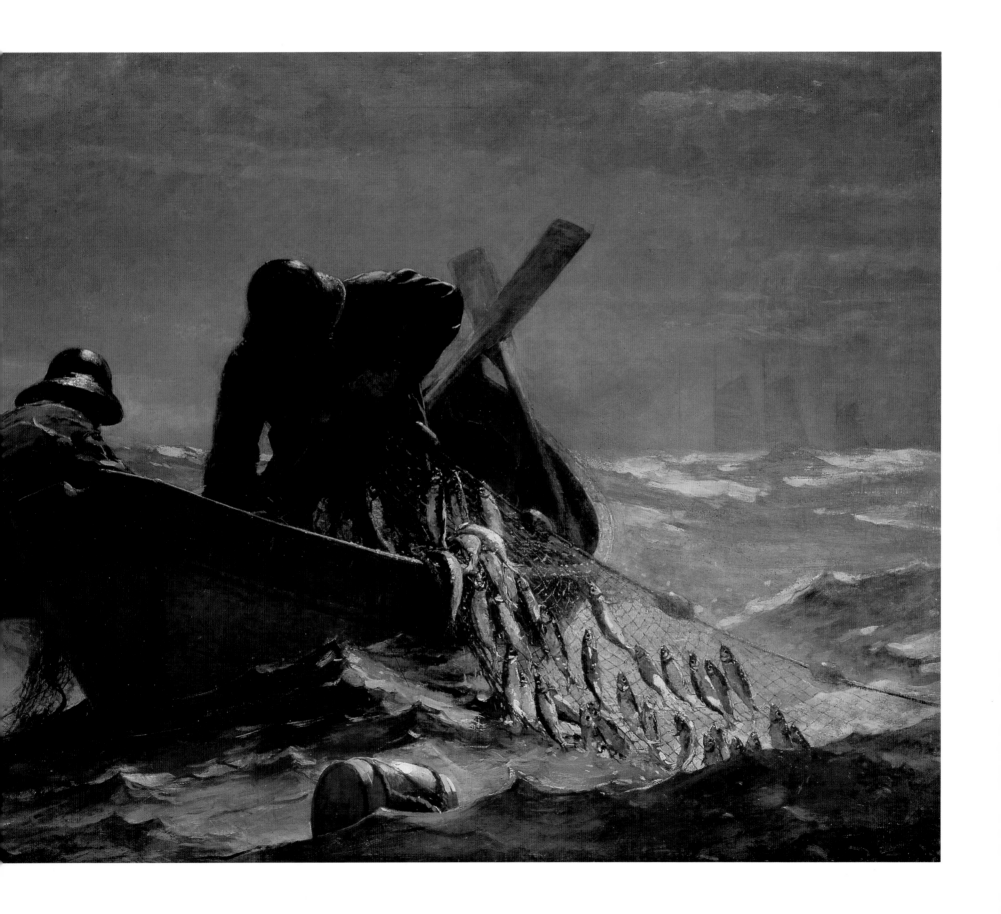

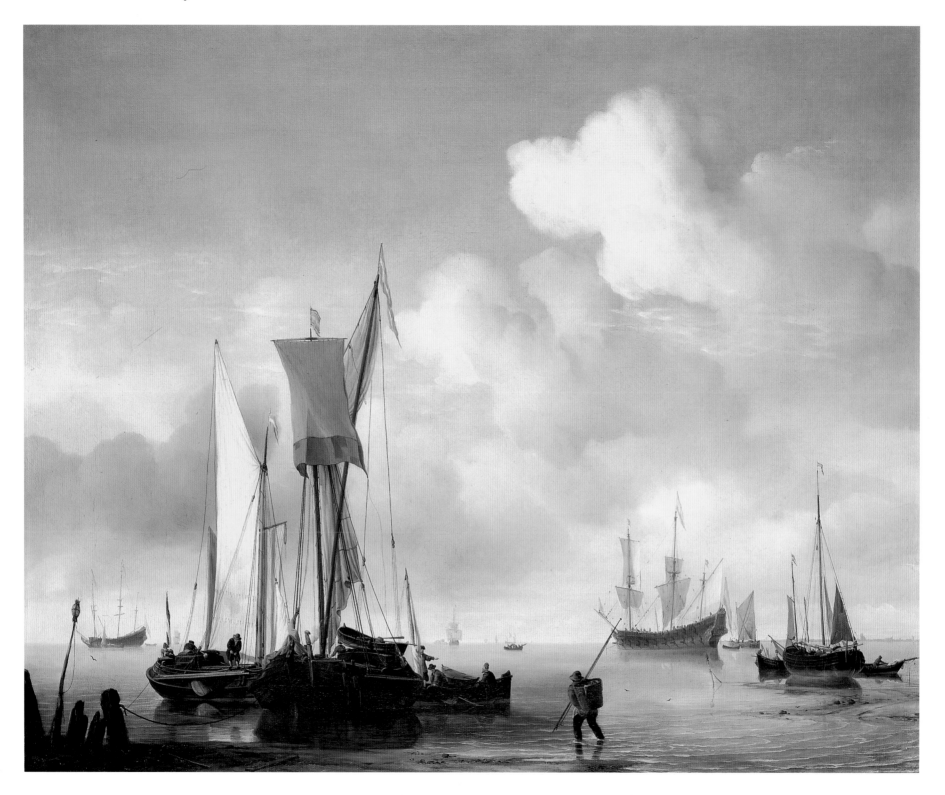

(left) An almost tactile sense of heat, stillness and heavy air is imparted by this painting of becalmed fishing boats. The painting's serenity, transmitted by careful brushwork, anticipates the atmospheric works of Turner.

(right) Workers gather oil in buckets from the carcass of a whale beached on a Dutch shore, while curious onlookers, some dressed in finery, watch the spectacle with seeming detachment.

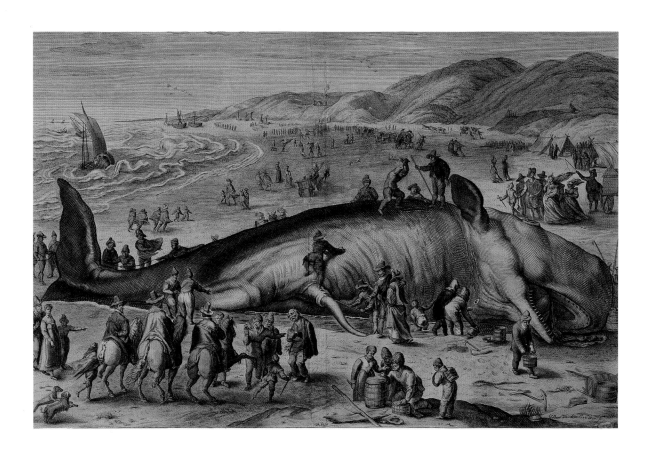

(left) *Fishing Boats Offshore in a Calm*, 17th century
Willem van de Velde the Younger
Oil on canvas
71.1 x 87.6 cm. (28 x 34.5 in.)
Museum of Fine Arts, Springfield, Massachusetts
James Philip Gray Collection

(above) *Stranded Whale on the Dutch Shore Near Katwijk, February 3, 1598*, 1684
Gilliam van de Gou Wen
Color engraving after a 1598 engraving
27.5 x 34.1 cm. (10.8 x 13.4 in.)
Peabody Essex Museum, Salem, Massachusetts
Photo: Mark Sexton

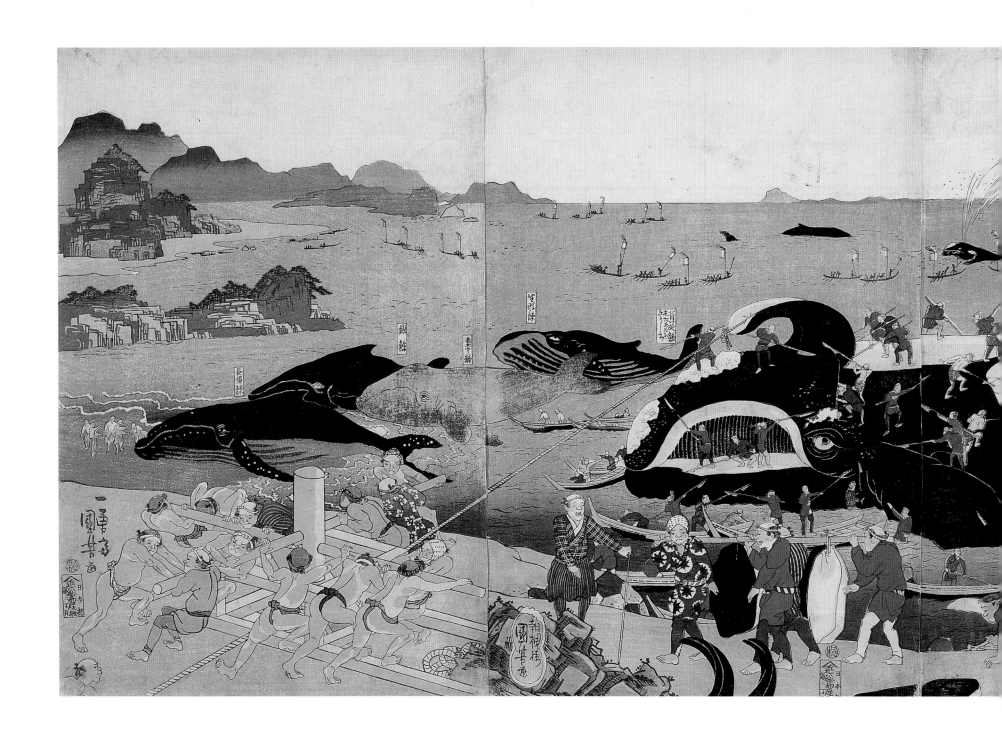

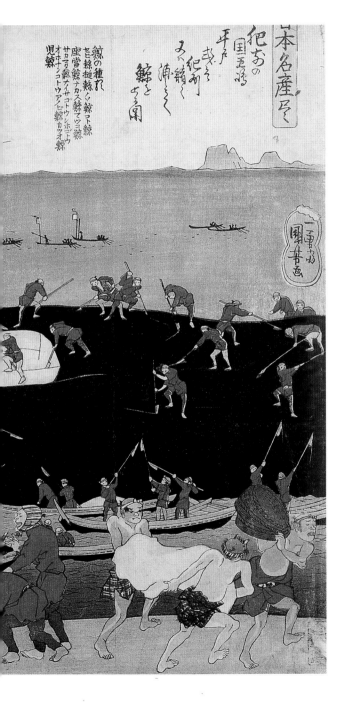

Catching Whales at Goto and Hirado, in Hizen Province, 1840
Ichiyusai Kuniyoshi
Woodblock, triptych, color on paper
36.8 x 76.8 cm. (14.5 x 30.25 in.)
Kendall Whaling Museum, Sharon, Massachusetts
Photo: Mark Sexton

like fishermen on the Grand Banks in their dory laden with herring, while the schooner from Gloucester, Massachusetts, or Lunenburg, Nova Scotia, hovers in the distance. The work often required the involvement of the entire community. In Norway's Lofoten Islands, for example, in spring during the cod season, the women of the village joined in cleaning and gutting, stacking and drying an enormous harvest of cod, and the water of the harbor ran as red as the traditional paint on the fishermen's houses. For many, an early model for ideal living was the saltwater farm where the men of the household were both fishers and farmers and the cycle of seasons determined the interactivity of gender and generation.

The hunt, however, became more ambitious, demanding both a technological and a social response. Ships ventured farther and longer for more-elusive quarry. Whaling took men to the opposite hemisphere in voyages of two and three years. Coastal fishing led to distant waters; the ships were constructed to venture into ice-laden seas, for example, in search of whales and seals from whose oil and skins fortunes could be made. On board, scrimshanders etched whale teeth and bone with images of the hunt, patriotic longing, and girlfriends left behind. Their lives were so

A scene of traditional 19th century whaling in Japan details how the giant mammals were pulled to shore with a windlass and then cut up for food and other resources. Whaling inspired some of Japan's greatest artists and printmakers to document what was then a leading industry.

The Sea's Bounty

much flotsam if the whale should turn to stave-in the boat or drag it under.

The skills required were as varied as the available bounty. Ingenuity devised methods for the gathering of coral, seaweed, pearls, sponges, lobster and eels. Migrating salmon were lifted from the rapids with nets. Shore-based seines dipped school fish as they moved in along the coast. Fish traps were constructed – in one wonderful instance leading sea bass to a holding pool just outside a restaurant's kitchen door. In Japan, cormorants were trained to dive for fish for sport. In the end, all this marine produce found its way to the market to be sold and consumed.

As with port life, fishing traditions encompass the full panorama of sociability. The fishing fleets were like villages at sea. Depicted against the salty, fog-enveloped background of mountain crag and wind-twisted trees, or passing to and from the inshore grounds in fulsome parade, the fleets can be seen as both fact and symbol of the coincident independence and interdependence of human endeavor. ❖

Vis. Vincitur. Arte, 1776
Anonymous
Oil
71.5 x 117 cm. (28 x 46 in.)
Altonaer Museum, Hamburg, Germany

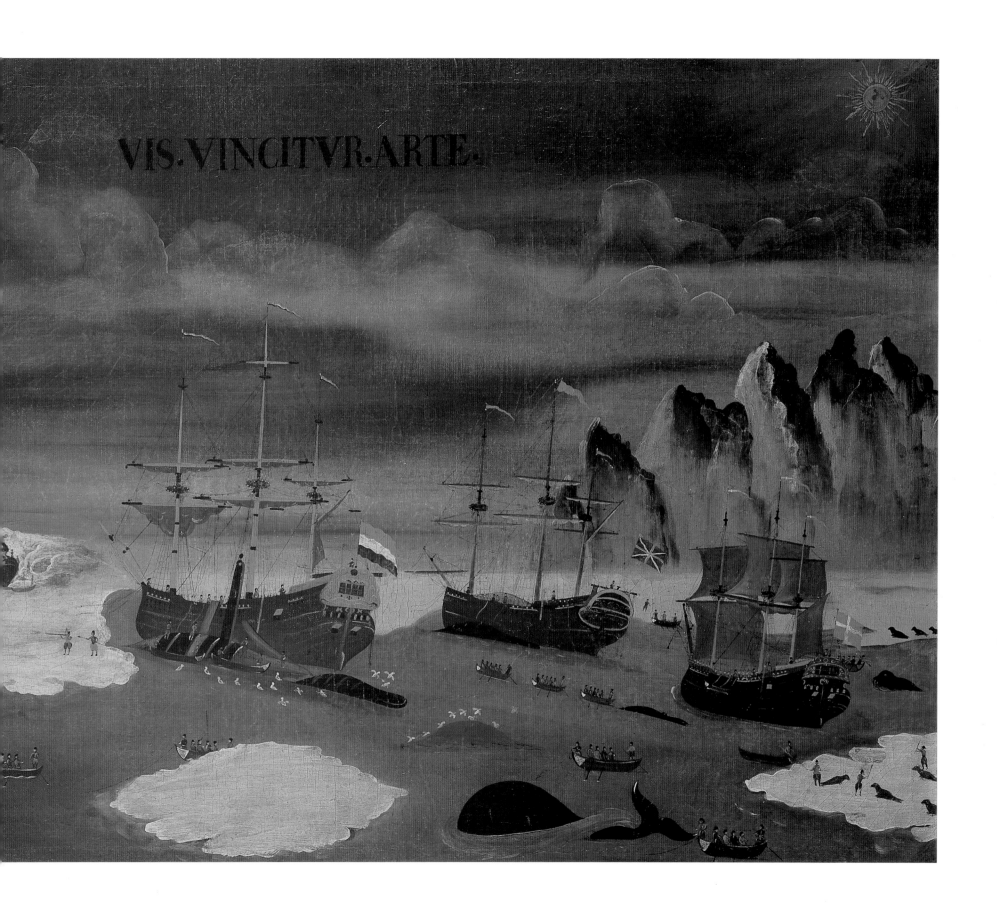

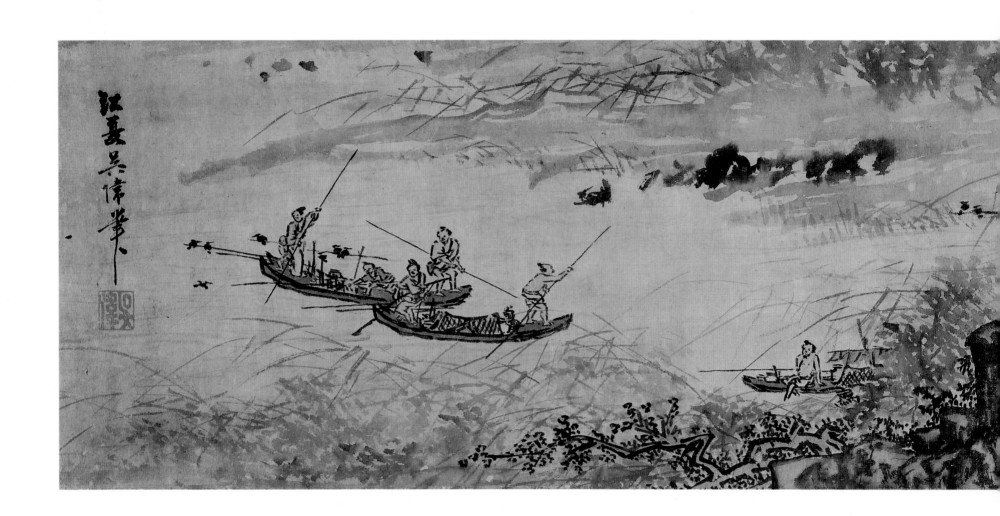

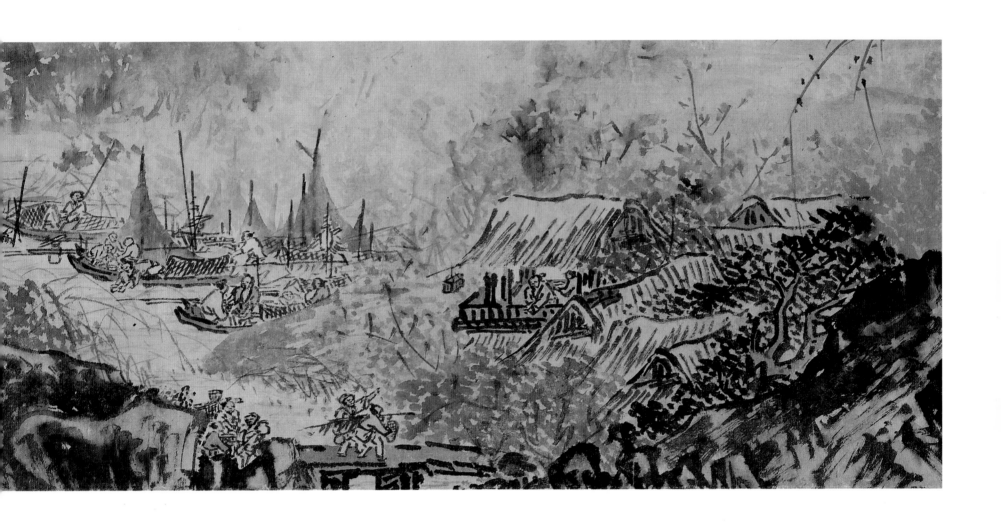

A myriad of fine brush strokes captures fishermen in shallow-draft boats pursuing a centuries-old pastime in China, where sport fishing was an integral part of society.

The Pleasures of the Fisherman, undated
Wu Wei
Handscroll: ink and light color on silk
27.3 x 223.2 cm. (10.75 x 87.9 in.)
University Art Museum
University of California at Berkeley
On extended loan from the Ch'ing Yüan-chai Collection

The Sea's Bounty

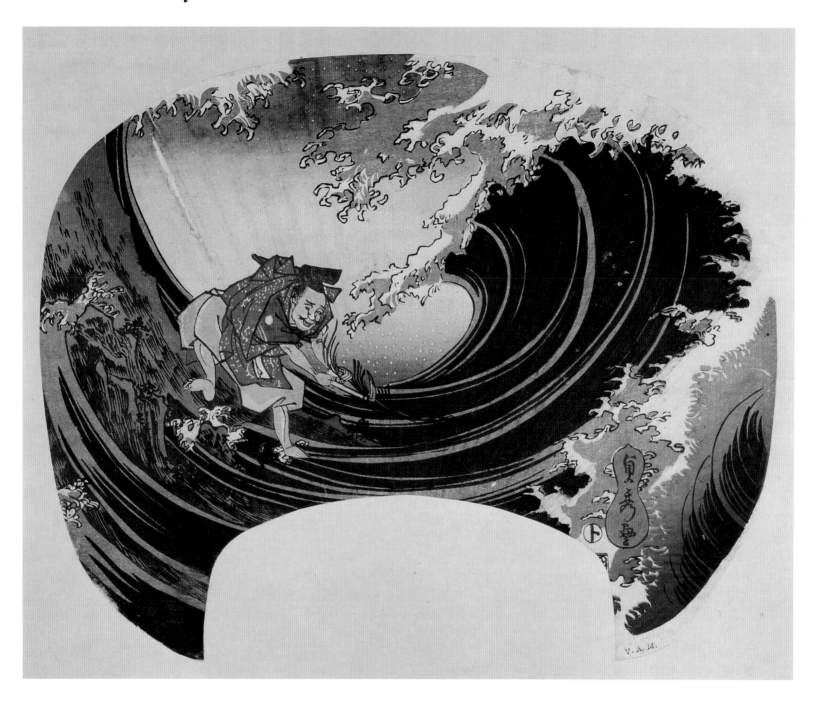

The Seaweed Gatherer, ca. 1850
Anonymous
Color woodcut, fan print
22.9 x 28.6 cm. (9 x 11.25 in.)
Courtesy of the Board of Trustees of the
Victoria and Albert Museum, London

In this highly unusual 19th
century Japanese work, the
artist used the shape of a
wooden fan to enhance the
swirling motion of the
waves, which seem about
to engulf the fisherman as
he gathers seaweed.

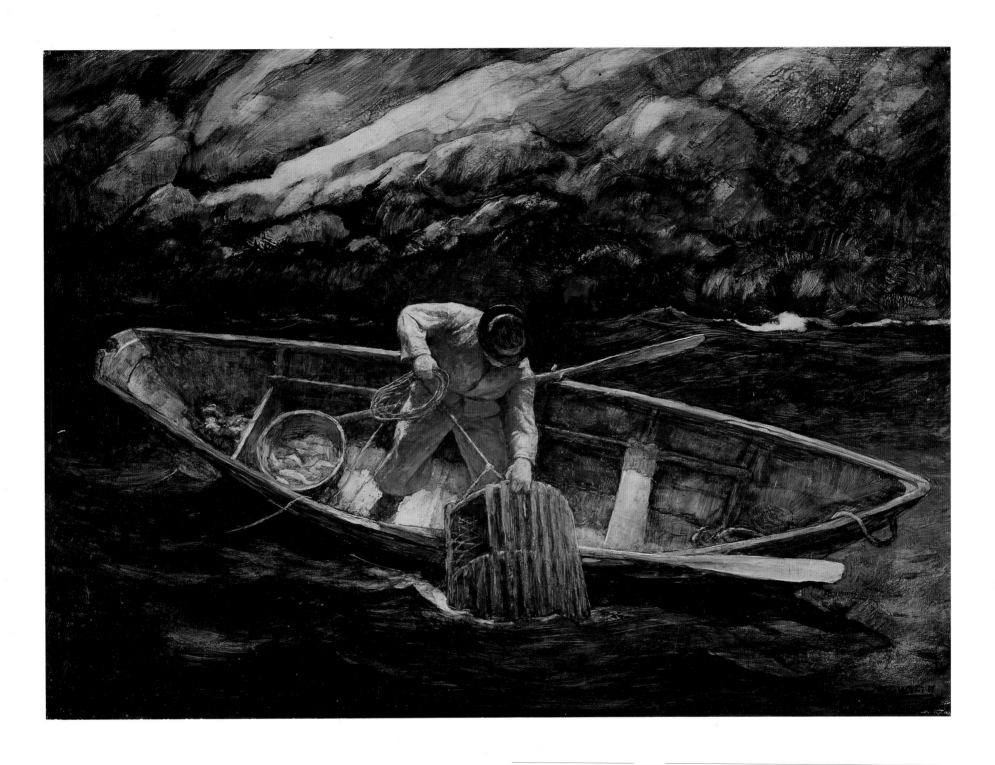

Lobster fishing along the chilly northeast coast of the U.S. is the subject of this powerfully realistic painting. Traps like the one shown here – still in use today – were deployed and retrieved year-round.

Deep Cove Lobster Man, 1938
N.C. Wyeth
Oil on gessoed board
41.3 x 57.8 cm. (16.25 x 22.75 in.)
Museum of American Art of the
Pennsylvania Academy of the Fine Arts, Philadelphia
Joseph E. Temple Fund

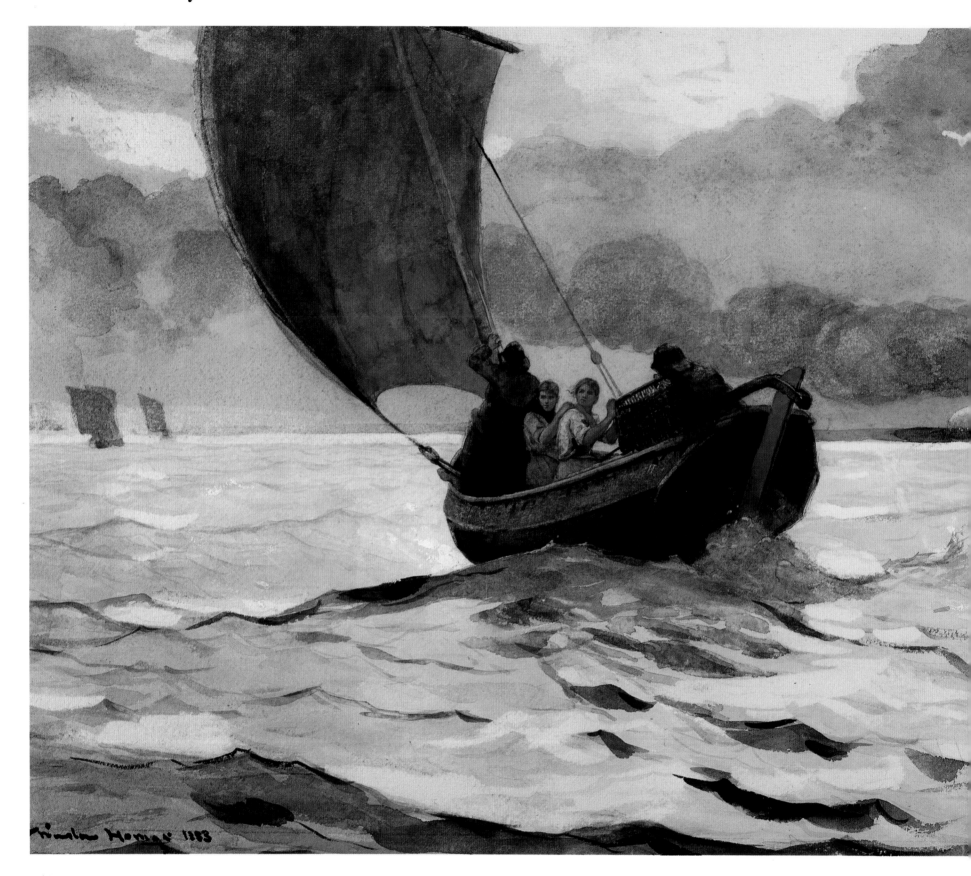

Two women and two fishermen in a small boat head for home beneath a lowering sky punctuated by a trail of smoke from a passing ship. The dark hull and sail of the fishing boat add a sense of melancholy that was probably intentional, since, for Homer, the sea was a primordial force that overwhelmed puny humans who dared sail on it.

Another scene of returning fishermen, from 16th century Norway, is highly stylized yet detailed in its depiction of fishing in the Norwegian Sea. As described by the artist, the man on the left has hooked a halibut and two cod.

(left) *Tynemouth, or Returning Fishing Boats*, 19th century
Winslow Homer
Watercolor and white gouache over graphite on white paper
40.3 x 62.9 cm. (15.7 x 24.8 in.)
Harvard Art Museums, Fogg Art Museum
Cambridge, Massachusetts
Anonymous gift

(above) *Natives of Norway Go Deep-sea Fishing*, ca. 1553
Olaus Magnus
Woodcut
5.9 x 9.3 cm. (2.3 x 3.6 in.)
Universitetsbiblioteket, Oslo, Norway

The Sea's Bounty

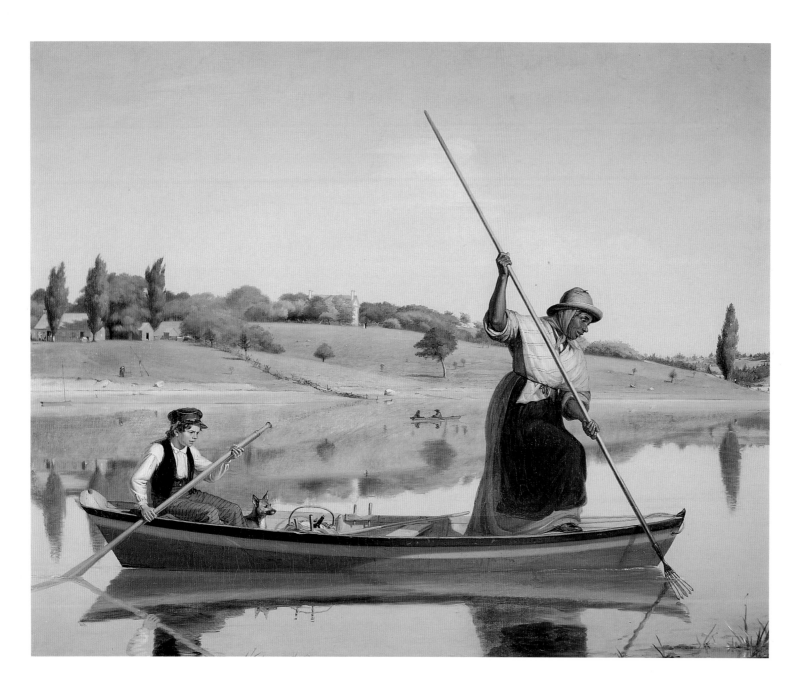

The concentration of the woman fishing for eel is evident, and the water is so clear and still that it mirrors the 19th century Long Island, New York, countryside. One of William Mount's masterpieces, it is also a significant record of a way of life long since vanished in the United States.

A giant whale crunches a whaleboat in its jaws and drives it beneath the surface in this illustration from Herman Melville's sea epic *Moby Dick*. In 1819, a sperm whale rammed and sank the square-rigged whaler *Essex*, inspiring Melville to invent Moby Dick and make a whale the centerpiece of his novel.

(left) *Eel Spearing at Setauket*, 1845
William Sidney Mount
Oil on canvas
72.4 x 91.4 cm. (28.5 x 36 in.)
New York State Historical Association
Cooperstown, New York

(right) Illustration from *Moby Dick*, 1929
Rockwell Kent
Pen and ink
The Rockwell Kent Legacies
Ausable Forks, New York

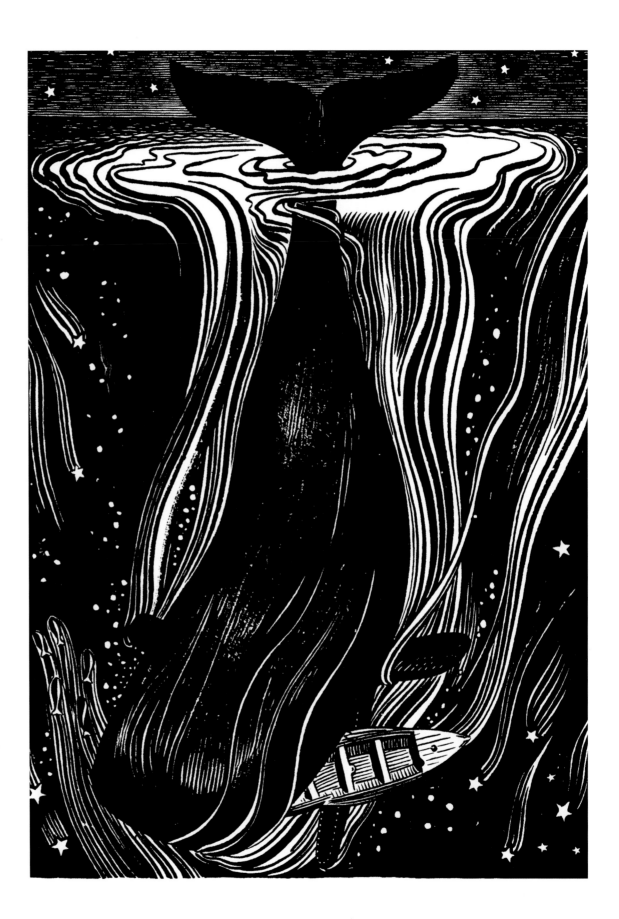

The Sea's Bounty

Fishermen engage in the hard work of stacking and cleaning salmon at a fish house in Race Point, on Nova Scotia's Bay of Fundy. Because harvesting of salmon by factory ships has endangered the species, the U.S., Japan and Denmark are helping meet global demand by breeding hundreds of millions of salmon in protected salmon farms.

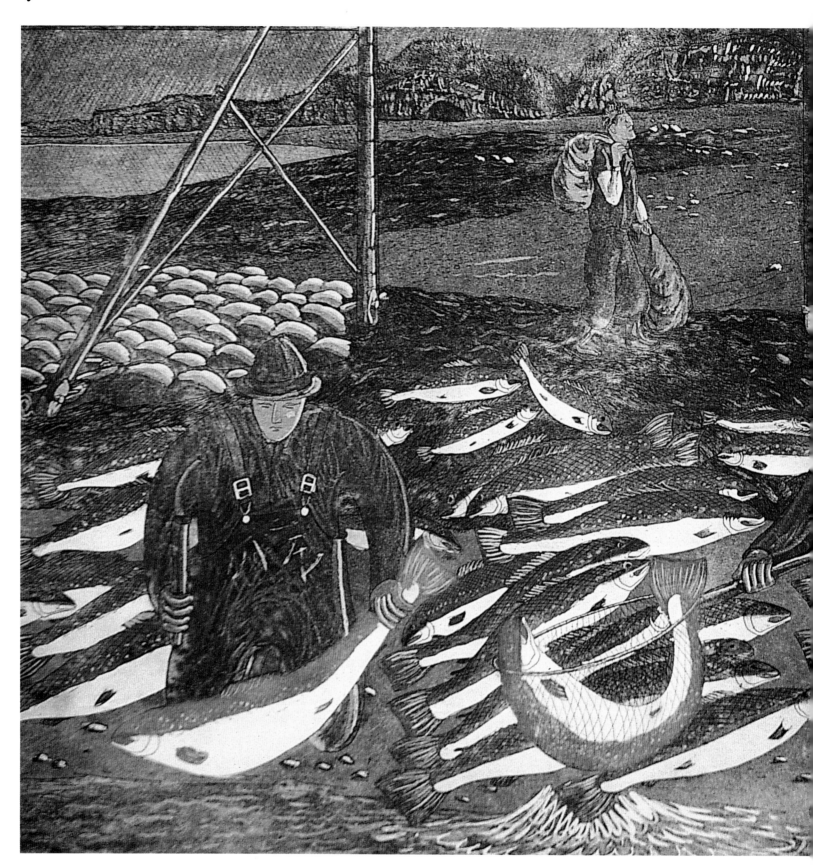

(left) *Salmon at Race Point*, 1993
John Neville
Etching, aquatint
45.7 x 61 cm. (18 x 24 in.)
Collection of the artist

(below) *Corallers in Plena Activitat*, 19th century
Manuscript-page engraving
Museu Marítim, Barcelona, Spain

In this engraving, Spanish divers called "corallers" use nets to gather coral from the seabed. This kind of fishing was hazardous, as divers worked without breathing apparatus. But coral was such a sought-after material in the 19th century – used for everything from jewelry to pharmaceuticals – that corallers were more than willing to take the risks.

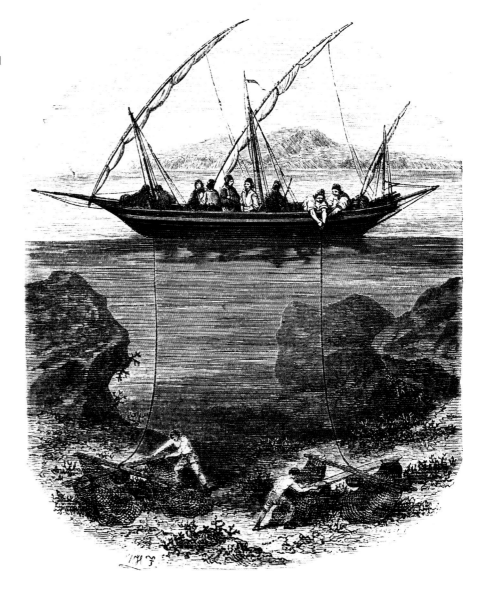

The Sea's Bounty

A fish market in Boulogne in the early 19th century is vividly brought to life by the fisherfolk in the foreground, while the sailboats that are their livelihood hover like ghosts in the middle-distance haze.

A Fish Market, Boulogne, 1824
Richard Parkes Bonington
Oil on canvas
81.3 x 122 cm. (32 x 48 in.)
Yale Center for British Art, New Haven, Connecticut
Paul Mellon Collection

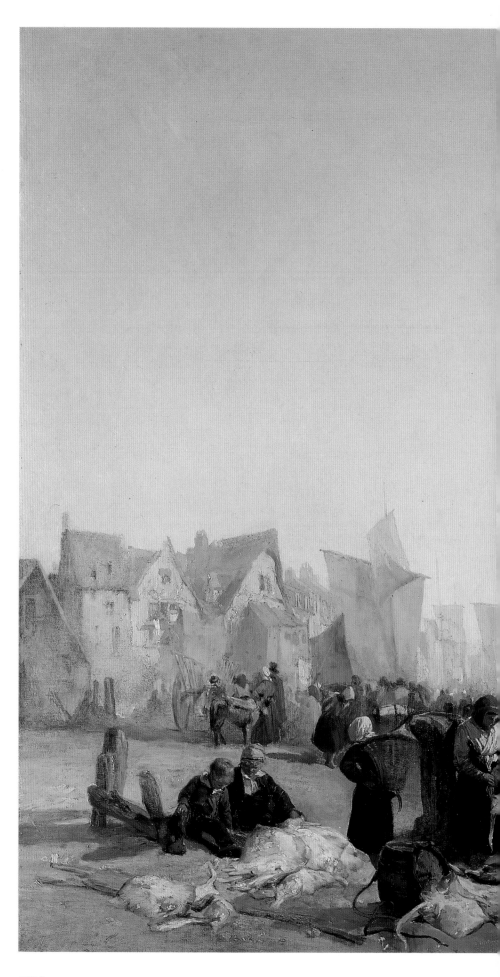

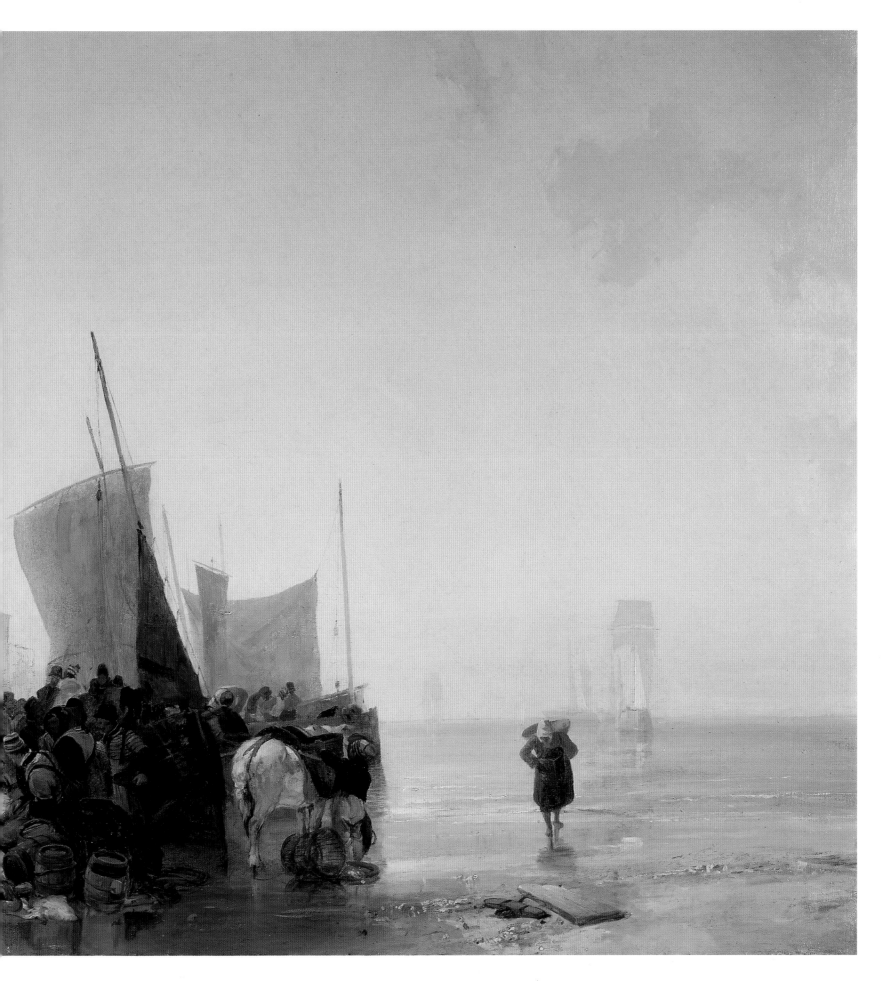

The Sea's Bounty

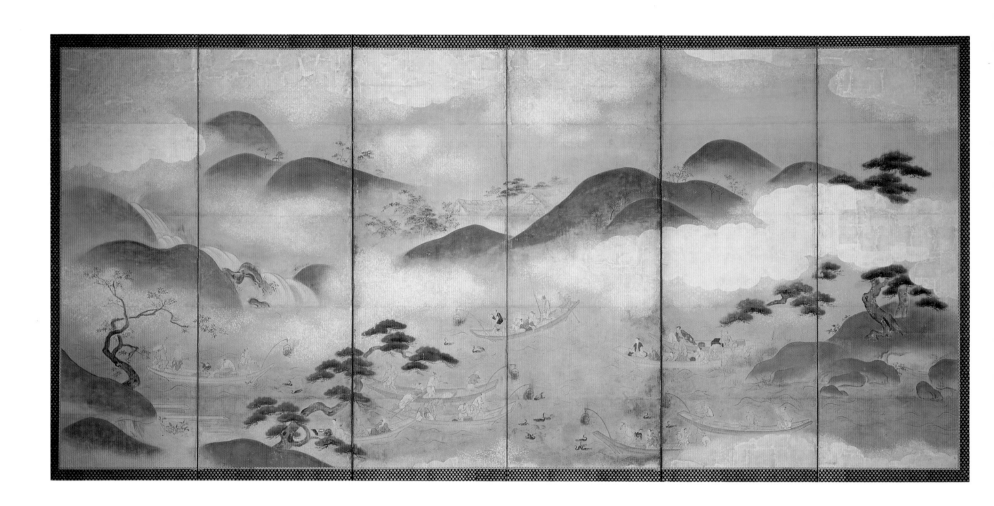

A highly organized sport in feudal Japan, *ukai*, or fishing with cormorants, is depicted on these 17th century screens with delicate, flowing brushwork. Cords around the birds' necks prevented them from flying off or swallowing the fish.

Fishing With Cormorants, 17th century
Kano Tannyu
Edo Period, pair of six-fold screens
Color on paper
Each screen: 164.8 x 364 cm. (64.9 x 143.3 in.)
Okura Shukokan, Tokyo

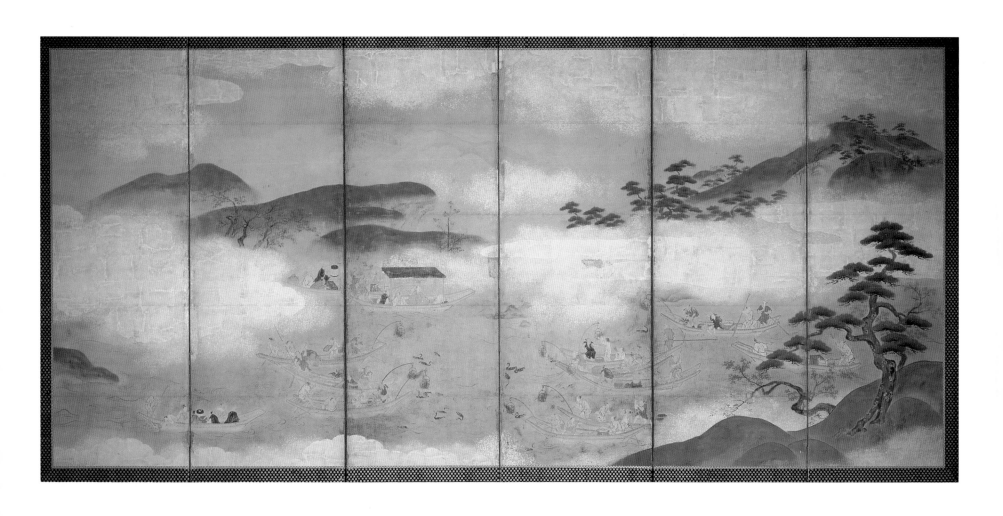

The Sea's Bounty

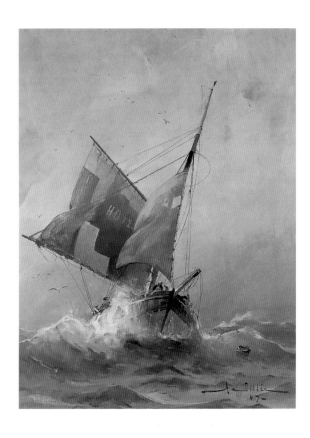

(left) A French fishing boat in a storm seems to hurtle at the viewer in this dramatic painting by the Swedish artist Gustaf af Sillén. He infuses the work with a naturalism that makes the sea come alive.

(above) *French Fishing Boat in High Seas*, 1907
Herman Gustaf af Sillén
Oil on canvas
57 x 74 cm. (22.4 x 29 in.)
Sjöhistoriska Museet, Stockholm, Sweden

(right) *An Afterglow*, 1883
Winslow Homer
Watercolor over graphite
38.1 x 54.6 cm. (15 x 21.5 in.)
Museum of Fine Arts, Boston, Massachusetts
Bequest of William P. Blake in memory of his mother,
Mary M.J. Dehon Blake

Considered by many art experts to be one of the most beautiful marine paintings, Homer's *An Afterglow* depicts two fishing boats anchored side by side. Their occupants are bathed in the golden hues of late-afternoon sunlight, at ease as they wind up a long day on the water.

The Fickle Sea

And now the STORM-BLAST came, and he
Was tyrannous and strong:
He struck with his o'ertaking wings,
And chased us south along.

Samuel Taylor Coleridge
From "The Rime of the Ancient Mariner"

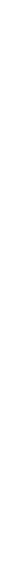

SEAMAN RIGHTFULLY FEAR the sea and its passions. The storm is their greatest source of danger, and thus marine art from all cultures depicts the horrors of shipwreck and loss — torn sails, broken spars, and terrified crewmen drowned and half-drowned along the rail. The dynamics of wind and wave are the most difficult challenge for the maritime artist to capture, and that energy and motion sets many marine pictures apart as aesthetic achievement from the more static considerations of landscape. Unlike the fixed composition of a portrait, still life or architectural view, the water is constantly in motion, changing its shape and color from one instant to the next. It implies a passage of time, the cause and effect of the moment depicted; it intimates a narrative before and after the coming of the foreboding cloud, black sky, and crack of

A sea monster sinks a ship in this 16th century Norwegian woodcut. Quaint superstitions today seemed very real to European mariners 400 years ago. In addition to storms and shipwrecks, they feared the unknown and filled unexplored ocean reaches with monsters.

Sea Monster Sinking Ship, ca. 1553
Olaus Magnus
Woodcut
5.8 x 9.4 cm. (2.3 x 3.7 in.)
Universitetsbiblioteket, Oslo, Norway

The Fickle Sea

lightning. The small boats abandon their work or idyllic sail and make for home across a sound suddenly, darkly placid.

Man-o'-war, clipper ship or whaler, in realistic, impressionistic or primitive style — the artistic effect of the vessel caught in a sudden, shifting progression of light is the same. Survival in question, the sailor calls upon all his superstitious beliefs, his religious credo, to implore for the safety of his craft. These prayers were not always answered, and the ship could founder, all hands lost to the voracious sea; or the ship, disabled by her damaged rig, could broach and be pounded to pieces by the waves before dismayed onlookers ashore. In the end, what would remain? An innocent ocean with no trace of the terrible drama of the night before. A wreck on the beach, the bones of a once-proud vessel, unseen by a lively schooner passing full and by.

What are the dangers? The storm. The reef. The shoal. The rogue wave. The iceberg. The lee shore. The survivors of shipwreck told incredible tales of rafts and clutched debris, of being attacked by relentless sun and thirst. In some cases, they endured beyond imagination. What were the chances of rescue? When the flare signaled wreck, those on shore would mobilize the lifeboats, brave the surf, and rig the breeches buoy to bring some souls safely to the beach. When the ship began to list, to sink by the bow, her hull ripped asunder, the passengers

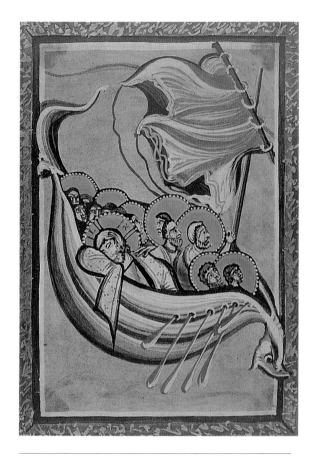

(above) *Storm at Sea*, 1020
"The Darmstadt Artist"
Color on parchment
Hessische Landes-und-Hochschul-Bibliothek, Darmstadt, Germany

(right) *A Storm Arises on the Sea When Khurshid is Deceitfully Sold into Slavery*, ca. 1560
Basawan, reign of Akbar
North India, Mogul Period
Opaque watercolor and gold on paper
20.2 x 13.4 cm. (7.9 x 5.3 in.)
San Diego Museum of Art, San Diego, California
Edwin Binney 3rd Collection

This work, dating from the 16th century Mogul Period in India, relates the tale of a storm suddenly rising when a princess named Khurshid was tricked and sold into slavery. Two of her abductors have been washed overboard, while others struggle with a sail.

184

The Fickle Sea

in their dinner clothes manned the boats; some jumped into the frigid water. The band played on, the crew did its duty, and the captain went down with his ship. The loss of the *Titanic* retains its powerful emotional hold on many who were not yet born at the time of its tragedy. It is a story of heroes and cowards, of achievement, pride and complacency, a still-vibrant metaphor for the conspiracy of circumstance. To this day, the news of such a loss is received with shock and disbelief.

The fickle sea sometimes gives back its victims. The women stand on the bluff, looking out toward a glowing sky, looking past the wreck to where they might glimpse a loved one in the waves, perhaps alive, perhaps something to bury and mourn. They cannot be certain that those shafts of light are signs of assured redemption. They know this: the painted ocean is the sea of mortality on which we sail with trepidation and hope. ✸

The Dutch Men-of-War Ridderscap *and* Hollandia
in a Storm in the Strait of Gibraltar, 1-3 March 1694
Ludolf Backhuysen
Oil on canvas
150 x 227 cm. (59 x 89.4 in.)
Rijksmuseum, Amsterdam

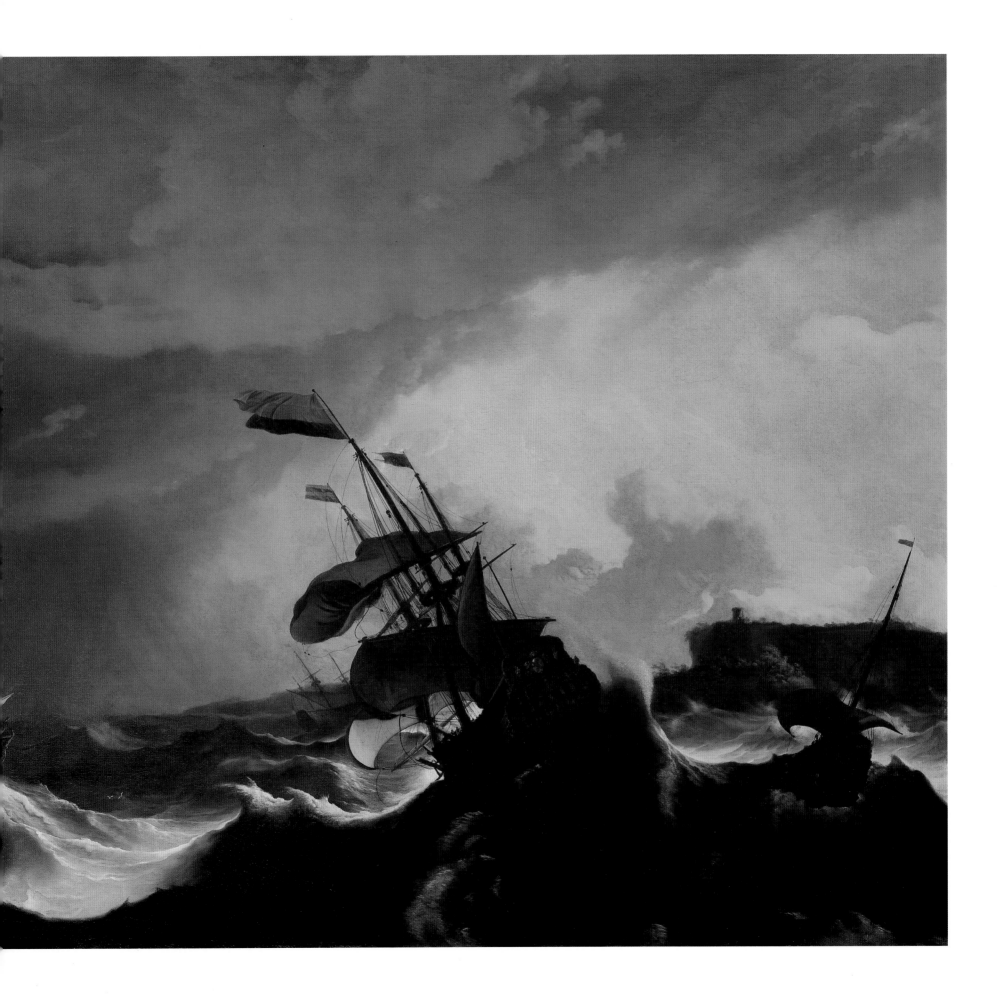

The Fickle Sea

An eerie calm pervades this painting of a thunderstorm rising over Narragansett Bay. Birds drift by, a sailboat is reflected in a black mirror of water – placid for the moment – and two boys stroll along the beach. All seem oblivious to the darkening sky, scored by a lightning bolt, that threatens a major storm.

Thunder Storm on Narragansett Bay, 1868
Martin Johnson Heade
Oil on canvas
81.6 x 102.5 cm. (32.12 x 40.37 in.)
Amon Carter Museum, Fort Worth, Texas

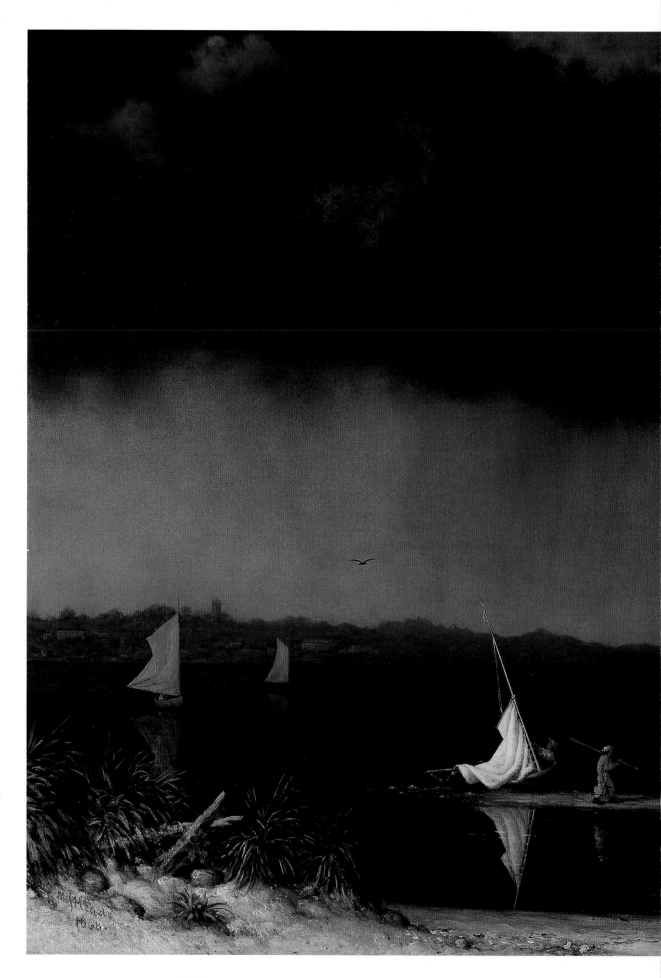

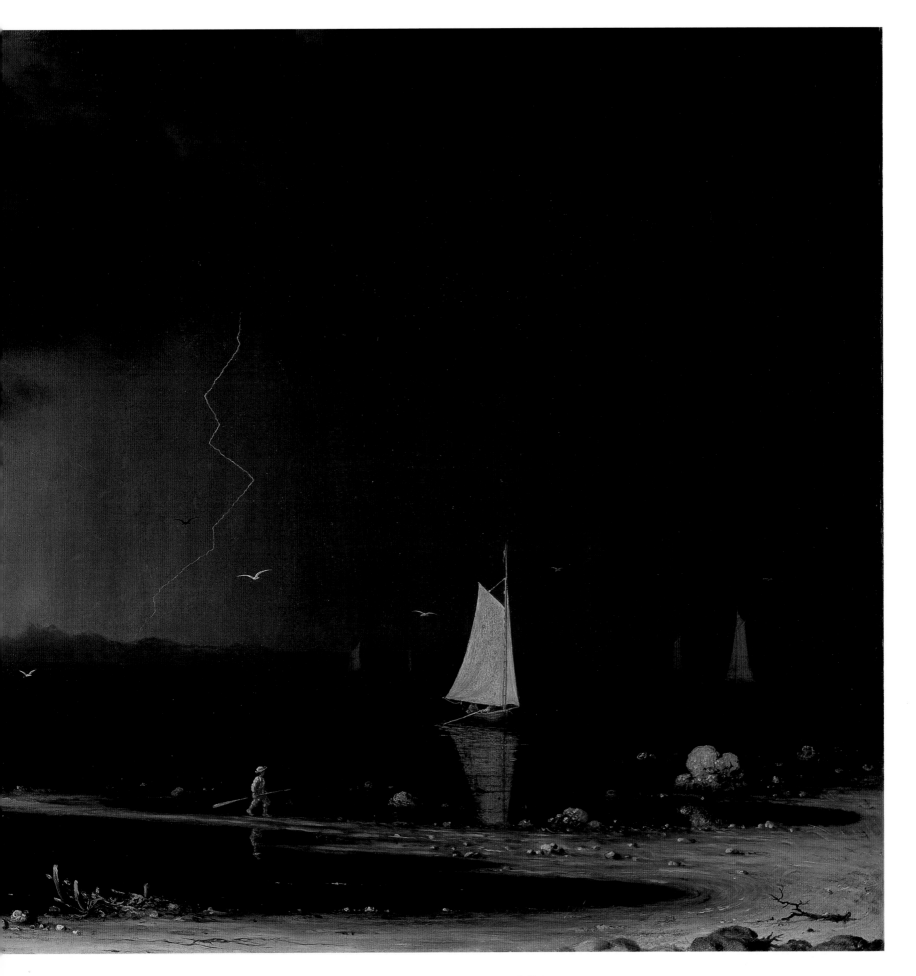

The Fickle Sea

Clipper Eagle *in a Storm*, ca. 1850
James Edward Buttersworth
Oil on canvas
51.4 x 76.5 cm. (20.25 x 30.12 in.)
South Street Seaport Museum, New York

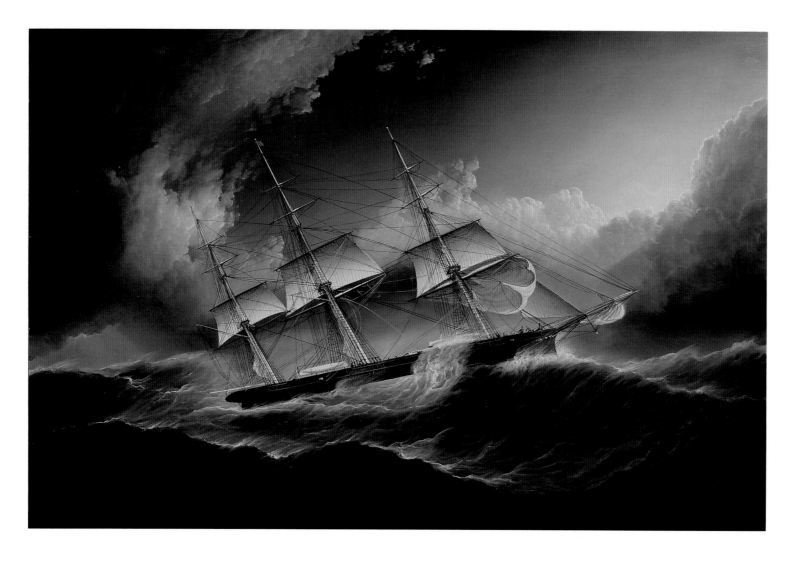

(left) Battling a storm, the American clipper ship *Eagle*, her mainsails reefed, slices through the waves. Even these swiftest of sailing ships on the seas in the mid-19th century were no match for Mother Nature, as many were lost in storms.

(right) This work by Henri Rousseau depicts the French cruiser *D'Entrecasteaux* struggling through towering waves. With broad, bold brush strokes Rousseau captures the unvarnished power and fury of a storm at sea.

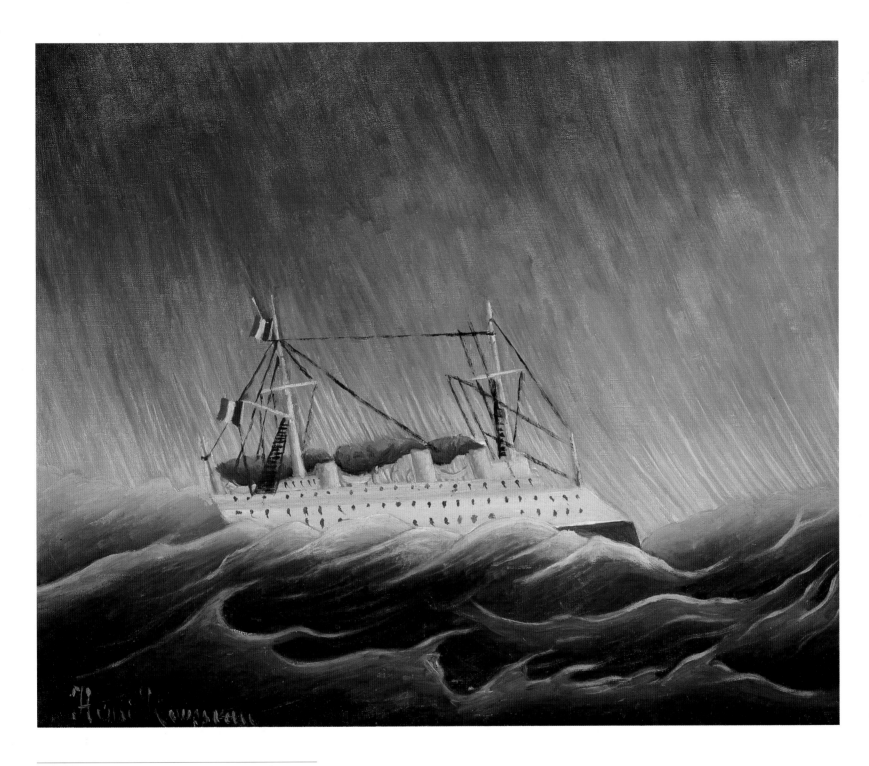

D'Entrecasteaux *dans la Tempête*, 1890-1891
Henri Rousseau
Oil on canvas
59.9 x 71 cm. (23.62 x 28 in.)
Louvre, Paris
J. Walter-P. Guillaume Collection
© Photo: R.M.N.

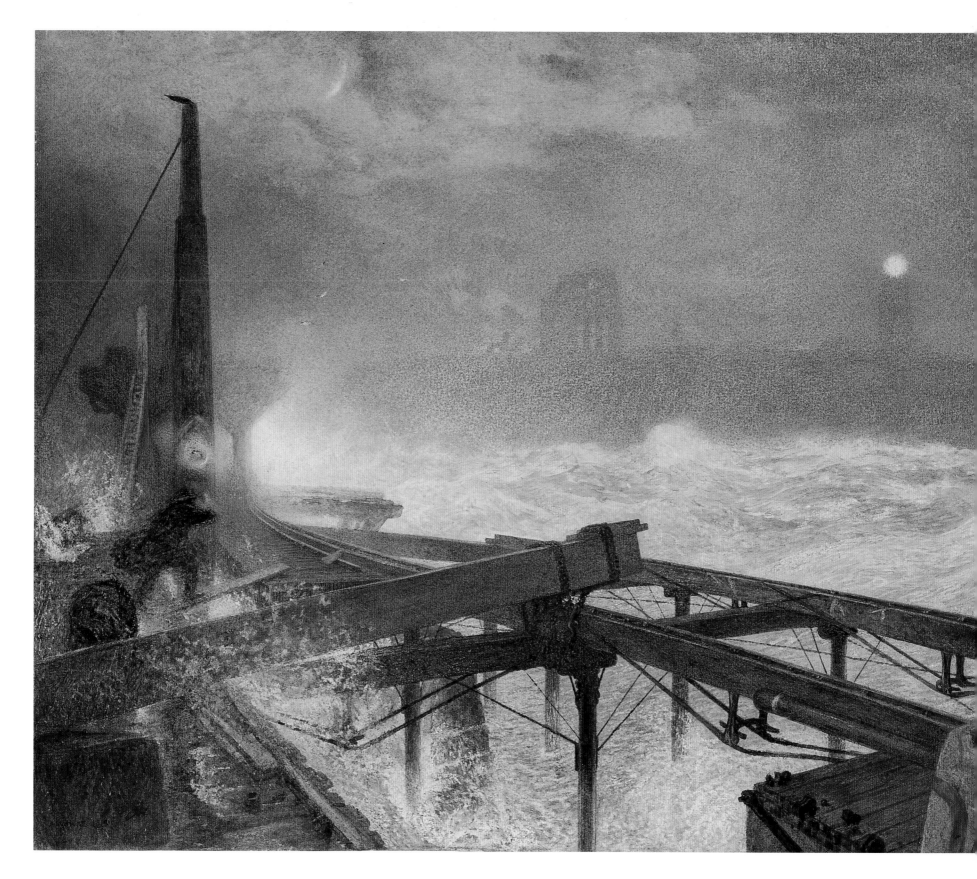

(left) Waves crash against a breakwater construction site illuminated by the baleful eye of a lighthouse as a lone figure braves the storm to light a lamp. When the painting was shown in 1868, a critic marveled: "The artist exhibits a startling sense of the tremendous in-roll of the water, its weight and terrible force."

(below) Wind rips the mainsail as mariners beseech Saint Nicholas for help. Floating in a clear, star-filled sky, he disperses the tempest.

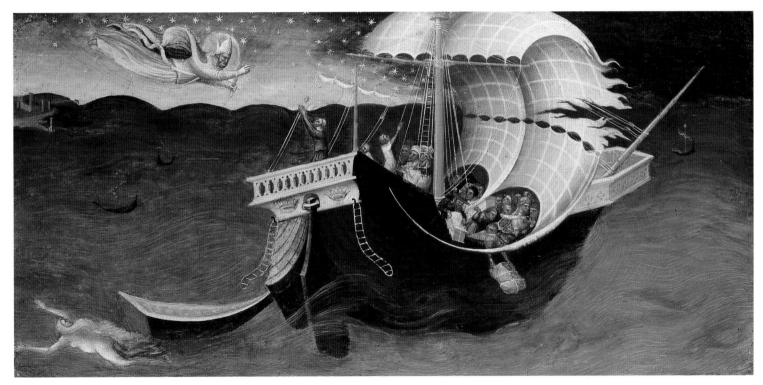

(left) *Blue Lights, Tynemouth Pier – Lighting the Lamps at Sundown*, 1866-1868
Alfred William Hunt
Watercolor, bodycolor, scratching and sanding out on wove paper
37.2 x 53.8 cm. (14.62 x 21.18 in.)
The Yale Center for British Art, New Haven, Connecticut
Paul Mellon Fund

(above) *Saint Nicholas of Bari Rebuking the Storm*, 1433
Bicci di Lorenzo
Oil on altarpiece panel
28.59 x 59.2 cm. (14.6 in. x 21.2 in.)
Ashmolean Museum, Oxford, England

The Fickle Sea

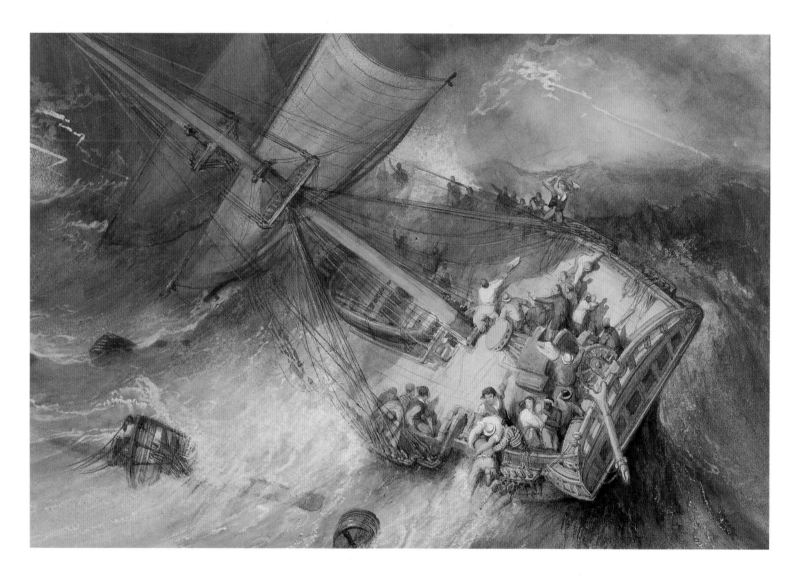

(left) This extremely powerful sea-catastrophe painting captures the *Circassian* about to capsize in a gale. Its crew, in a desperate attempt to save the ship, cuts away the shrouds holding the masts.

(right) The *Dutton* was carrying British troops bound for the West Indies when she was wrecked during a gale in Plymouth Sound in 1796. Through the heroic efforts of naval officer Edward Pillow, a lifeline was secured to the sinking ship and all but four of the soldiers were saved. The artist's knowledge of the sea and ships added to the realism of the painting.

Cutting Away the Masts, 1836
Clarkson Stanfield
Pencil, watercolor, bodycolor
and surface scratching on paper
26.1 x 38.8 mm. (10 x 15.3 in.)
The Whitworth Art Gallery
The University of Manchester, Manchester, England

The Wreck of the East Indiaman Dutton
at Plymouth Sound, 26th January 1796, 1821
Thomas Luny
Oil on canvas 76 x 112 cm. (30 x 44 in.)
National Maritime Museum, London

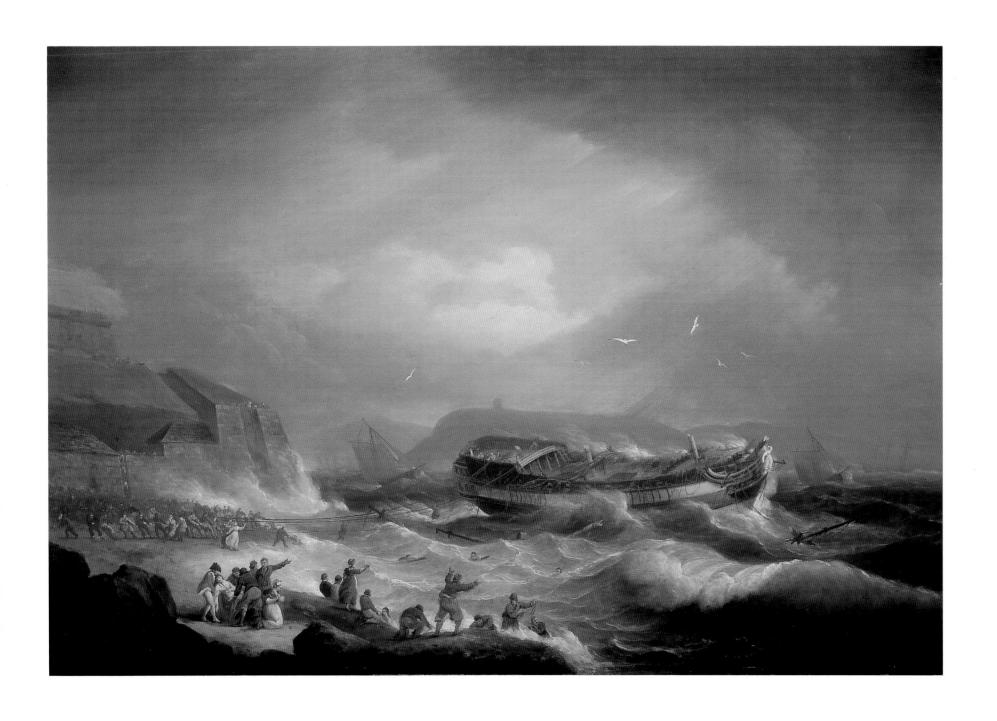

The Fickle Sea

A bare skeleton jutting from the sand is all that remains of the once-proud schooner *Progress*. She foundered in 1874 off Coney Island, New York, on the Fourth of July, America's Independence Day. Offshore, another vessel heads to sea, oblivious of the beached wreck.

Schooner Progress *Wrecked at Coney Island, July 4th 1874*, 1875
Francis Augustus Silva
Oil on canvas
51.1 x 96.8 cm. (20.12 x 38.12 in.)
Manoogian Collection, Taylor, Michigan

The Fickle Sea

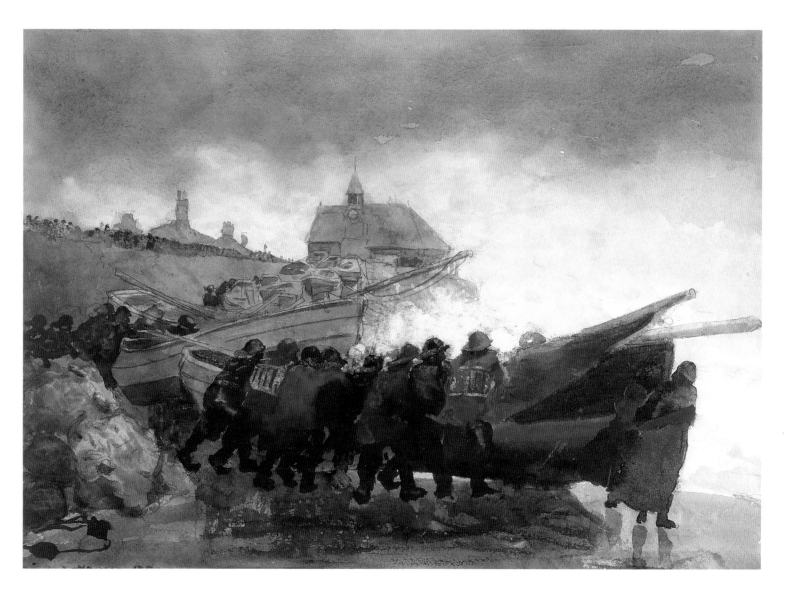

(left) Huddled forms, anonymous in their oil-skins, wait to push long-boats out into a stormy sea. As with many of the marine works that made Homer famous, this one of rescue teams, painted under the brooding skies for which Tynemouth, England, is known, pits fishermen against an elemental force much stronger than themselves.

(right) Homer witnessed firsthand a rescue using a breeches buoy like the one shown here. He charged the event with high drama by obscuring the face of the rescuer with a wind-blown scarf, and dangling the two figures over huge waves. He produced a number of versions of this popular painting, including one with the figures reversed. Perhaps bowing to public sentiment, he called the new work *Saved*.

(left) *Watching the Tempest*, 1881
Winslow Homer
Watercolor over graphite on white paper
35.3 x 50.3 cm. (13.7 x 19.6 in.)
Harvard University Art Museums, Cambridge, Massachusetts
Bequest of Grenville L. Winthrop

(above) *The Life Line*, 1884
Winslow Homer
Oil on canvas,
73.7 x 114.3 cm. (29 x 45 in.)
Philadelphia Museum of Art, Philadelphia, Pennsylvania
George W. Elkins Collection

The Fickle Sea

Shore of the Turquoise Sea, 1878
Albert Bierstadt
Oil on canvas
107.3 x 163.8 cm. (42.25 x 64.5 in.)
Manoogian Collection, Taylor, Michigan

The Sinking of the Titanic, 1966
James Dixon
Oil on paper
55.9 x 74.9 cm. (22 x 29.5 in.)
The Anthony Petullo Collection
of Self-Taught and Outsider Art
Milwaukee, Wisconsin

(left) The awesome power of the sea is depicted in an unusual way in the curl of a beautiful, turquoise wave, which carries in its wake a mast sundered from a sailing ship, while flotsam already dots the beach.

(right) In this composition by Irish artist James Dixon, bodies fall through the air like bright sparks, making palpable the sinking in 1912 of the *Titanic*. The disaster occurred when the "unsinkable" liner struck an iceberg while on her maiden voyage from Southampton to New York.

The Fickle Sea

(left) A peculiarly whimsical air pervades this piece of marine art from Thailand. While a deity smiles down from the sky, sailors, pieces of their ship floating around them, are devoured by sea monsters.

(right) Desperate sailors hail a distant ship in *The Raft of the Medusa*. The huge painting is based on an actual 19th century shipwreck in which mutiny, insanity and cannibalism unfolded during the tragedy.

Prince Janak Shipwrecked, late 18th century
Mahabuddhagunam
Pali (Thai workmanship)
Detail of paper folding-book
60 x 19 cm. (23.6 x 7.5 in.)
The British Library, London

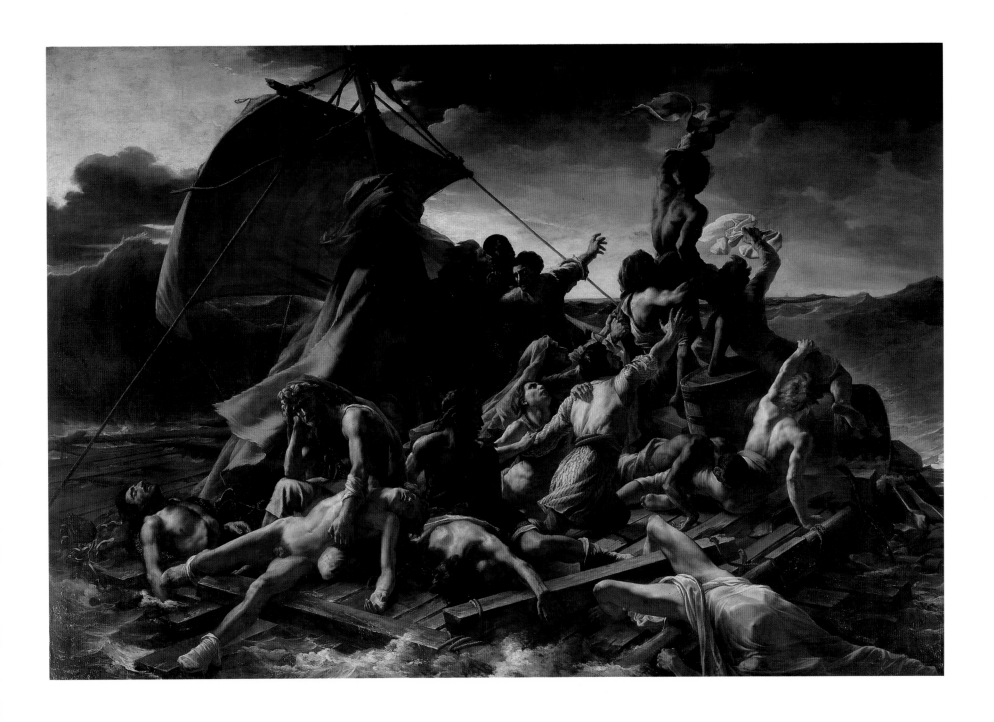

The Raft of the Medusa, 1818-1819
Théodore Géricault
Oil on canvas
4.87 x 6 m. (16 x 20 ft.)
Louvre, Paris
© Photo: R.M.N-Arnaudet

The Fickle Sea

Sunlight breaks through
the clouds as a group of
women watch a ship
founder on rocks off the
coast of Ireland. The paint-
ing tells its story through
the women, who are help-
less to assist and who don't
know if their loved ones
are alive or dead. Two sur-
vivors climb up the rocks
behind them – a touch that
adds a special poignancy
to the work.

Shipwreck, Coast of Ireland, 1926
Rockwell Kent
Oil on canvas
71 x 111.7 cm. (28 x 44 in.)
The Rockwell Kent Legacies
Ausable Forks, New York

A Revolution Called Steam

Just as you stand and lean on the rail, yet hurry with the
swift current, I stood and was hurried,
Just as you look on the numberless masts of ships
and the thick-stemm'd pipes of steamboats, I look'd.

Walt Whitman
From "Crossing Brooklyn Ferry"

THE IMAGE OF THE MACHINE** transformed marine art which, like the rest of the world changed by the inexorable effect of mechanization, lost its sense of the pastoral. The invention of the steam engine forever mutated ships, from majestic arrangements of wood, white sails and light to awkward structures of metal, smoke and dark. It was appropriate that when Admiral Perry steamed into Tokyo Bay and brought the seeds of the Western industrial revolution, his vessels were called "black ships."

This technological advance, of course, brought great utility: even larger vessels—constructed first from riveted iron and then from welded steel—faster speeds, greater reliability in the face of adverse weather, larger holds, bigger cargoes, greater return on investment. This progress, from patent drawing to behemoth carrying 2,000 passengers at 15 knots,

The Japanese artist who painted Commodore Matthew Perry's "black ship" on its arrival in Japan in 1853 added an oversized, sinister-looking figurehead. He was more accurate in depicting its smoke-belching stack and giant paddlewheel—a reflection, perhaps, of Japan's keen interest in Western technology at the time.

Perry, Matthew Calbraith, Commodore,
U.S.N., Expedition to Japan (detail), 1853
Anonymous
Color print
Size of whole: 33 x 50 cm. (13 x 18.5 in.)
The Mariners' Museum, Newport News, Virginia
Carl H. Boehringer Collection of Japanese Prints

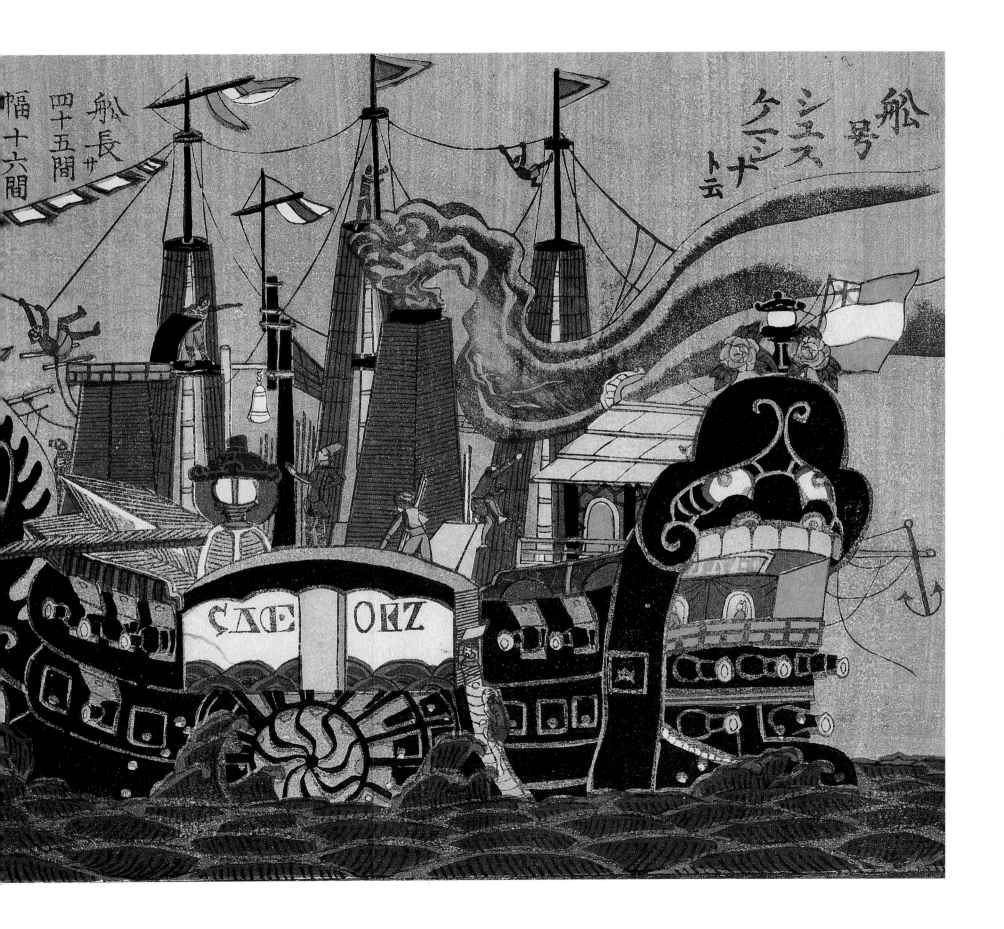

was astonishingly rapid; and its momentum so dis-
placed the sail-powered vessel that the world fleet,
once ubiquitous, sails drying in the harbors of every
nation, was reduced in a few decades to near aban-
donment, rotting hulks in backwater graveyards, at
deteriorated piers, or in the artifact collections of a
small number of marine museums.

The new ships at first were clumsy hybrids,
with stacks and masts, propellers and sails. That
moment, however, was brief, and soon steamships
of numerous styles and varieties of propulsion
pushed their bows up frozen, once impassable
rivers and tramped across every ocean. Some were
beautiful in their own right: the double sidewheelers
with walking beam engines and graceful longi-
tudinal supports, for example, or the greatest of the
great liners with their raked funnels, engineered
design and elegant furnishings. Ironically, these
vessels, too, were soon to be displaced by the rail-
road and the airplane, the modern container ship
and the supertanker. The old ships were often towed
out, burned and scuttled.

Sic transit gloria mundi.

A Revolution Called Steam

Not really so. Just when sentiment threatens to overwhelm us with a lament for ships gone by, another technology appears and maritime endeavor finds its next cunning iteration. Floating oil platforms, bridges, tunnels. Hovercraft. Powered drydocks. Catamarans. Roll-on/Roll-off ships. Car transports. Hydrofoils. Submersibles that permit us to explore the depths. Fish factory ships. Nuclear-powered, missile-carrying submarines. These vessels affirm the ongoing compulsion to exploit the oceans for knowledge, defense, food and commerce. The need remains while inevitably the technology changes.

Maritime art has not been well-served by this technological evolution and complexity. Paintings have become more precise, more illustrative, as if they must compete with photography. Many modern works are nostalgic, banal, and betray a noble tradition. Those looking for modern evocations of the sea, those in search of today's painted ocean, should also look beyond the circle of contemporary marine artists to find the open sensibility required to capture the sea. ✿

The Building of the Great Eastern, 1857
John Wilson Carmichael
Watercolor over graphite
21.7 x 32 cm. (8.5 x 12.6 in.)
National Maritime Museum, London

The *Great Eastern*, shown here in dry dock on the Thames in 1854, was a startling foretaste of modern ship design. She could carry more than 2,000 passengers. Power was provided by two paddlewheels and a 7-meter (24-foot) propeller, which together drove the leviathan through the water at a speed of 15 knots. But she also carried sails on six masts — an indication that her owners still did not trust steam.

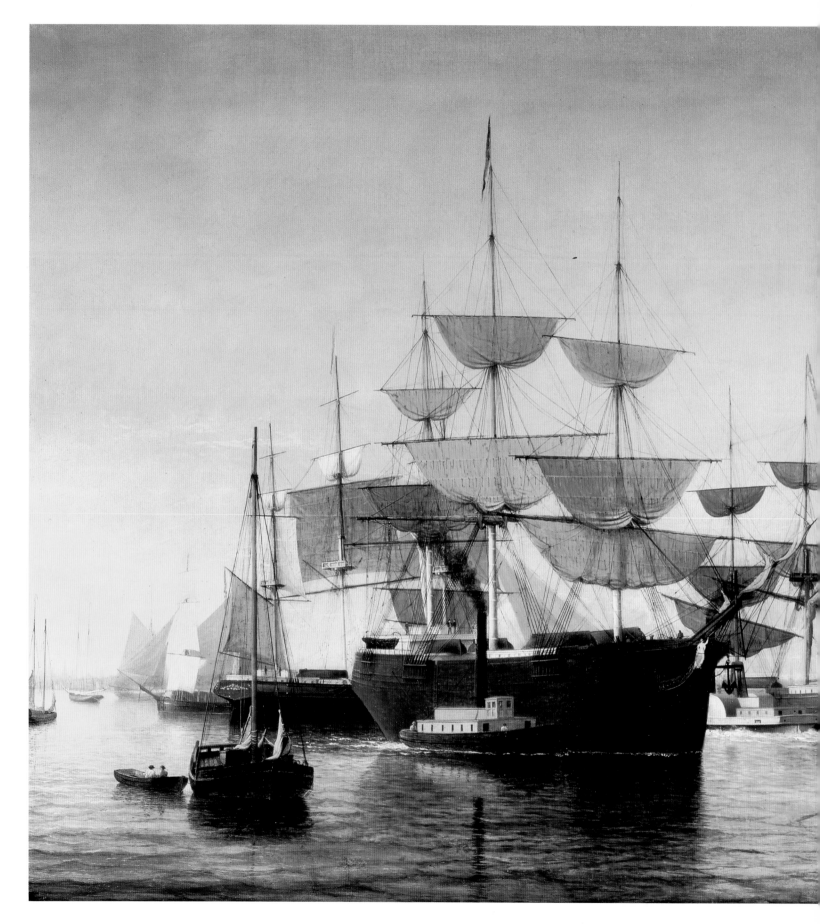

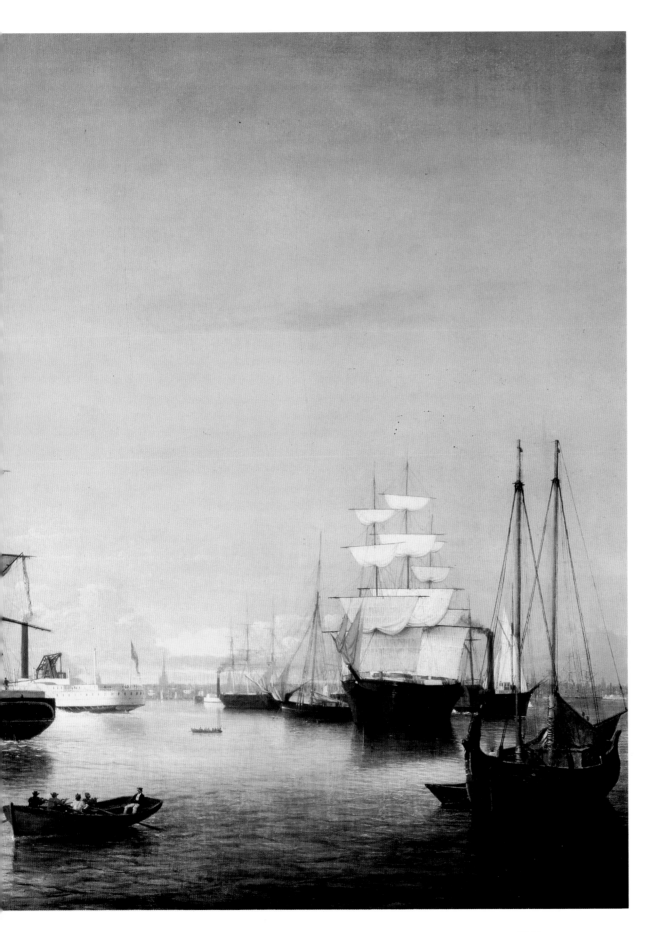

Fitz Hugh Lane, one of America's foremost marine artists, produced this exceptional view of New York Harbor as it appeared in 1860. Of particular note are the signs of change: a traditional brig pushed by a steam-powered paddle-wheeler, and a large merchant ship maneuvered by a propeller-powered vessel that resembles the tugboats in use today.

New York Harbor, 1860
Fitz Hugh Lane
Oil on canvas
91.4 x 152.4 cm. (36 x 60 in.)
Museum of Fine Arts, Boston, Massachusetts
Bequest of Martha C. Karolik for the
M. and M. Karolik Collection

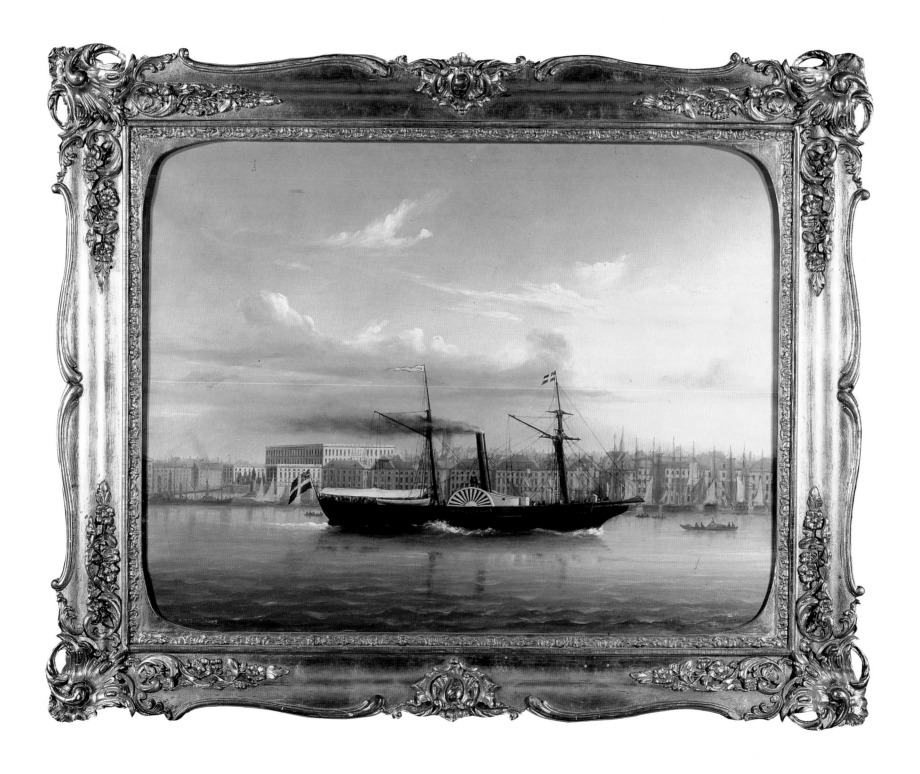

(left) The Swedish paddle steamer *Norrland* is pictured in the port of Stockholm in the 19th century. The ship was built in 1873 and was powered by a 60-horsepower steam engine.

(right) On a beautiful winter day, the side-wheel steamer *Forest Queen* glides up a river. Another sign of the Age of Steam, a locomotive, puffs along the shore while an artist on a hill overlooking the river (Reissner perhaps?) sketches the scene.

(left) *Paddle Steamer* Norrland *in the Port of Stockholm*, late 19th century
P. Wilh. Cedergren
Oil on canvas
57 x 74 cm. (22.4 x 29 in.)
Sjöhistoriska Museet, Stockholm, Sweden

(above) Forest Queen *In Winter*, 1857
Martin Andreas Reissner
Oil on canvas
76.5 x 102.5 cm. (30.12 x 40.37 in.)
Manoogian Collection, Taylor, Michigan

A Revolution Called Steam

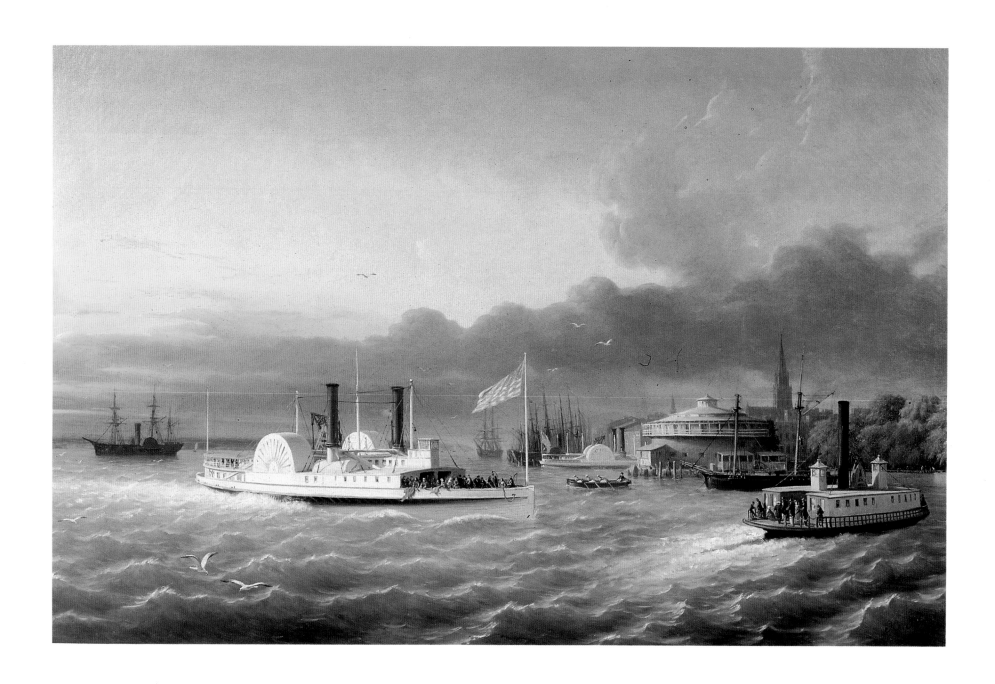

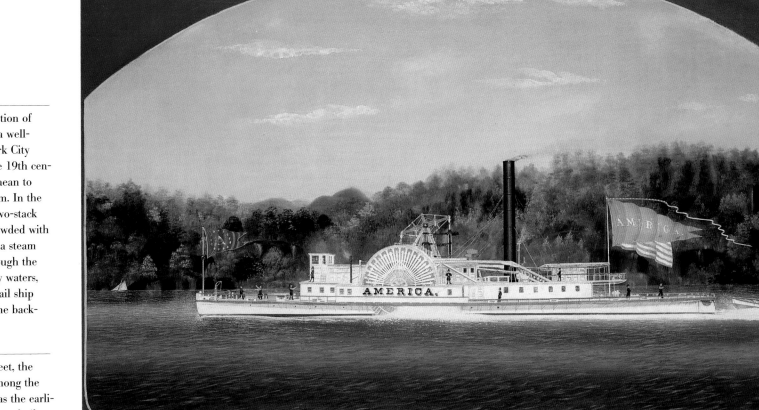

(left) This depiction of Castle Garden, a well-known New York City landmark in the 19th century, is also a paean to the Age of Steam. In the foreground, a two-stack sidewheeler crowded with passengers and a steam ferry surge through the harbor's choppy waters, while a steam-sail ship maneuvers in the background.

(right) At 212 feet, the *America* was among the biggest as well as the earliest of the steamers built specifically for use as tow boats on the Hudson River. She towed everything from passenger barges to sailboats. Her portrait is a colorful and accurate depiction of a vessel from a bygone era.

(left) *Castle Garden*, 1856
Hippolyte Sebron
Oil on canvas
59 x 99.4 cm. (23.25 x 39.12 in.)
South Street Seaport Museum, New York

(above) *Steam Towboat* America, 1853
James Bard
Oil on canvas
86.4 x 134.6 cm. (34 x 53 in.)
The Mariners' Museum, Newport News, Virginia

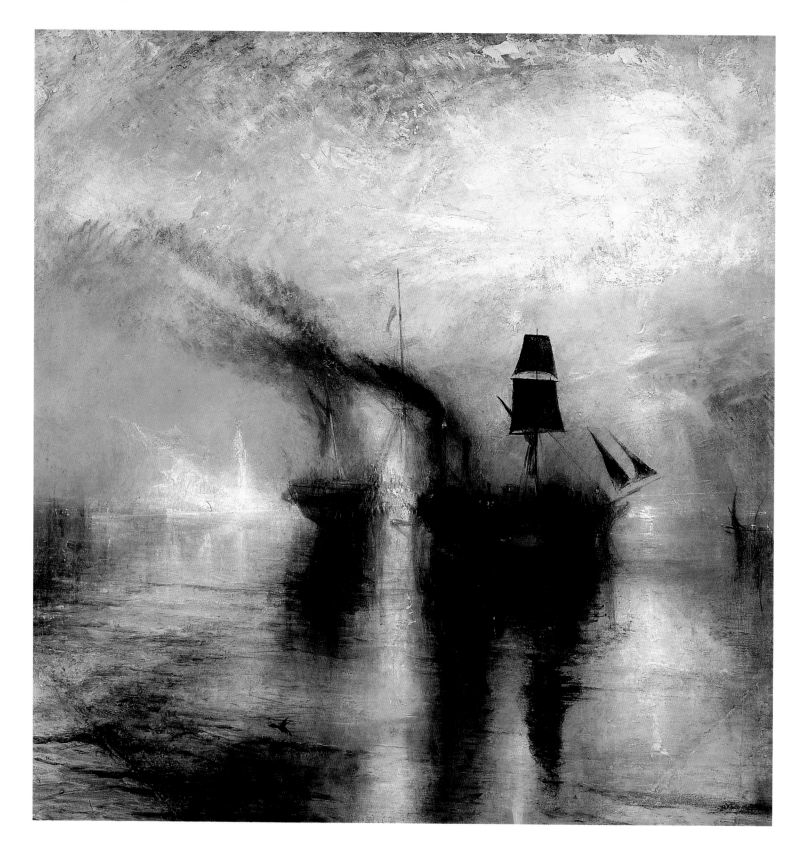

(left) Smoke from a steam-sail ship nearly obscures a burial at sea. The somber painting is a memorial by artist Joseph Turner for a friend who died aboard ship. When another artist complained that the burial ship's sails were too dark, Turner retorted: "I only wish I had any colour to make them blacker!"

(right) Viewed from the deck of a sailing ship, a tugboat marks the end of an era as it nudges the vessel, one of the last of her kind operating on New York's East River, to a final resting place in a scrap yard.

(left) *Peace, Burial at Sea*, 1841
Joseph Mallord William Turner
Oil on canvas
87 x 86.7 cm. (34.2 x 34 in.)
Clore Collection
The Tate Gallery, London/
Art Resource, New York

(above) *Towing Out—End of Sail on the East River*, 1975
John A. Noble
Lithograph on limestone
35.6 x 45.7 cm. (14 x 18 in.)
Snug Harbor Cultural Center, Staten Island, New York
The John A. Noble Collection

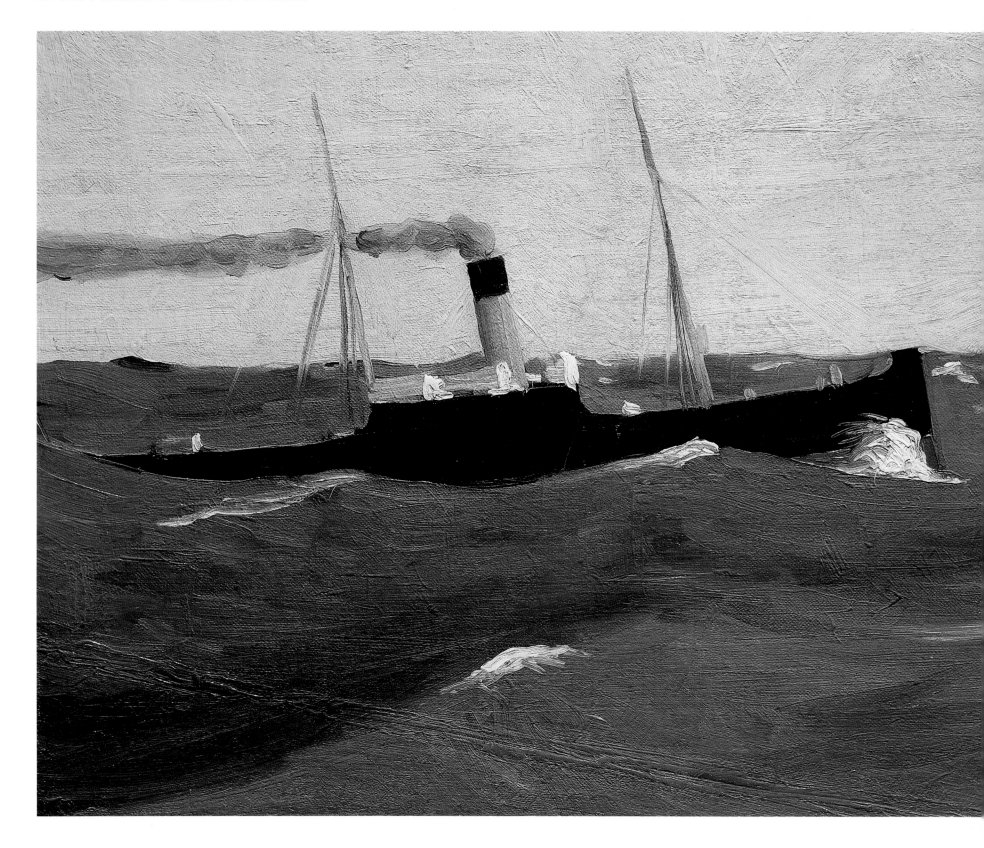

(left) In one of the few sea paintings produced by Edward Hopper, he portrays a marine workhorse in 1908 called a tramp steamer. Ever-newer ships would be launched in the decades to come, but the "tramps" would continue to hold a special place in the hearts of mariners everywhere.

(right) His images, he said, came to him in dreams, and, in fact, Joseph Yoakum, an American self-taught artist, depicts places he had seen, both in his travels and in his imagination. Here, he captures the romanticism of steamship travel by placing such a vessel in the Arctic Ocean off "Sydnia" (Sydney) Australia – a geographic impossibility to be sure, but a notion that generated a fascinating work of art.

(left) *Tramp Steamer*, 1908
Edward Hopper
Oil on canvas
51 x 74.3 cm. (20.12 x 29.25 in.)
Hirshhorn Museum and Sculpture Garden
Smithsonian Institution, Washington, D.C.
Gift of Joseph H. Hirshhorn, 1966
Photo: Lee Stalsworth

View of the Arctic Ocean at Sydnia Australia, 1970
Joseph Yoakum
Colored pencil and ballpoint pen on paper
30.5 x 45.7 cm. (12 x 18 in.)
Janet Fleisher Gallery, Philadelphia, Pennsylvania

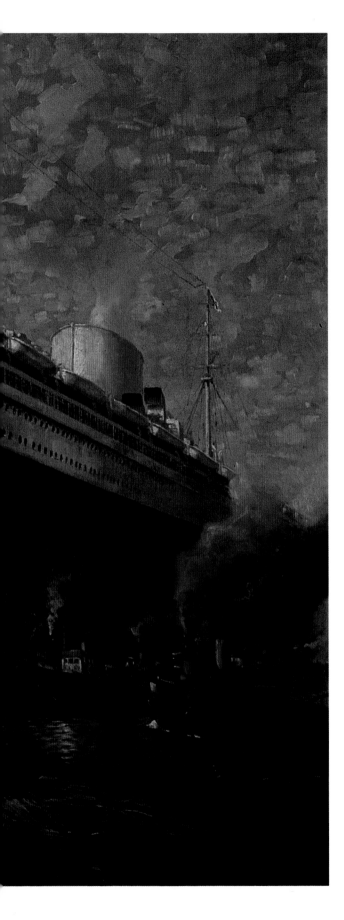

(left) Tugboats nestle alongside the gigantic ocean liner *Bremen* as she's pushed out of her berth. A truly modern liner in 1930, the North German Lloyd flagship weighed 50,000 tons and was 274 meters (900 feet) long. With a revolutionary bulbous nose and a knife-sharp bow, she was as fast as she looked. In 1929, on her first voyage, she took the Blue Riband for the fastest transit of the Atlantic – four days, 17 hours.

(right) In the 1930's, the great age of ocean liners, even advertisements were *grand luxe*. So this poster, touting a Mobil lubricant used on the sleek *Normandie*, is notable for its high Art Deco style – a statement in itself about one of the grandest grande dames of them all.

(left) *Lloydschnelldampfer* Bremen
Verlässt die Columbuskaje, 1930
Hans Bordt
Oil on canvas
177 x 276 cm. (69.9 x 108.7 in.)
Deutsche Schiffahrtsmuseum, Bremerhaven, Germany

(above) "Mobiloil" Poster, ca, 1935
Lithograph
Mobil Oil Française

Emanations

But that same image, we ourselves see in all rivers and oceans. It is the image of the ungraspable phantom of life; and this is the key to it all.

Herman Melville
From *Moby Dick*

*T*HE STERN OF A MAN-OF-WAR was lavishly decorated, typically carved with elaborate arrays of angels, mermaids and griffins arranged around a coat of arms, the crest at its center the consummate symbol of power on the seas. This decoration was intended to celebrate the standing of the ship's patron—be it king, duke or investor—and to intimidate the opposing fleet. That crest declared authority—human force extended; in its name, the ships sailed out from port, and through their unifying influences—migration, warfare, and trade—they contained the world in a perfect circle of society. The only way to circumnavigate the surface of the globe is by sea: Thus, every continent has its coast; all cultures, then, are ultimately marine.

The historian Simon Schama in "Water,"

This 17th century Italian drawing of a ship's stern encrusted with angels, mermaids, griffins and a crest, transmutes a baroque design into an object of beauty that is symbolic of the power and glory of the seafaring days of yore.

Studio di Decorazione di Poppa di Vascello,
1670-1680
Domenico Piola
Pen, ink and color wash
37.5 x 29.5 cm. (14.8 x 11.6 in.)
N.I. Gabinetto Disegni di Palazzo Rosso
Genoa, Italy

part two of *Landscape and Memory* — his extraordinary analysis of how we comprehend nature — refers to "fluvial myths" and "hydraulic societies" in which rivers are revered as the source of identity and order, their shores the sites of temples and beliefs, their confluences the sites of cities and civilization. In his view, rivers were a system of circulation, "the *line* of waters, from beginning to end, birth to death, source to issue... supplying imagery for the life and death of nations and empires and the fateful alternation between commerce and calamity." The rivers fed the oceans, and the line of waters was extended infinitely.

How do we understand a system of such complexity? Science, of course, is one way, and we probe the ocean today with ever-increasing sophistication at ever-increasing depths to discover how little we know about the waterworld. We illuminate the darkness and are stunned by the array of unknown creatures. Angels? Mermaids? Griffins? Our way of seeing them is through the photograph.

Another way is through abstraction, and in Willem de Kooning's painting *North Atlantic Light*, we may find the consummate contemporary image of the sea. In this picture, no lines are straight, nothing is constant. The itineraries are disrupted and change is the natural condition. The color is rich, harmonic like a gale of wind, as

if the paint has been applied here in microburst and there in cyclonic abandon.

At the center is a recognizable shape, a blue triangle. The crest of a wave? Another symbol of consummate power? A sail perhaps, alone, persevering in this chaotic canvas? Or a whirlpool into which we are drawn, sucked down, drowned, thrown up again to eddy near the shore? Are we looking into the bottom of the sea at the source from which all this nurturing peace, all this terrifying anger, derives? Are we seeing the center of our universe, the ultimate source from which we originate? This central image is reflected: the world above, the world below; inside, outside, port, starboard—the duality of being that has perplexed philosophers and mariners forever.

By suspending in it *all* possibility, the ocean must be understood as the ideal context for creativity—for imagination and invention, for renewal and re-creation of the soul. Just as ideas are borne in our stream of consciousness, so art flows from the sea. History is the beneficiary. Those moved by the stimulus of waves and water—the image makers, artists, poets, others drawn wordlessly to the shore—are the activists, the optimists, the builders, the revolutionaries. They move confidently among us; they cleave to the ocean; they sit by the sea, their brush and paints in hand. And they illuminate our lives. ✲

That the complexity and power of the sea need not be depicted literally is illustrated by this composition. Liberated from specific shapes, its brilliant colors suggest the changeable, yet immutable, sea and the human encounters with it and within it.

North Atlantic Light
Willem de Kooning
Oil on canvas
203 x 178 cm. (80 x 70 in.)
Stedelijk Museum, Amsterdam

Index

by artist and title

(overleaf) A detail from
the 11th century Bayeux
Tapestry chronicles William
the Conqueror's invasion
of England and depicts the
ships of the invaders.
The invasion, launched
across the English Channel
in 1066 with hundreds of
ships and thousands of
men and horses, was the
largest seaborne assault
of its day.

(overleaf) *Tapisserie de Bayeux* (detail), 11th century
Embroidered linen
49.5 cm. x 70.4 m. (19.5 in. x 231 ft.)
Centre Guillaume le Conquérant,
Bayeux, France

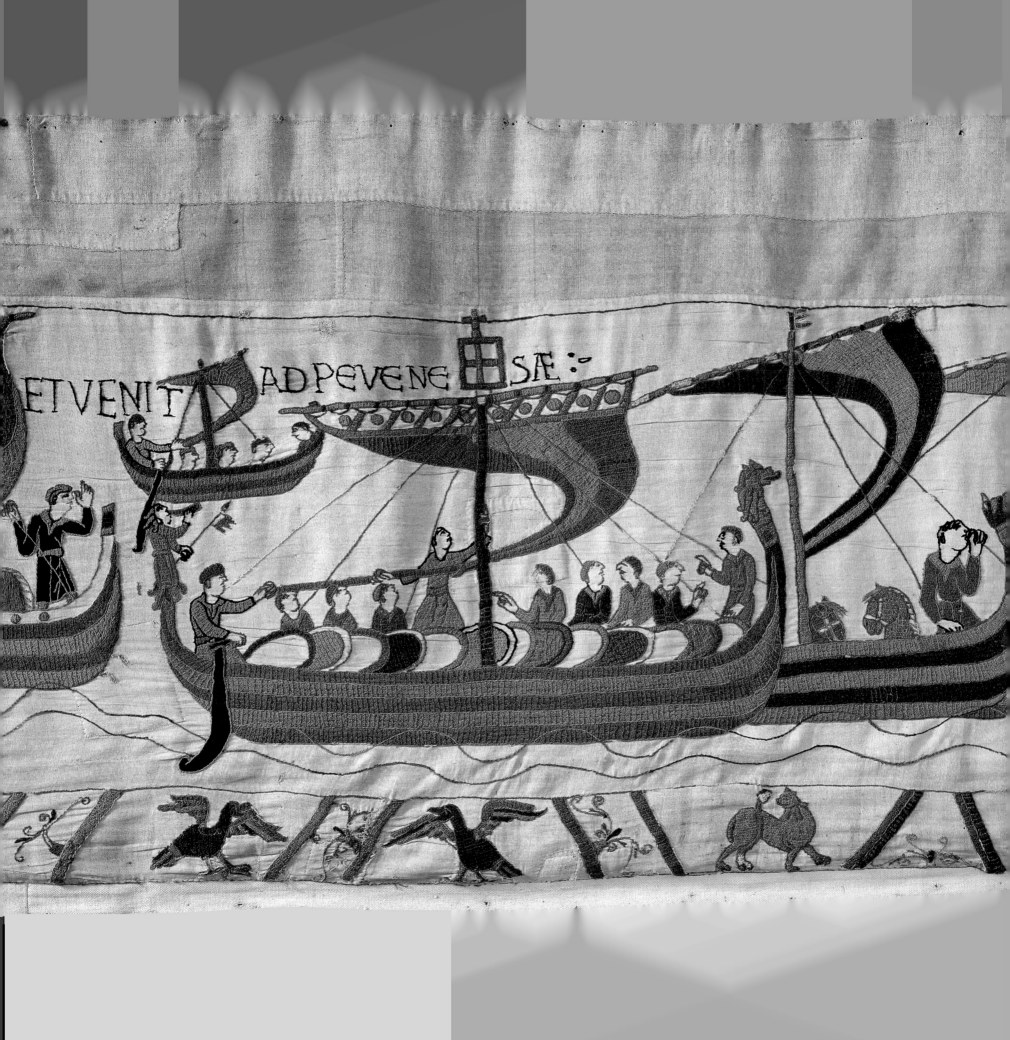